WILHELMINA
DEFINING
BEAUTY

WILHELMINA
DEFINING
BEAUTY

New York · Paris · London · Milan

CONTENTS

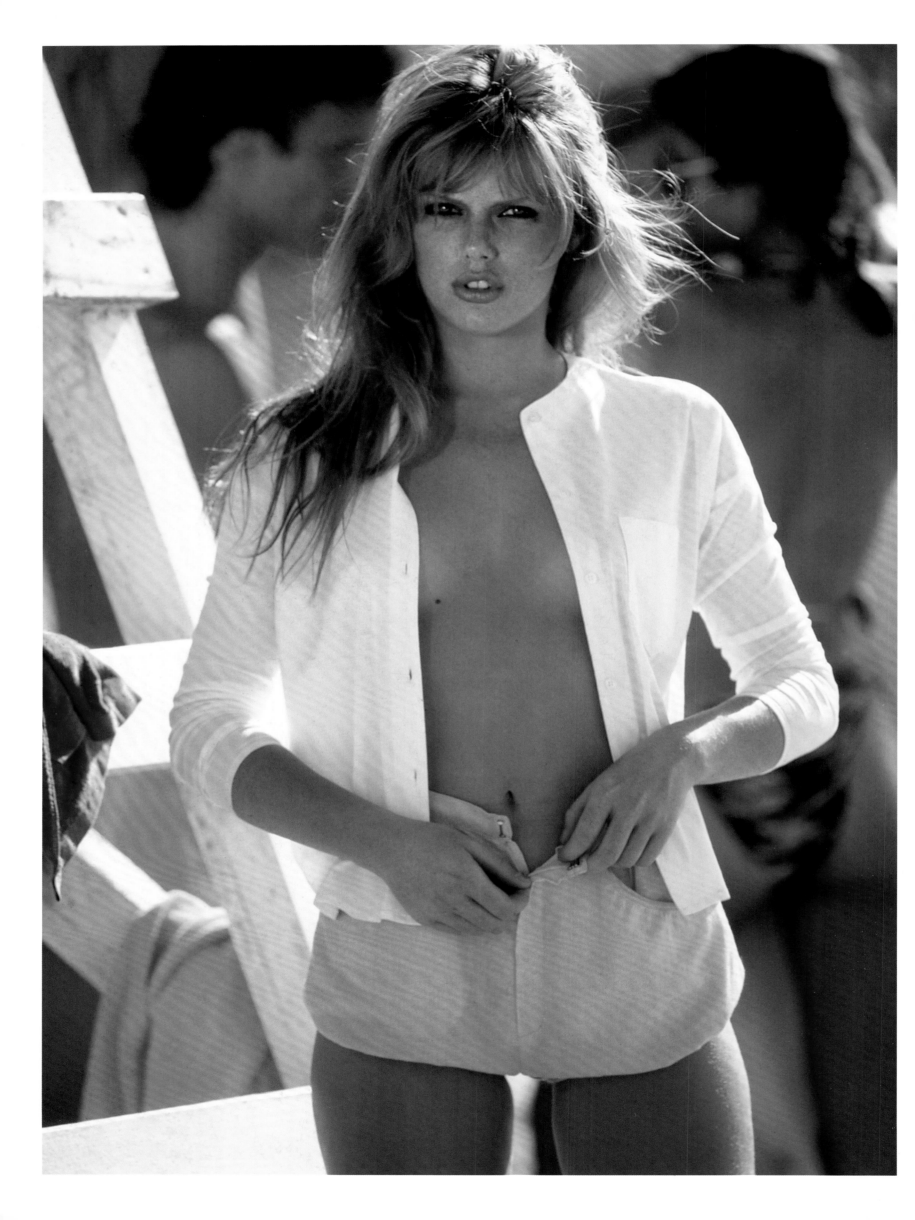

FOREWORD

By Patti Hansen

I first met Wilhelmina in the summer of 1972 at a party I was invited to by Peter Gert, a photographer I had been introduced to. A vision of typical '70s fashion, my hair was shagged and I wore a long skinny blue spaghetti-strapped number.

Buzzing with glamour and style, it was a night to remember. Girls wore hot pants and flashy gold lamé. But what sticks out to me most is a brief introduction to "Willy." Incredibly gracious and kind, she asked me to come see her with photos.

Armed with shots that Peter had taken of me, off I went to Wilhelmina's office dressed in a halter top and wide bell bottoms. When I arrived, it was just as enchanting as she was. The walls were adorned with her iconic *Vogue* covers. A slinky metal beaded curtain marked the entrance to her office. With an ever-present cigarette in her long, elegant painted nails, Willy sat behind her desk, majestic and beautiful.

Though she would usually spend time giving new girls instruction on makeup and the "how and whatnots" of modeling, I went to see *Glamour* magazine that same week, and they booked a shoot with the legendary photographer Rico Puhlmann. For the next few years, I never really stopped working. Jetting around the world to remarkable places and collaborating with wonderful people, I was living an absolute dream life.

Wilhelmina truly took a personal interest in each of her models. She put me in elocution lessons for my thick Staten Island accent at the time. She also met my entire family at our home, where she convinced my reluctant father into sending me to a professional children's school in New York, so that I could continue modeling while finishing my education.

For sure, the idea of beauty changed from 1972 onward. Just like in fashion, beauty is dictated by the ebbs and flows of trends and technology. Modeling has changed in many ways, from models' compensation to the ever-improving Internet. Most of my forty-five-year-long career has been with Wilhelmina Models, and I am so grateful for having been able to travel the world and enjoy my work. I am forever thankful to Wilhelmina for launching my career, for mentoring me, and for being the most genuine example of grace, charisma, and professionalism that I have ever known. Today, her agency is still infused with her beautiful spirit and her groundbreaking legacy.

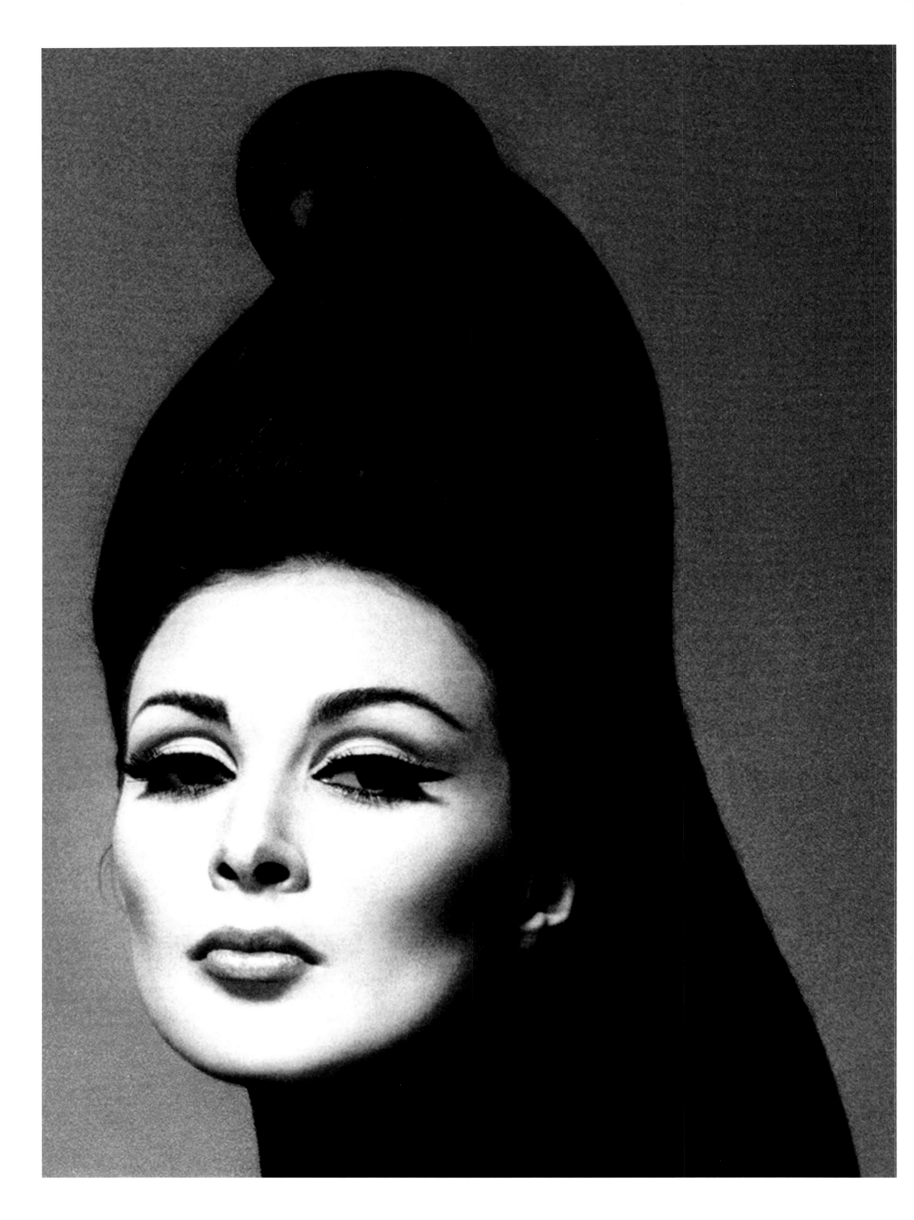

LETTER FROM THE CHAIRMAN

By Mark E. Schwarz

It was sometime during late 2007 when I was first asked, "Would you be interested in buying Wilhelmina, the modeling agency?" The prospect of acquiring one of the biggest modeling agencies in the world is not something one plans for—it just sort of happened. But sometimes things happen for a reason.

From almost my earliest memories until my late twenties, music was the only life I'd known. The life of a rock star does little to prepare one for much of anything else in this world. But the thread of fashion, through its connection to music, had been woven into the most essential elements of my DNA. That was then, before the hand of fate intervened in my life in a way that can never be imagined. Before I accidently became involved in the world of business and finance, and when the possibility of owning Wilhelmina became a reality.

Unexpected though it was, a vision immediately took hold. Fashion is uniquely the single element that touches all forms of art, music, film, and media. Its impact has been with us for centuries and its influence grows every day. In Wilhelmina, there was an opportunity to invest in people, processes, and systems; to become an innovator; and to rewrite the definition of the new modern agency—all the while preserving the delicate balance between art and commerce.

Nearly a decade on, the journey of owning Wilhelmina continues. A business started by a pioneer, Wilhelmina Cooper, fifty years ago thrives today, surely larger and more successful than anything she could have imagined at the time. In addition, Wilhelmina has become the first-ever publicly traded modeling agency on a U.S. stock exchange. It is certain that Wilhelmina is destined to help shape the next fifty years of fashion history.

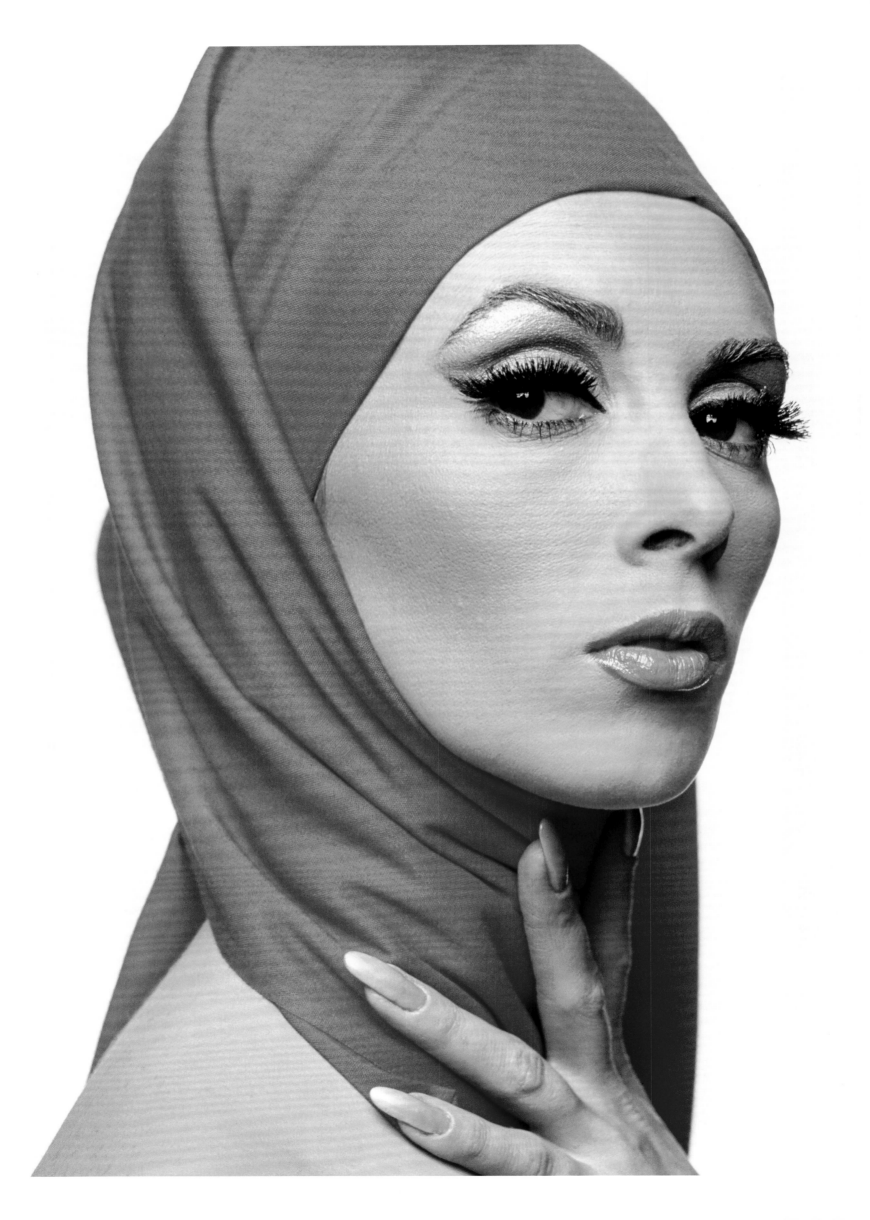

THE BUTCHER'S DAUGHTER

Once upon a time, there was a young and ambitious girl who believed in the power of reinvention to create her own image and change the definition of beauty around the world, with a company that still bears her name.

On May 1, 1939, Gertrude Behmenburg is born in Culemborg, the Netherlands, under the sign of Taurus, strong and determined, to a butcher and his wife.

In time, Gertrude grows taller, but life in Oldenburg, Germany, where the family had moved after the war, was hard. And so, in 1954, at the age of fifteen, her family moved to Chicago to reinvent themselves in a country of opportunity.

Striking, at five foot eleven, she attends modeling school in Chicago under the name "Winnie Heart."

In time, Winnie visits New York, where she meets Eileen Ford. She is told she can't model "with those hips." Ford sends her to Paris to refine her look.

Winnie is no longer: Wilhelmina is born.

She appears on 280 magazine covers, including a record twenty-six *Vogue* covers. The butcher's daughter who understood the power of pose and mystique becomes the most photographed model of the 1960s.

But just when you think she has got it all, she reinvents herself again. Wilhelmina falls in love with a producer of *The Tonight Show*, Bruce Cooper and in 1965 they marry. Two years later, Wilhelmina leaves modeling at the height of stardom to launch her own agency, at a time when less than 5 percent of businesses in America were owned by women.

Fiercely determined, she champions the notion that beauty comes in all shapes, sizes, and colors, and that flawed beauty is often the most interesting.

In time, this passion made Wilhelmina Models the hottest agency in the 1970s, placing this smart cookie as the first businesswoman to grace the cover of *Fortune* magazine.

But, time is not fair, and just as things are growing, Wilhelmina develops a cough. She dies at age forty in 1980, leaving behind a husband and two small children.

Her spirit is alive today in the agency that she founded fifty years ago. Wilhelmina would be proud to know that every three minutes a model is being booked on a job somewhere in the world through her namesake agency.

Once upon a time, a young girl's belief in the power of recreation inspires a new generation today.

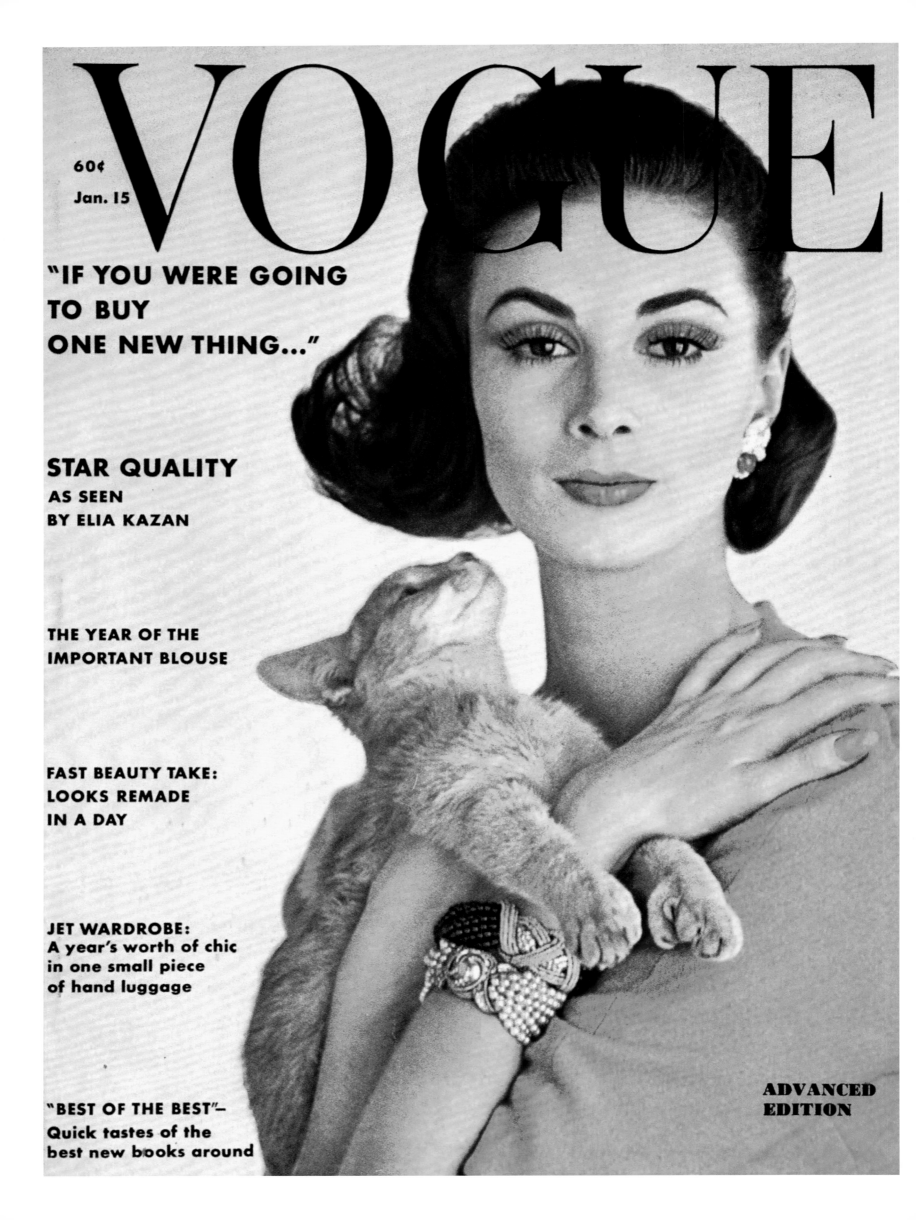

VOGUE

60¢
Jan. 15

"IF YOU WERE GOING
TO BUY
ONE NEW THING..."

STAR QUALITY
AS SEEN
BY ELIA KAZAN

**THE YEAR OF THE
IMPORTANT BLOUSE**

**FAST BEAUTY TAKE:
LOOKS REMADE
IN A DAY**

JET WARDROBE:
A year's worth of chic
in one small piece
of hand luggage

"BEST OF THE BEST"–
Quick tastes of the
best new books around

**ADVANCED
EDITION**

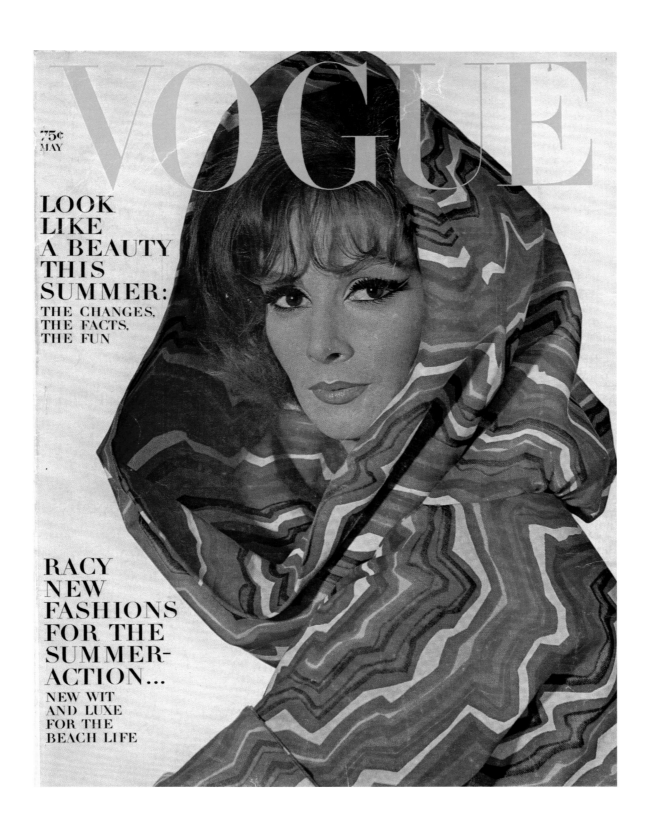

VOGUE

75¢
MAY

LOOK
LIKE
A BEAUTY
THIS
SUMMER:
THE CHANGES,
THE FACTS,
THE FUN

RACY
NEW
FASHIONS
FOR THE
SUMMER-
ACTION...
NEW WIT
AND LUXE
FOR THE
BEACH LIFE

OPPOSITE PAGE: WILHELMINA COOPER, 1962
THIS PAGE: WILHELMINA COOPER, 1964

13

INTRODUCTION

By Eric Wilson

If there is one thing that the fascinating and fractious history of the modeling industry can tell us about beauty, it is that the face of fashion changes as constantly as the clothes.

Think of the iconic graces of mid-century couture—Dovima, Suzy Parker, Dorian Leigh, and Lisa Fonssagrives—or the otherworldly stars of London in the Swinging '60s, like Jean Shrimpton and Twiggy. Or think of the supermodels of the 1990s or the social media "influencers" of the present day. Models have, for better or worse, reflected a very specific vantage on our times, our perceptions, and ultimately our desires to be fashionable, skinny, sexy, voluptuous, famous, or simply in style.

The prevailing aesthetic of any moment in fashion is closely aligned to the standard of physical beauty of the time, seen as much throughout the history of art as through the history of runways. And yet for as much as models may be representatives of a particular set of preexisting ideals (often those of a Eurocentric and Caucasian lens, it must be noted), some of the most successful stars have also managed to impose their own sort of order on beauty. And this is something that Wilhelmina Behmenburg Cooper, the Dutch-born model who became one of the most successful faces of the 1960s, recognized early on in her career, shortly after her family moved to Chicago, where she was discovered.

Willy, as she was known to friends, appeared on the covers of nearly three hundred magazines, including twenty-eight covers of American and European editions of *Vogue*, before launching her own agency in 1967. Sophisticated and charismatic in an industry that is not well known for its high regard of ethics or manners, Cooper became a substantial player just at the beginning of a moment of intense, sometimes scandalous, competition in the industry. These were the years that were chronicled in the tabloids as the "Model Wars," when agencies fought tooth and nail in a business that depends on perfect teeth and nails.

By the 1970s, Wilhelmina had become the hottest agency in town, according to Michael Gross's *Model: The Ugly Business of Beautiful Women*, signing stars like Patti Hansen, Shaun Casey, Pam Dawber (who would go on to star in *Mork & Mindy*), and the tragically fated Gia Carangi, considered in some circles to be one of the first supermodels, but also a precursor to the dangerous years of "heroin chic." At a time when there was very little respect for models of color,

Wilhelmina took on Naomi Sims, who became one of the most successful black models and entrepreneurs of the 1970s, credited by Halston as the first black supermodel and by The Metropolitan Museum of Art's 2009 exhibition *Model as Muse* for ushering in the "black is beautiful" moment. Wilhelmina, as tenacious and determined as she was generous, was once lauded for spotting Iman in a photograph and sending her a plane ticket to New York from Somalia.

"It's hard enough to become a successful model," she said. "But it's twice as hard to stay successful."

Cooper was known for her keen eye, especially for spotting new talent, and for mothering her charges in a kindly way, though she could recognize on sight if an applicant was exaggerating in the slightest about her height or weight. But to hear her say, "I really loooove the way you look" meant the start of a real career.

While Jerry and Eileen Ford, whose Ford Models started in 1946 was largely responsible for bringing some sense of order and accountability to the modeling world, tangled with John Casablancas, the brash upstart behind Elite Models who brazenly mixed business with his own personal pleasure, Wilhelmina remained a pragmatic and tenacious force on her own. It was Wilhelmina's face that appeared on the cover of *Fortune* magazine in 1979 to illustrate a story about the rivalry between the three agencies, titled "Ugly Competition for Pretty Faces."

Though she passed away in 1980 of lung cancer at only forty years of age, the agency she left behind has carried forward a tradition of breaking the boundaries of what a model can be with an expansion into talent management and beyond. Throughout its five decades and various divisions, Wilhelmina went on to represent major models like Kim Alexis and Beverly Johnson, as well as artists, athletes, actors, and singers, today including Nick Jonas, Shawn Mendes, and Nicki Minaj.

Famous for her chestnut locks, Cooper herself once said, "If I had to start all over again, I never would make it—not in this day of girl-next-door, California blonde, outdoor types." Throughout these pages you will find a diverse array of characters whose only unifying quality is that each is remarkable for his or her own achievement, representing the ideal of a moment in time, perhaps, but also a sense of beauty that is in a way timeless. Faces may come and go, but even after fifty years, the image of a Wilhemina model remains.

Wilhelmina
Defining Beauty
celebrates the people,
passions, and beauty of
the talent that has
walked through the
doors of the agency over
the past fifty years.

All About Personality
THE SUPERS

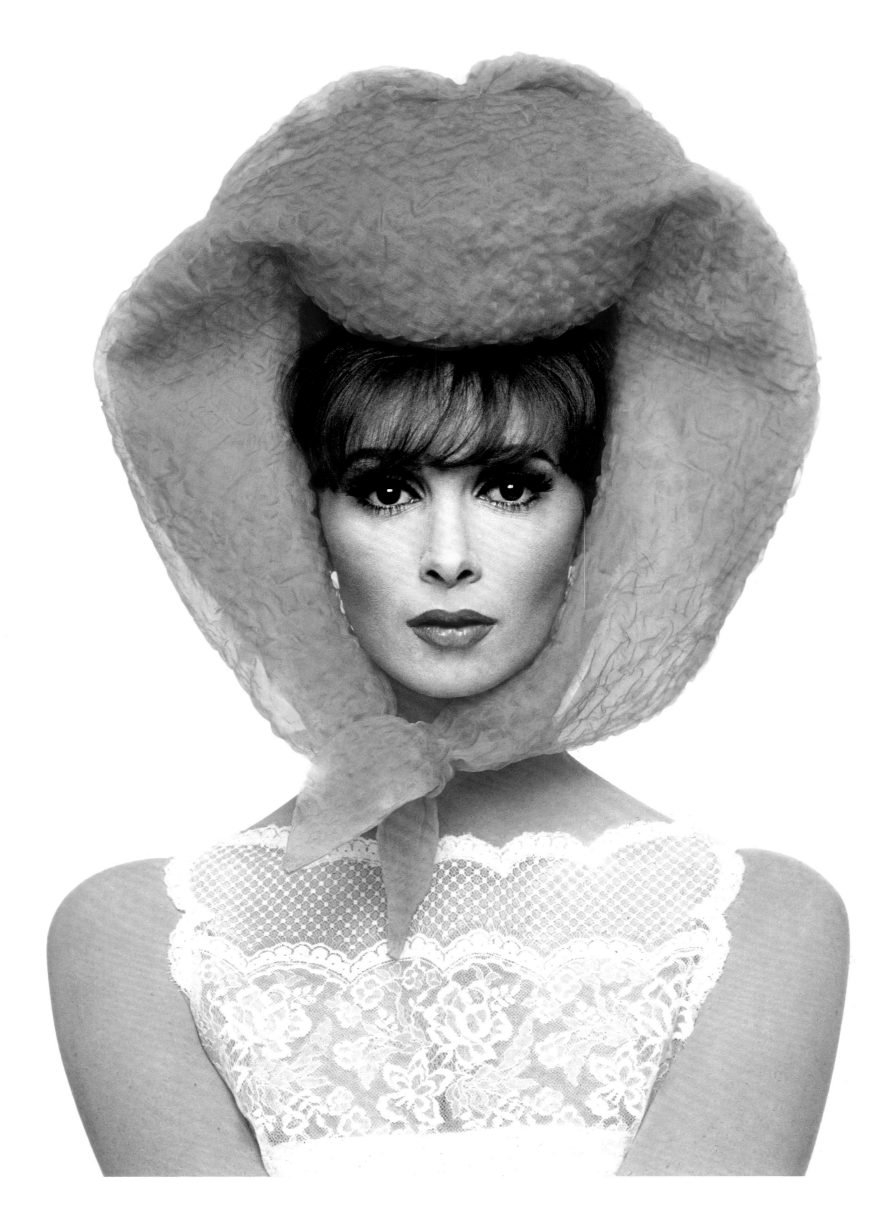

All About Personality
THE SUPERS

What makes the difference between a successful model and a supermodel?

"There will never be anything like the era of the supermodel again," Peter Lindbergh said in the catalog for a 2016 Sotheby's sale of contemporary photographs, which referenced his iconic image of Naomi Campbell, Linda Evangelista, Tatjana Patitz, Christy Turlington, and Cindy Crawford that appeared on the cover of British *Vogue* in January 1990. "They were more than a group of models, they were carrying a message and represented a lot of things at the same time."

In fact, they represented the times—with a fin de siècle sense of extravagance that embraced ultra-glamour, bombshell beauty, and rich-bitch fashion with abandon. These were the Versace years, the RuPaul "Supermodel" years, the George Michael "Freedom! '90" years. It was also at this moment that Evangelista made a famous comment to *Vogue* that came to define the supermodel attitude of unapologetic egotism: "We don't wake up for less than $10,000 a day."

Of course there had been many supers before them. Twiggy was the supermodel of her day, and many have claimed to have been the world's first (Janice Dickinson made that boast as part of the title of her titillating 2002 memoir, *No Lifeguard on Duty: The Accidental Life of the World's First Supermodel*. But what really changed in the late twentieth century, as Evangelista astutely noted, was the arrival of life-changing money to the industry, the result of decades of industry competition and the beginning of an era of Big Fashion, as historic luxury houses catering to a growing yuppie class were transformed from small family businesses into global luxury conglomerates. Suddenly it was possible for a model to earn millions of dollars through advertising contracts and beauty endorsements, and everyone wanted to be a part of fashion.

Those years are most fondly remembered for the personality that the models brought to the shows, each with a distinctive walk, a turn, or pose. But it was a short-lived moment, it turns out, as the intense media focus on models and their diva behavior—their tantrums and their cell phone fights—began to take the spotlight away from the designers. The most influential ones began to seek out models who would not compete with the clothes, often resulting in bland, monochromatic casts (and eventually a major diversity problem). At the same time, magazines recognized the newsstand power of featuring celebrities on their covers. Eventually, luxury brands did the same in their advertisements.

While the age of the supermodel really started to fizzle at the turn of the century, in fashion, everything is cyclical. Designers remembered one very important thing: clothes need the personality of the wearer to come to life. And so it is no surprise on the runways of 2017 to see so many faces from past and present generations—Naomi Campbell, Liya Kebede, Irina Shayk, even Lauren Hutton—joining the new supers—Gigi, Bella, Kendall—of today.

"For a long time we didn't have supermodels," Donatella Versace recently said. "Now they're back again, but in a different way."

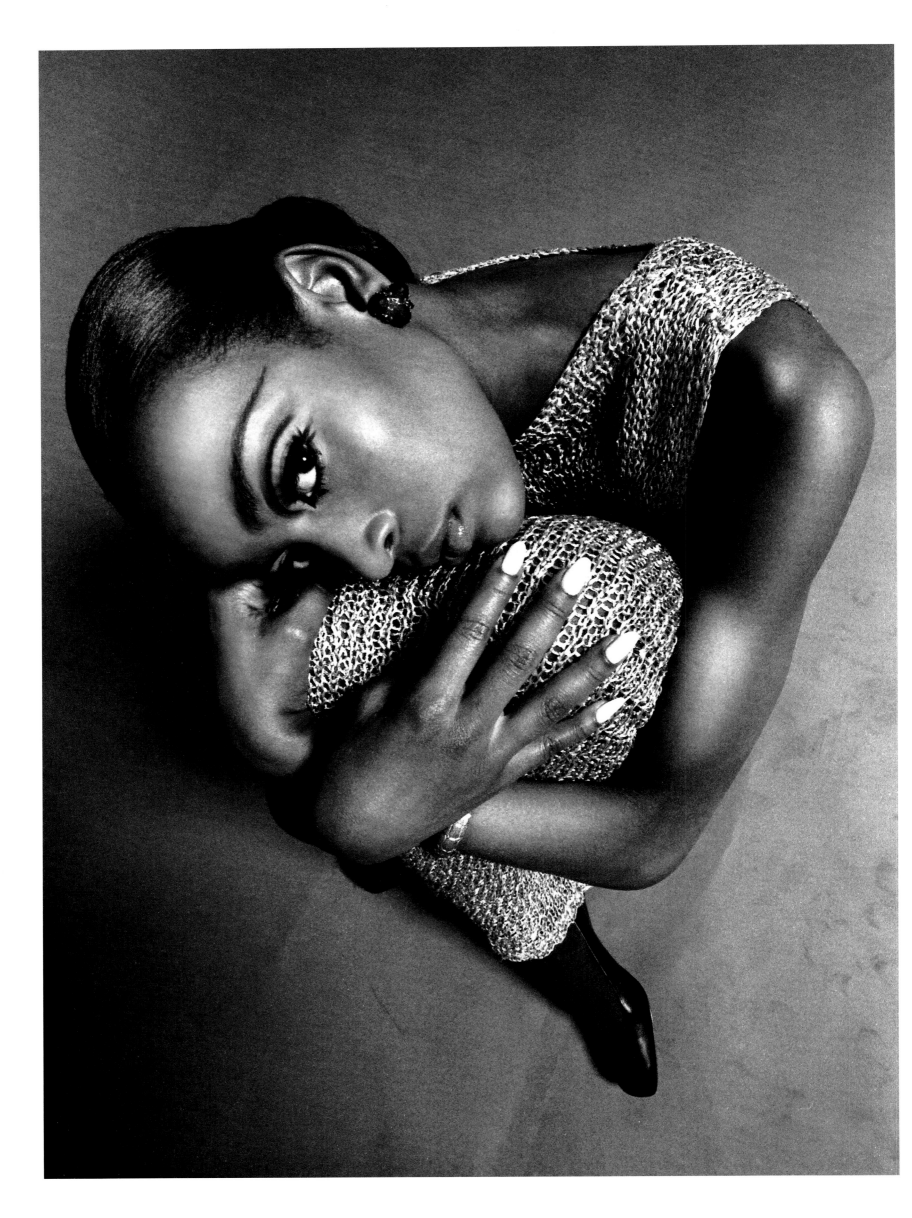

"Maybe I won't see it in my lifetime, but there will come a day when it will be quite common to see a black face on the cover of Harper's Bazaar *or* Vogue.*"*

–Naomi Sims

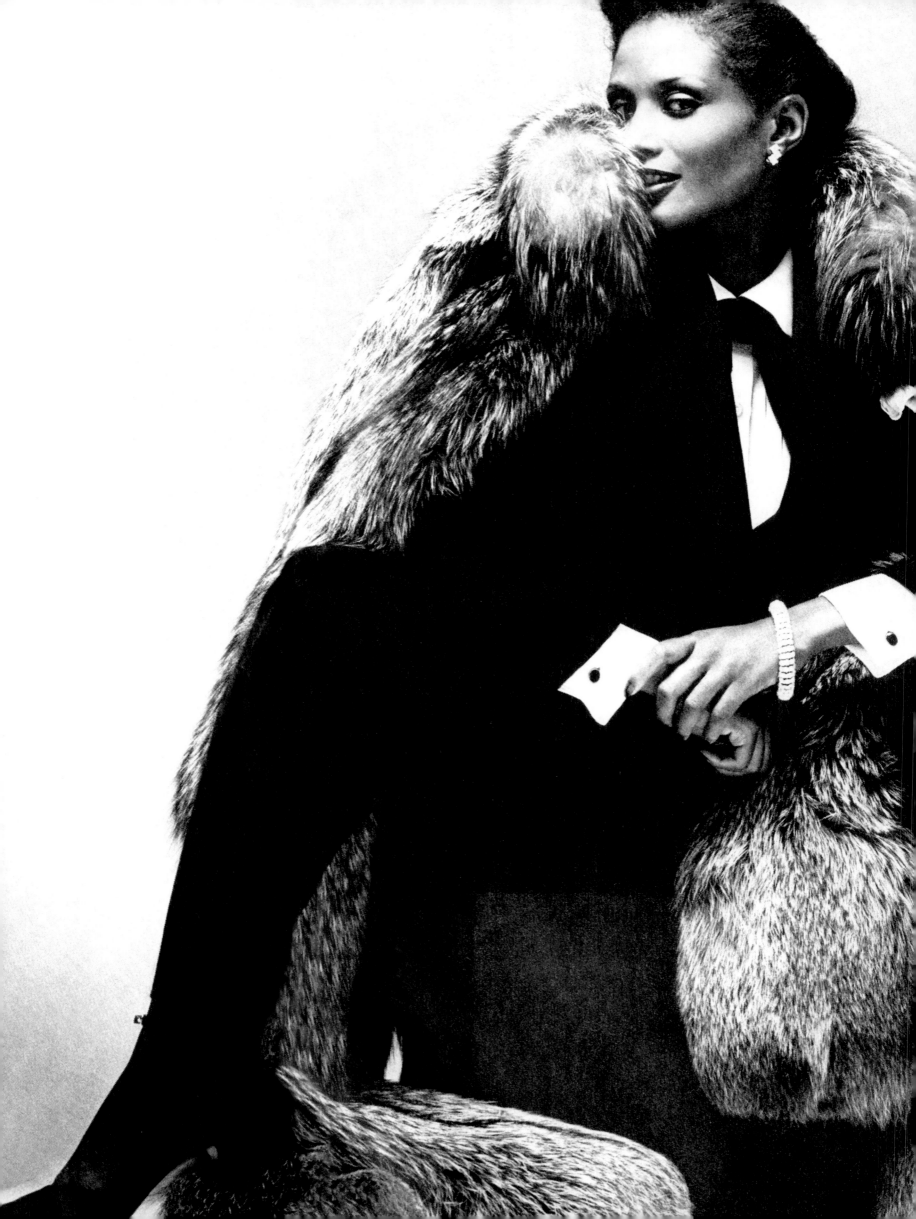

OPPOSITE PAGE: BEVERLY JOHNSON, 1977

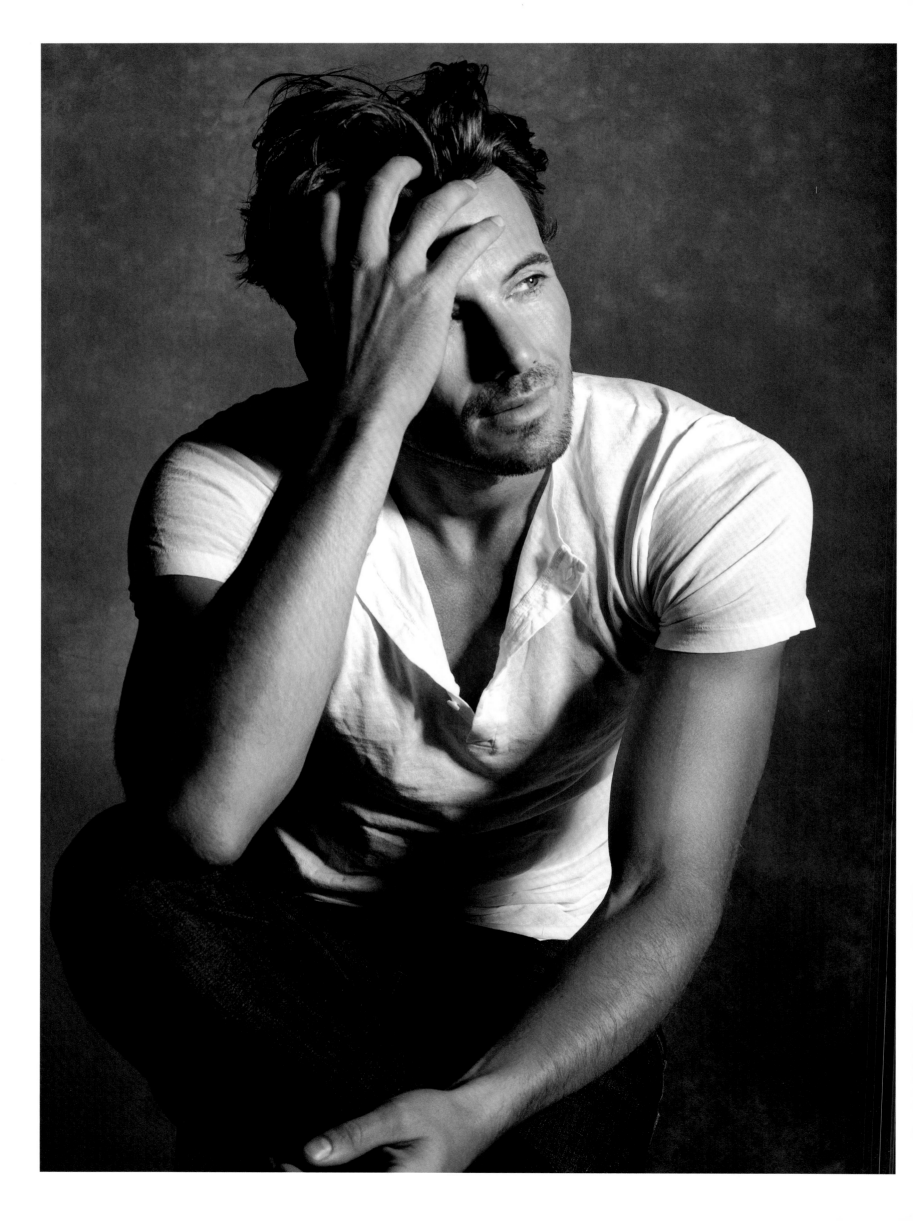

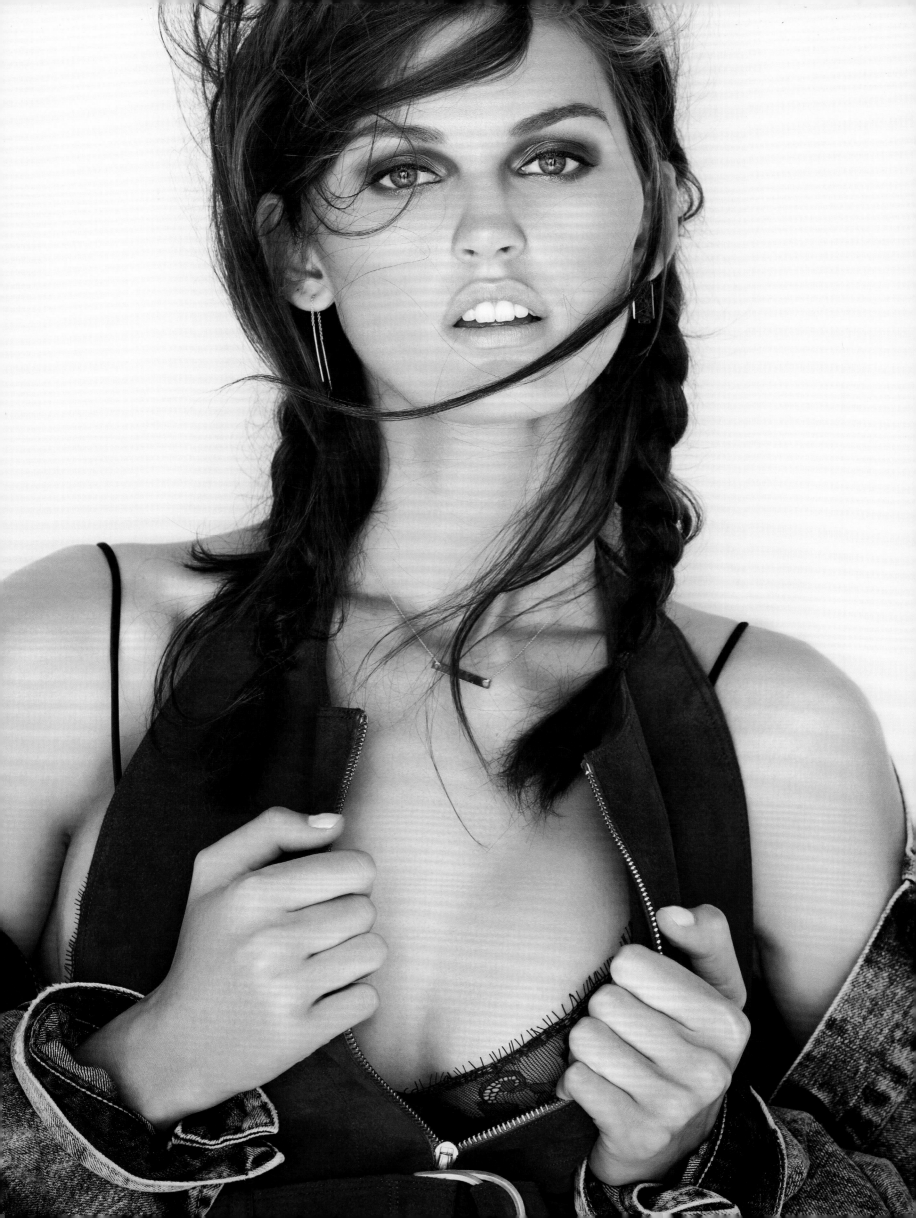

*"Every sweet, humble,
young model is
only one campaign away
from becoming
a fashion monster."*

—*Coco Rocha*

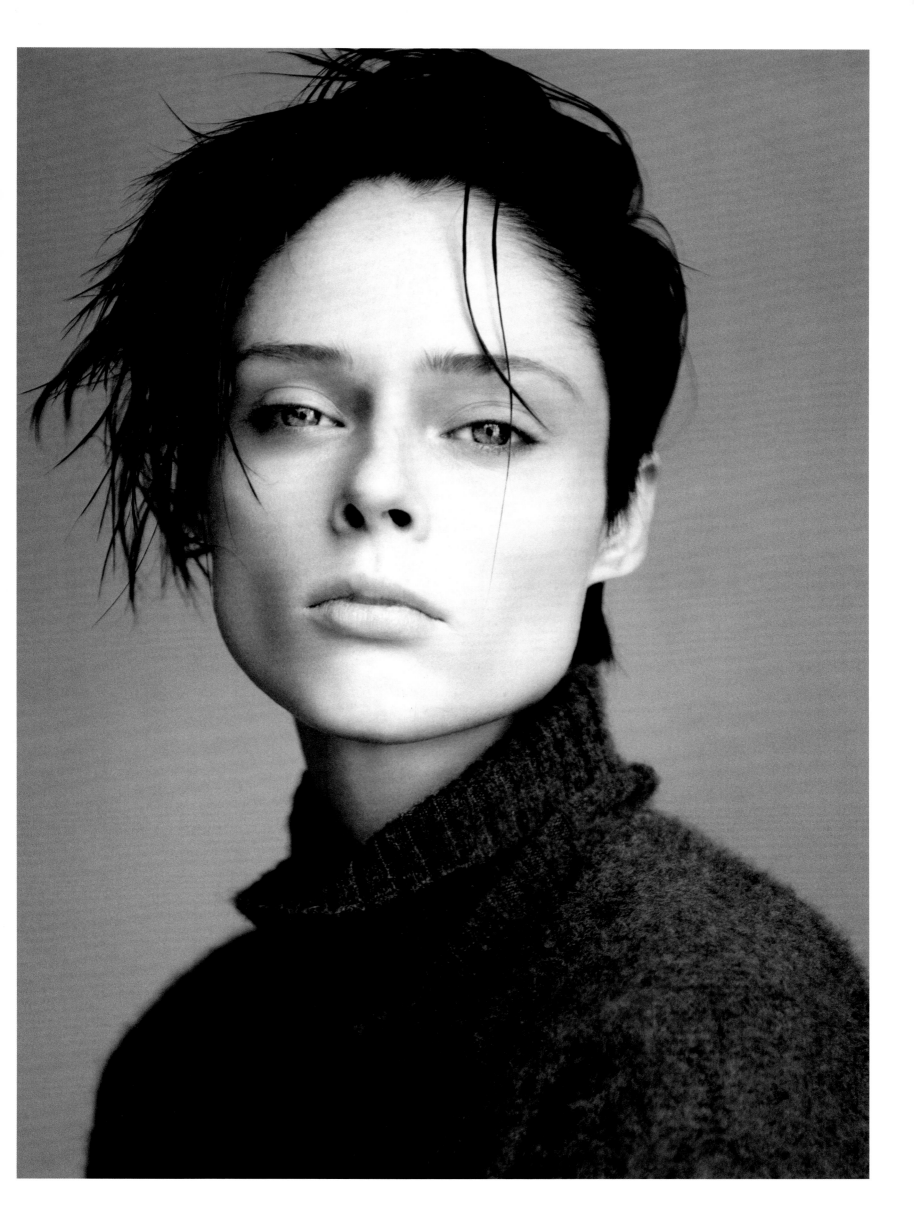

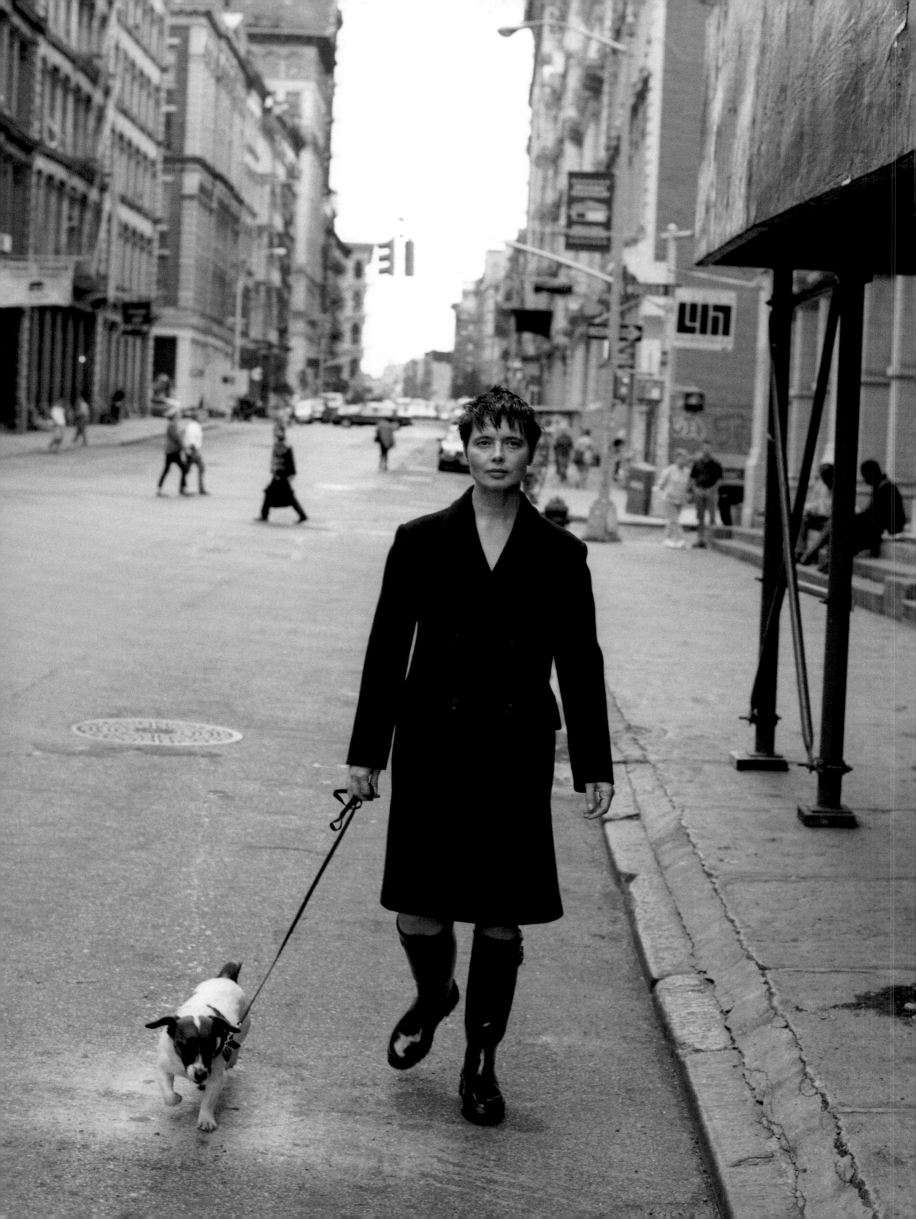

*"True elegance for me
is the manifestation of an
independent mind."*

–Isabella Rossellini

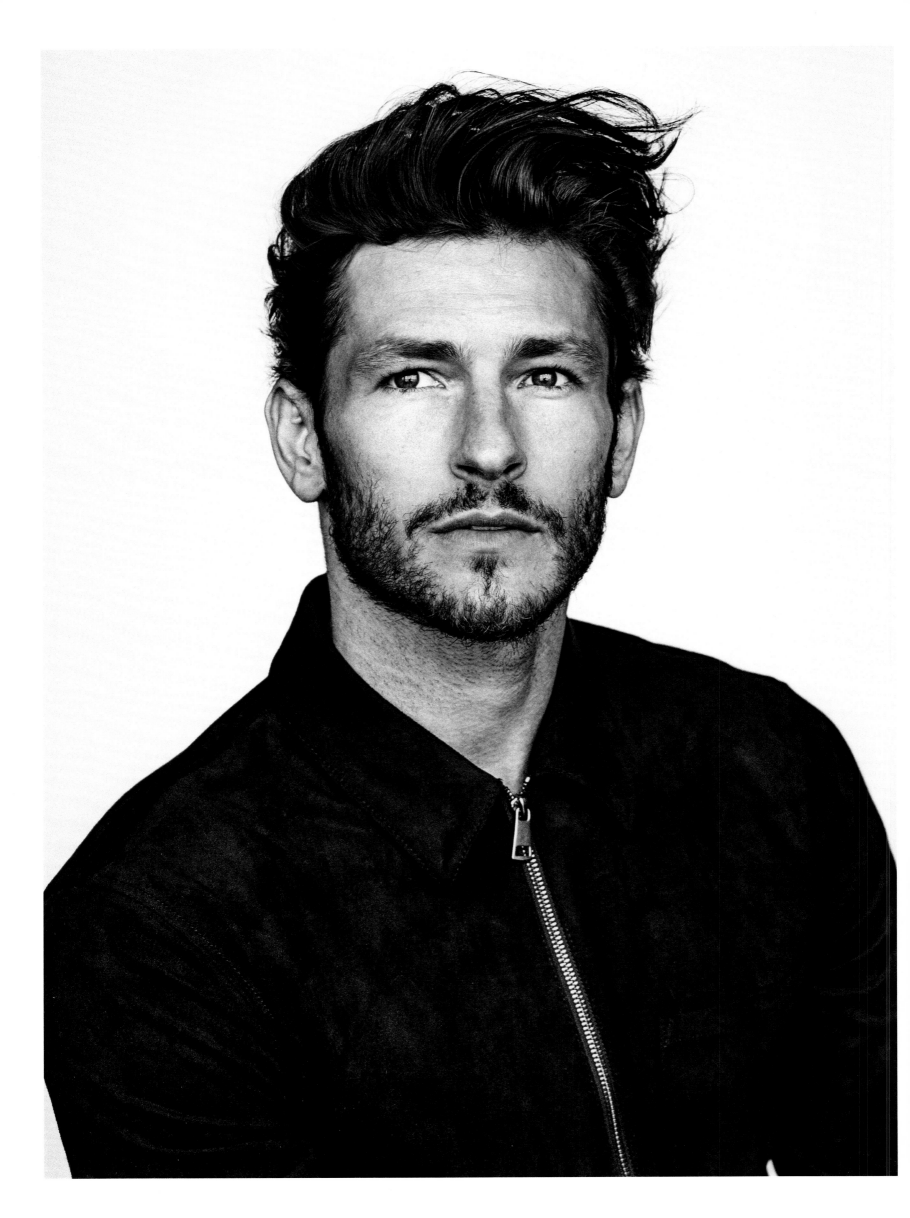

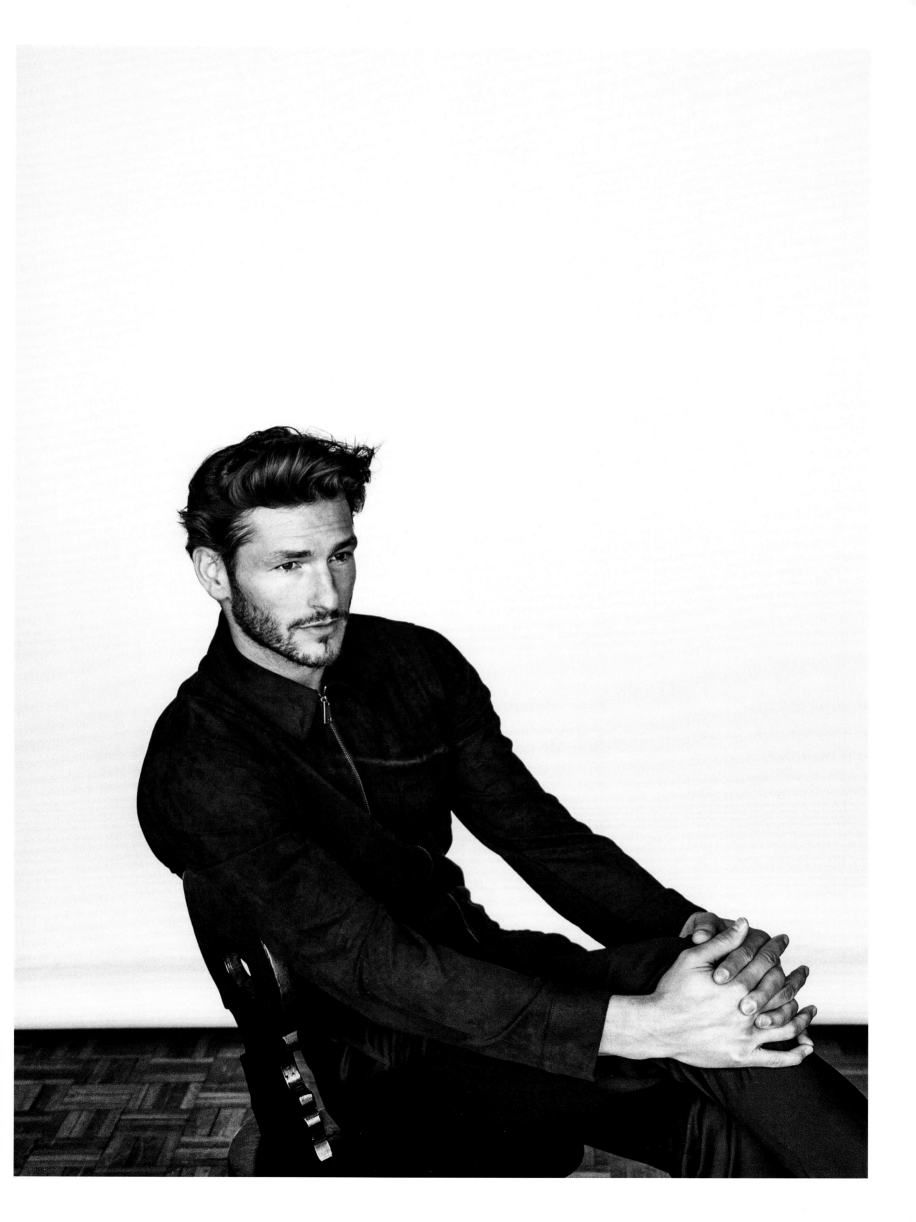

*"A supermodel needed to be
able to be on* Sports Illustrated,
*to be able to walk runways,
to be able to do beauty ads,
to be on covers.
And the girls now can no
longer be on covers and be in the
ads because your actresses have
taken over all the jobs.
I don't know what happened, but
we want our jobs back."*

–Kim Alexis

OPPOSITE PAGE: KIM ALEXIS, 1985

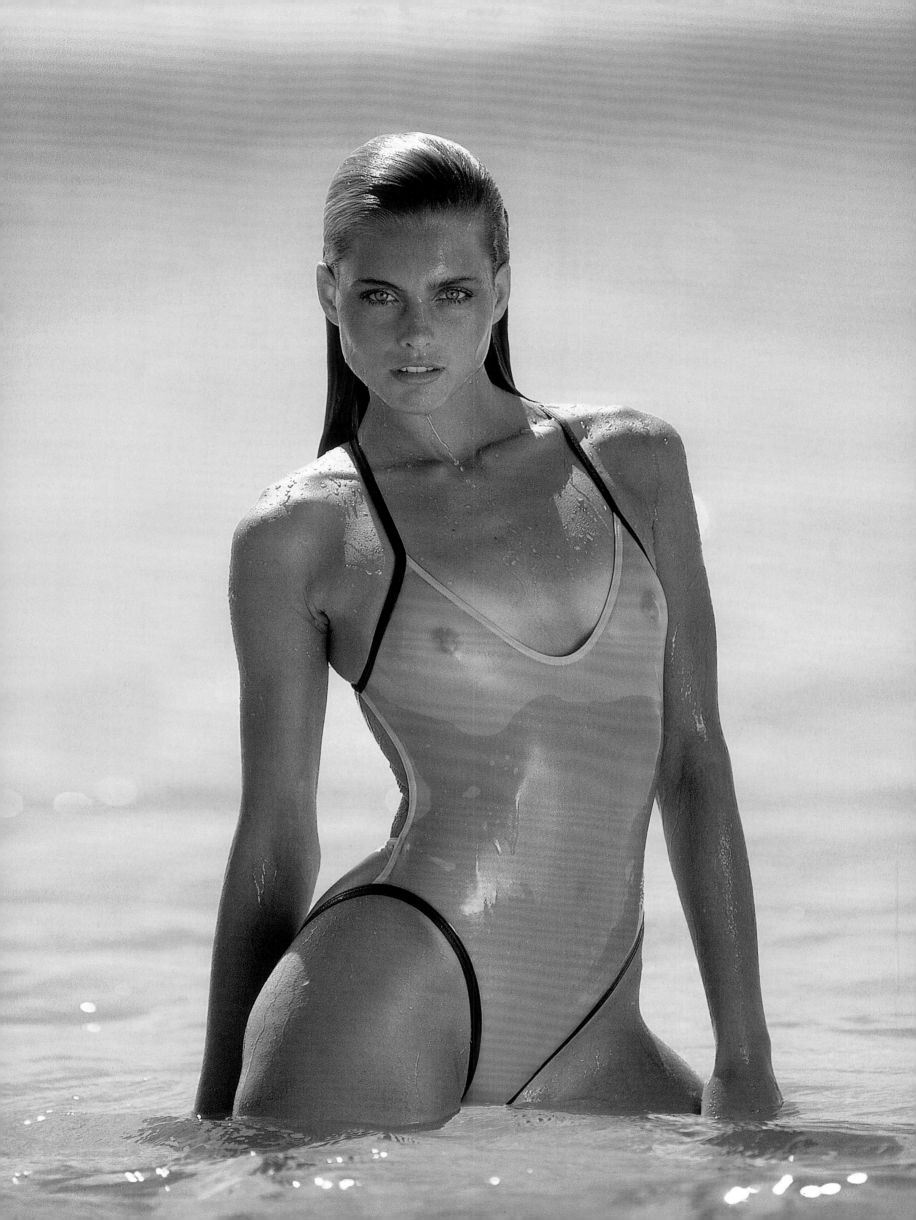

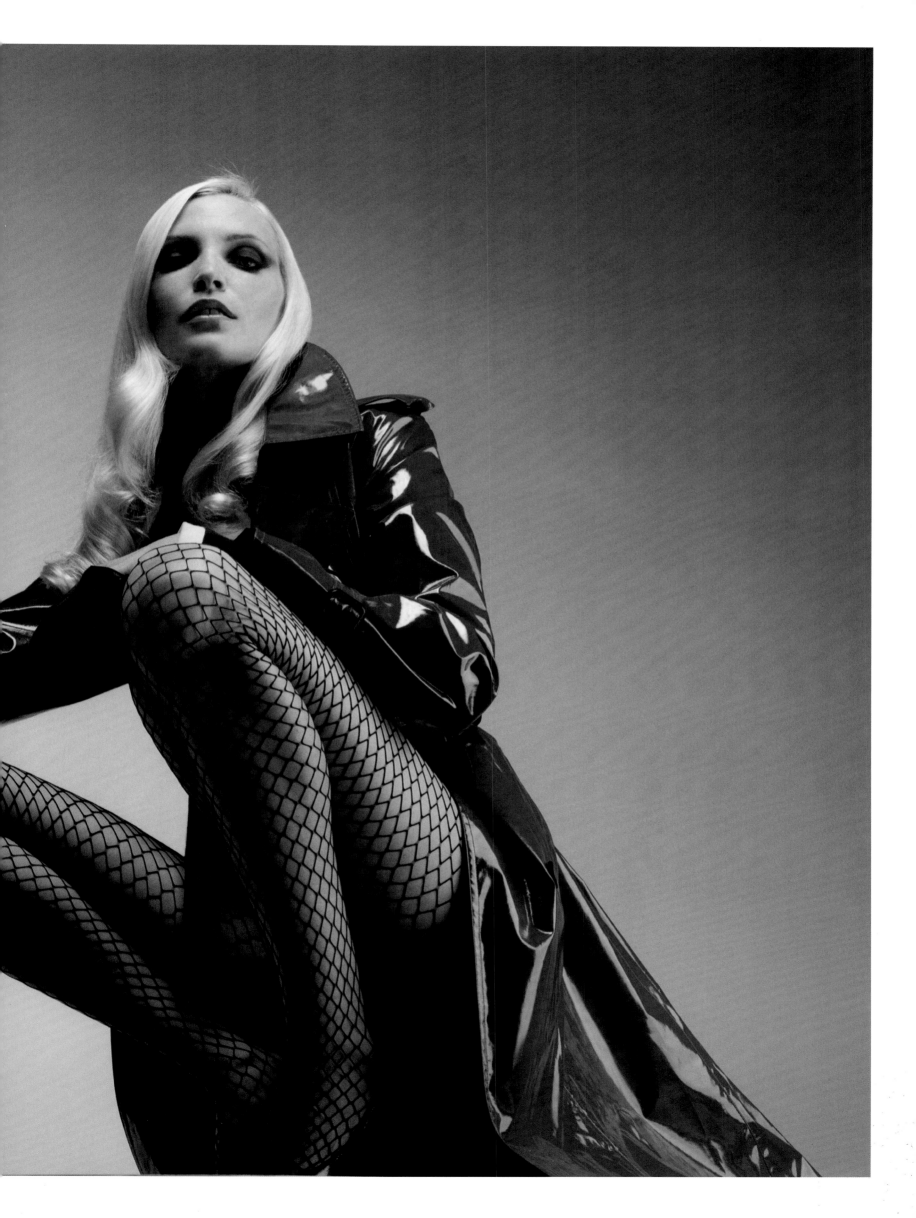

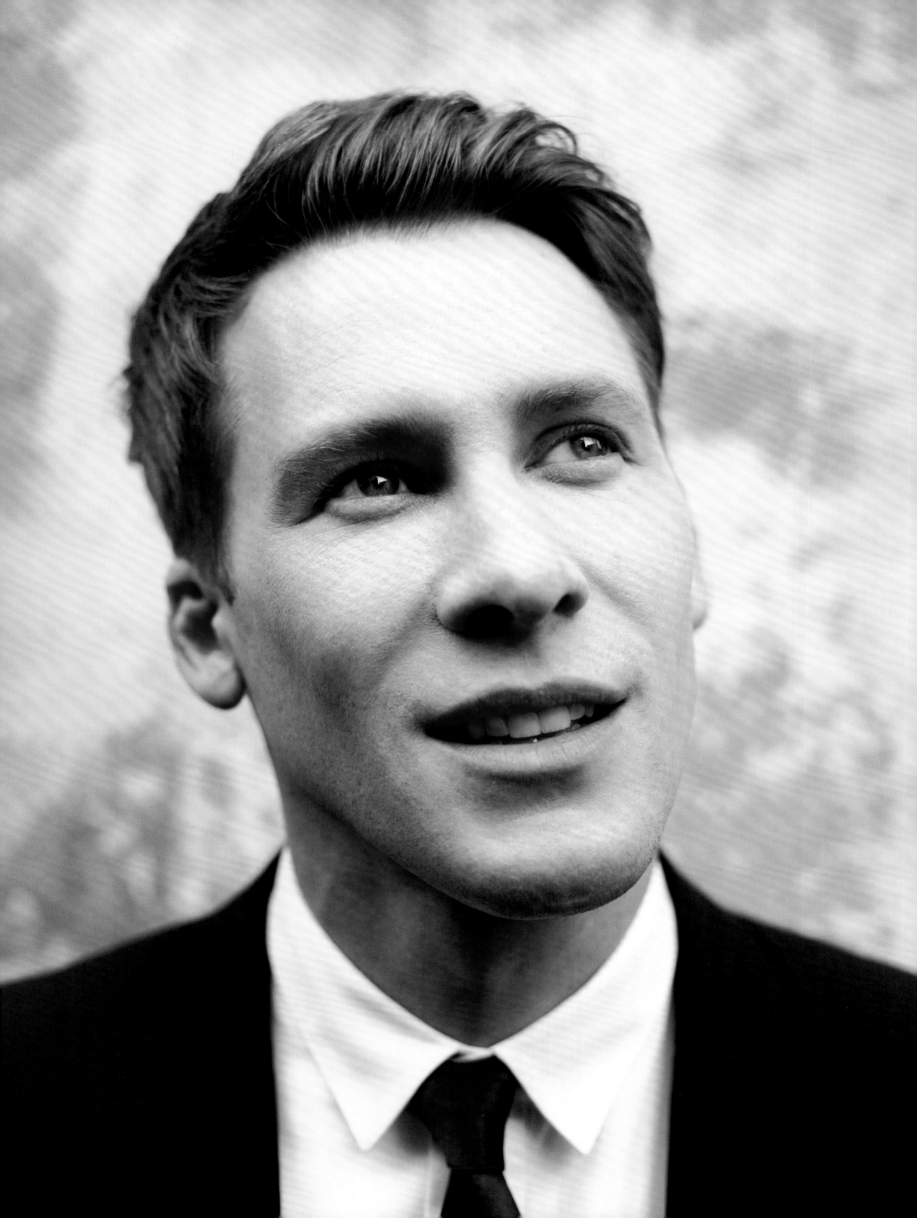

OPPOSITE PAGE: NICKI MINAJ, 2016
FOLLOWING SPREAD: ZOE SALDANA, 2010
PAGES 46-47: ENRIQUE PALACIOS, 2012

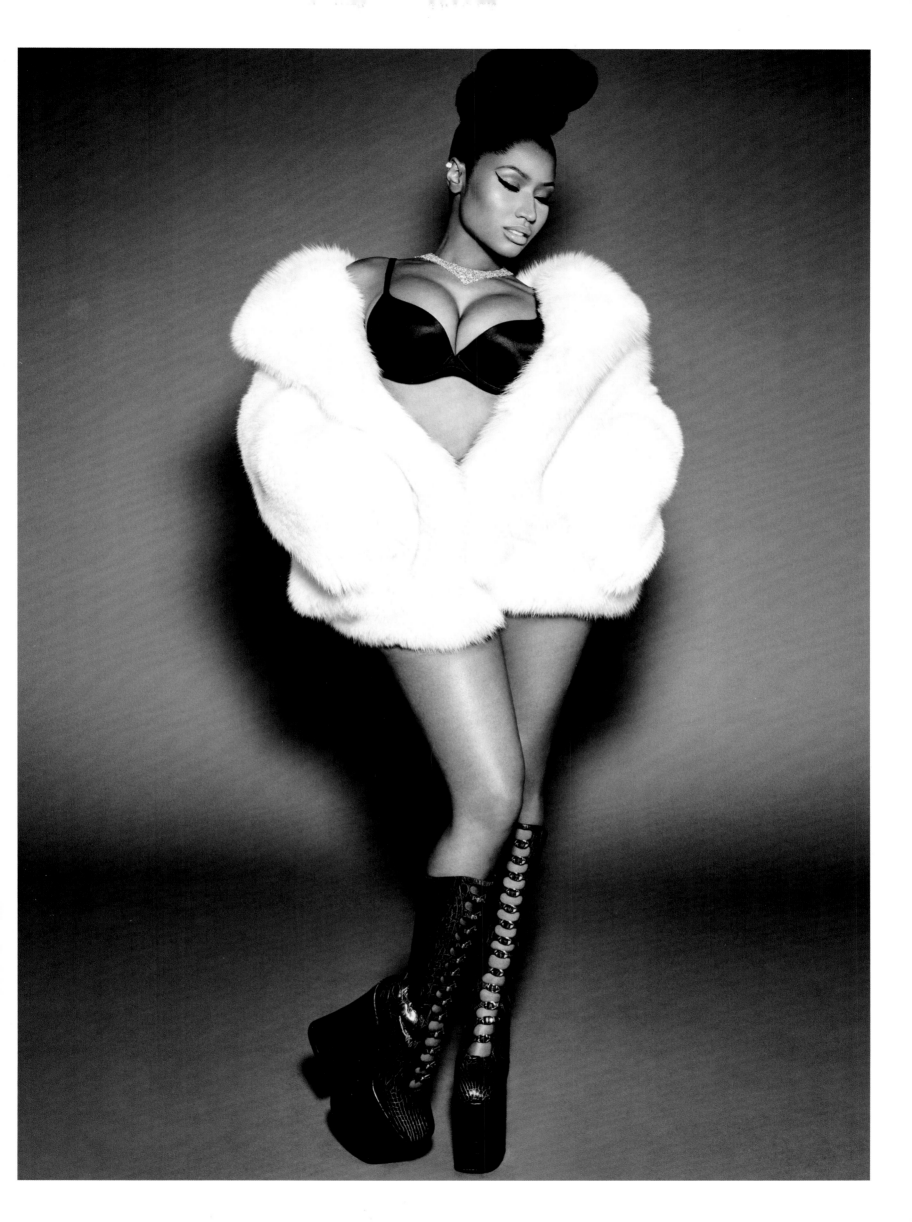

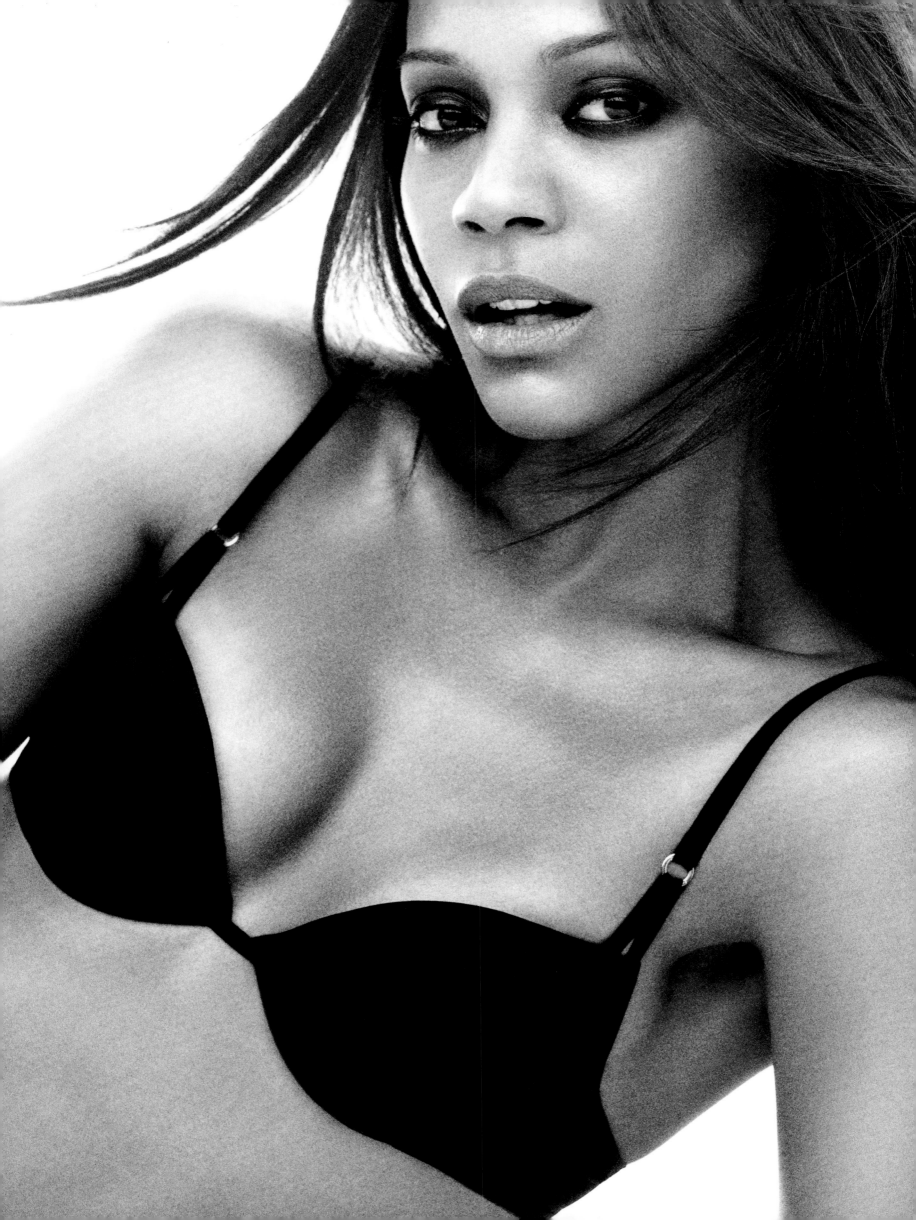

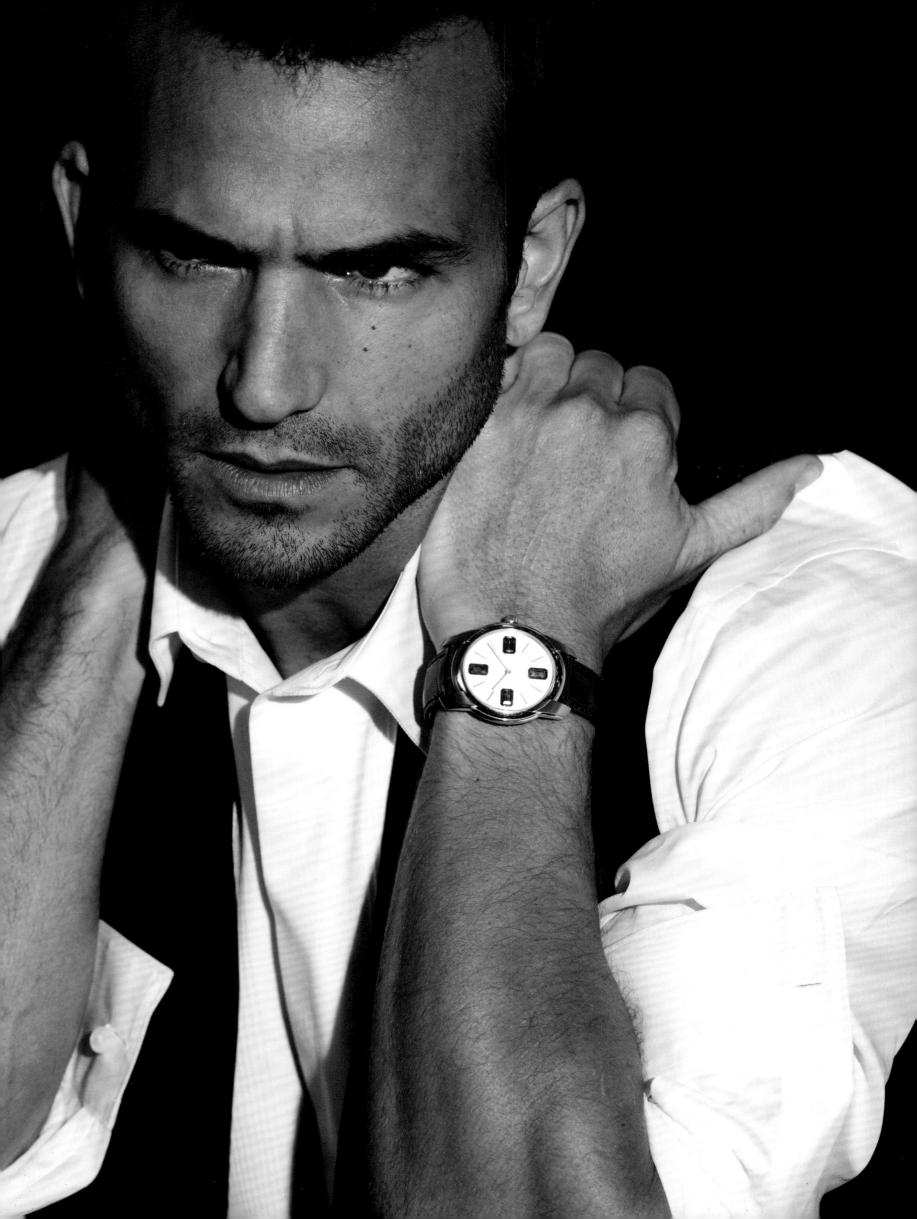

OPPOSITE PAGE: ROBYN LAWLEY, 2009
FOLLOWING SPREAD: ARMANDO AND FERNANDO CABRAL, 2016

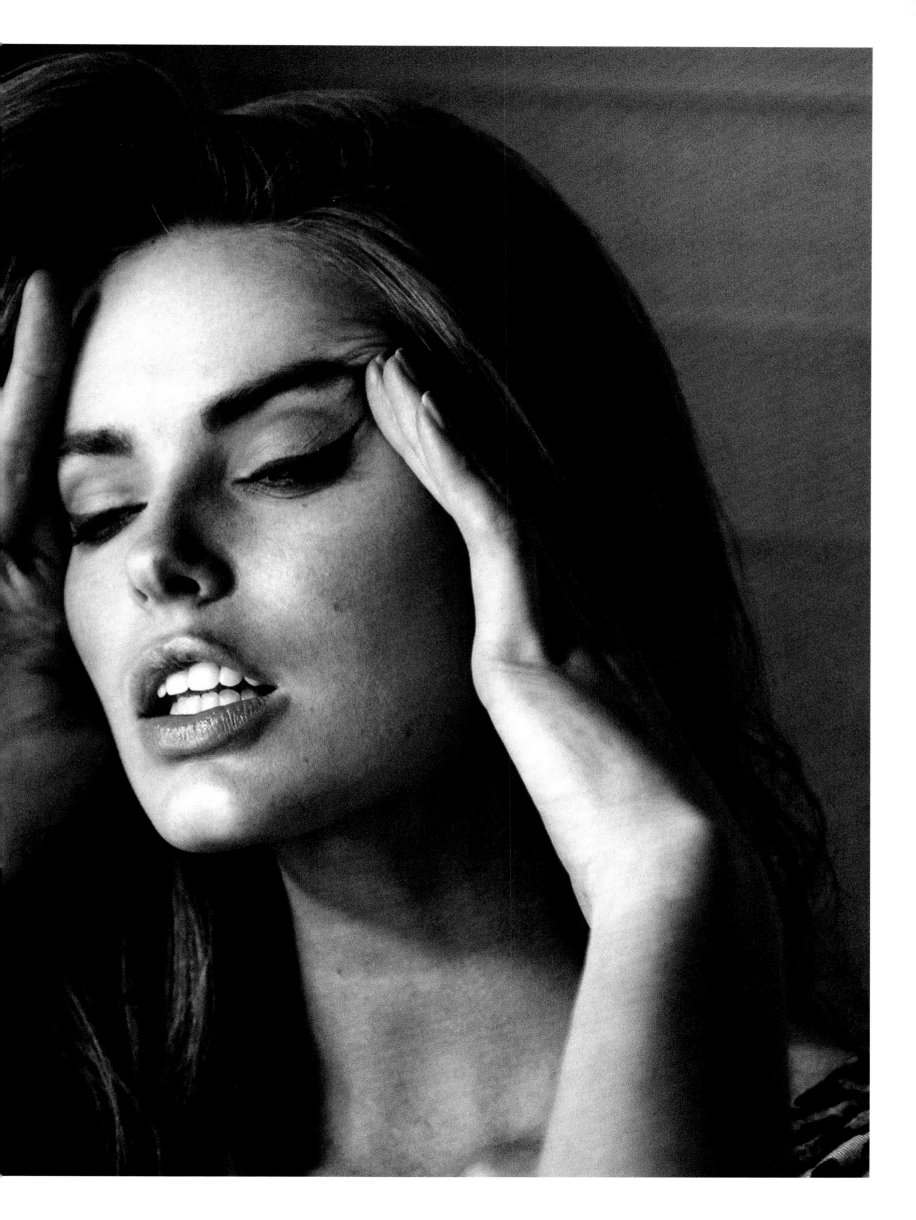

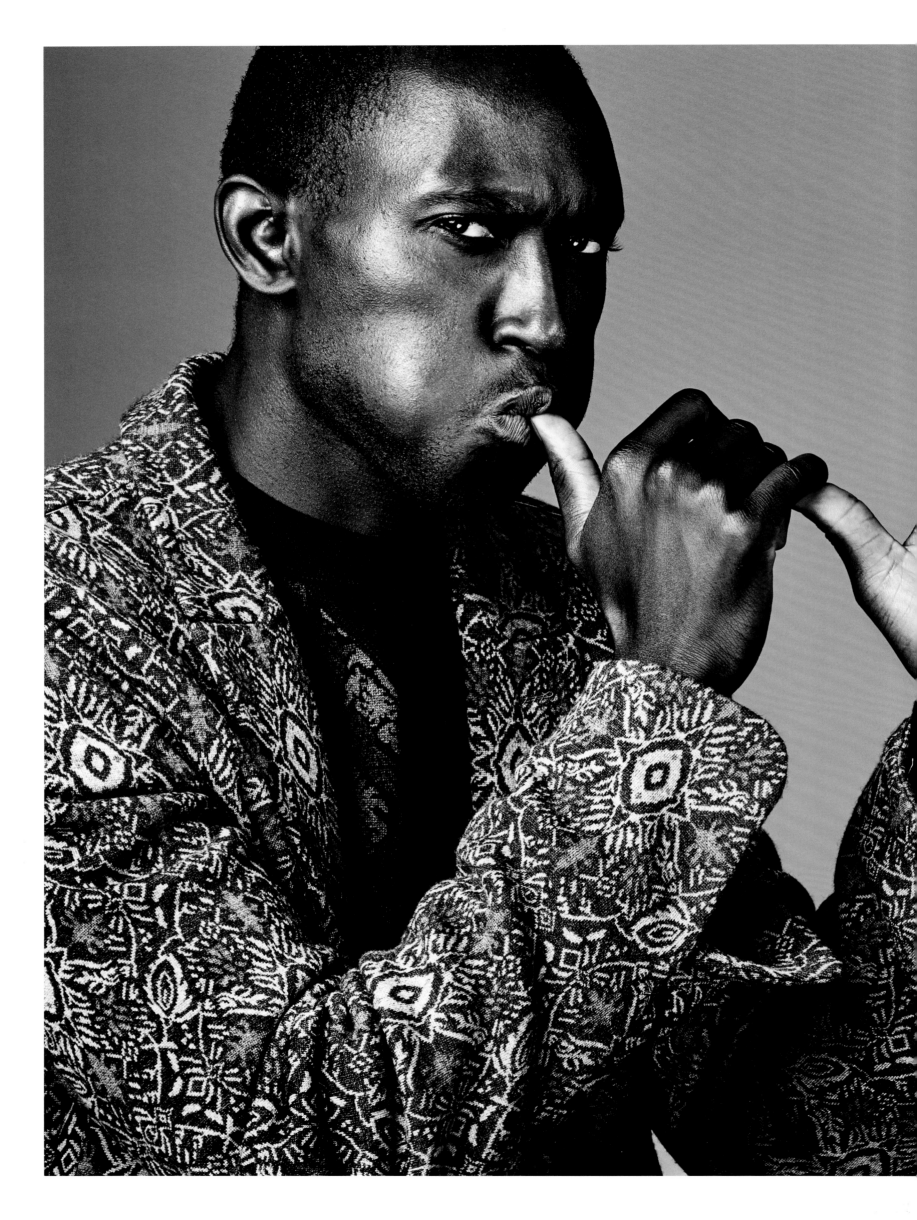

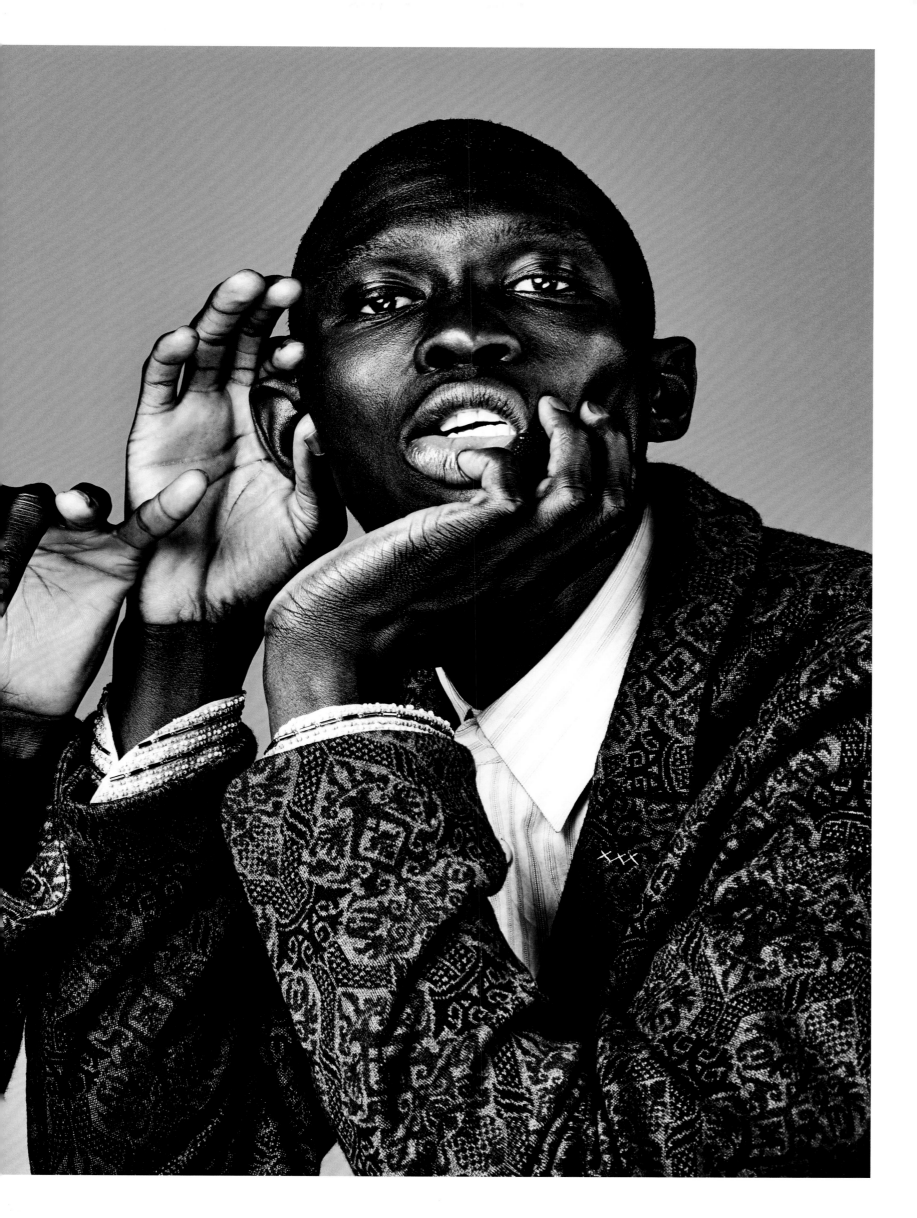

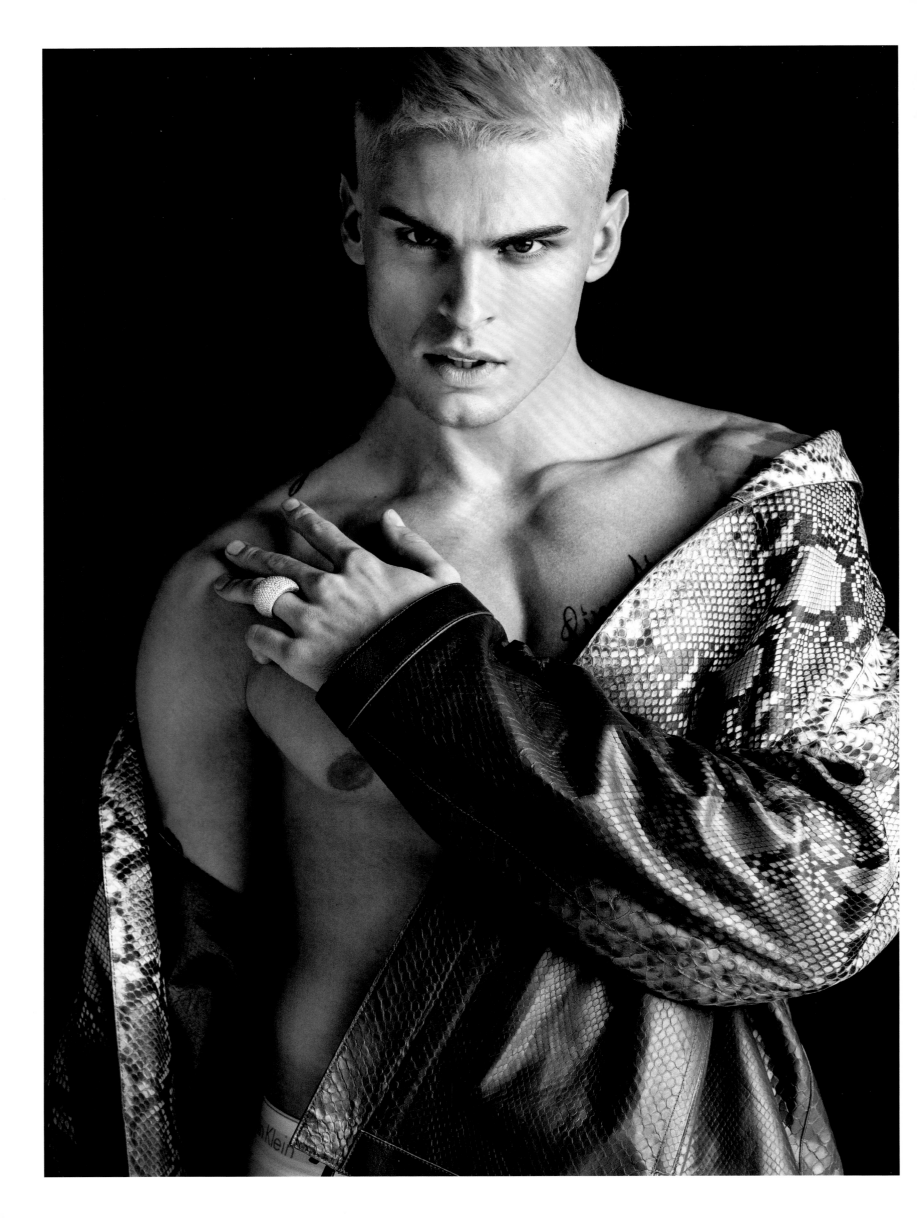

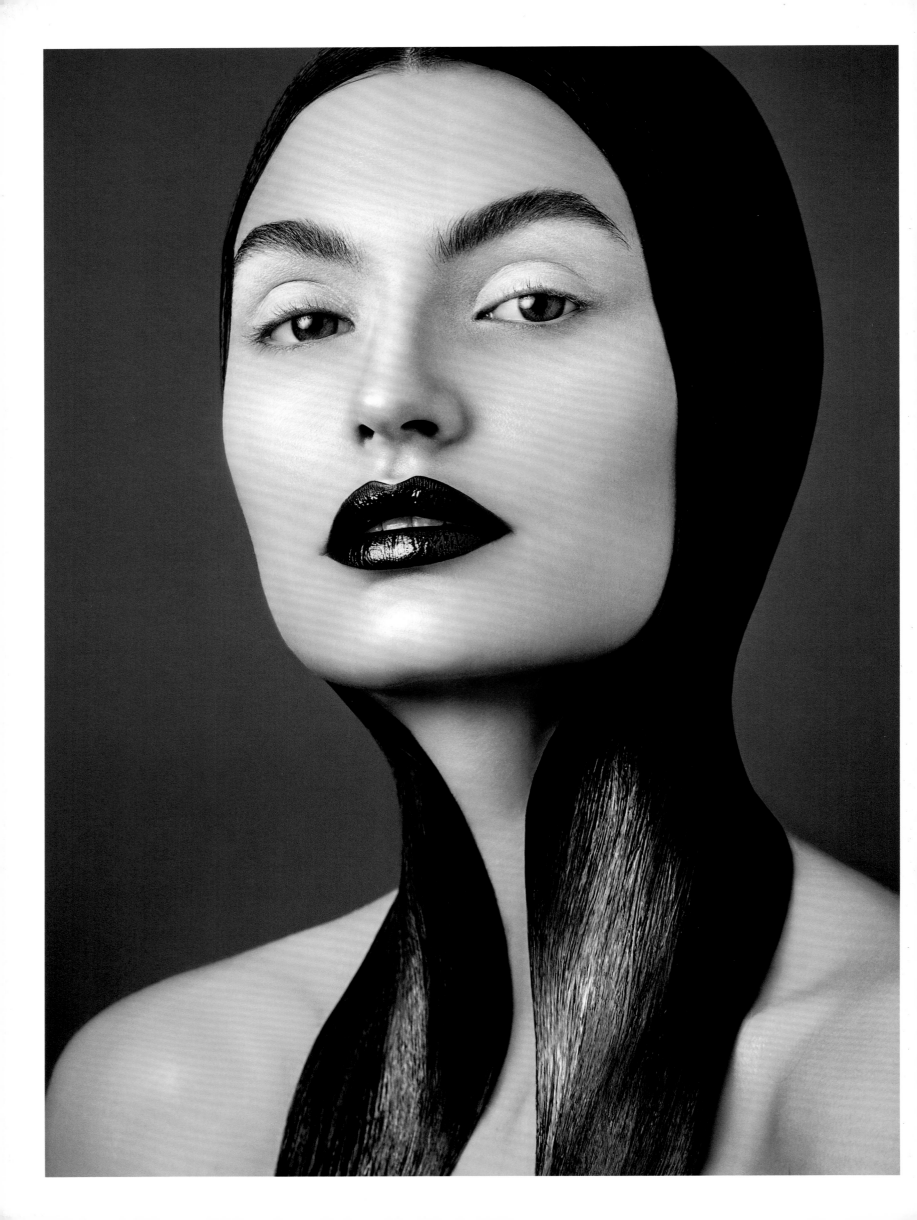

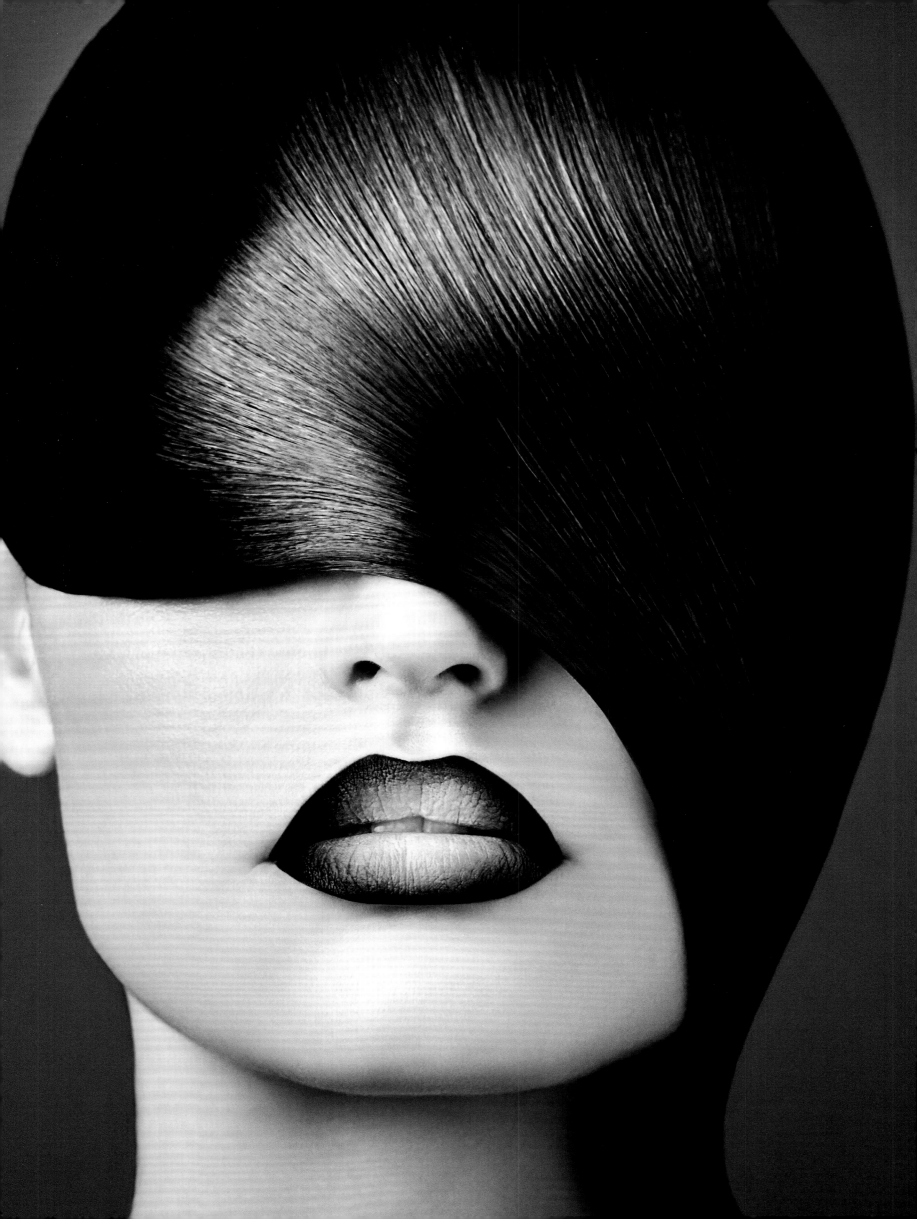

OPPOSITE PAGE: ALLY ERTEL, 2017

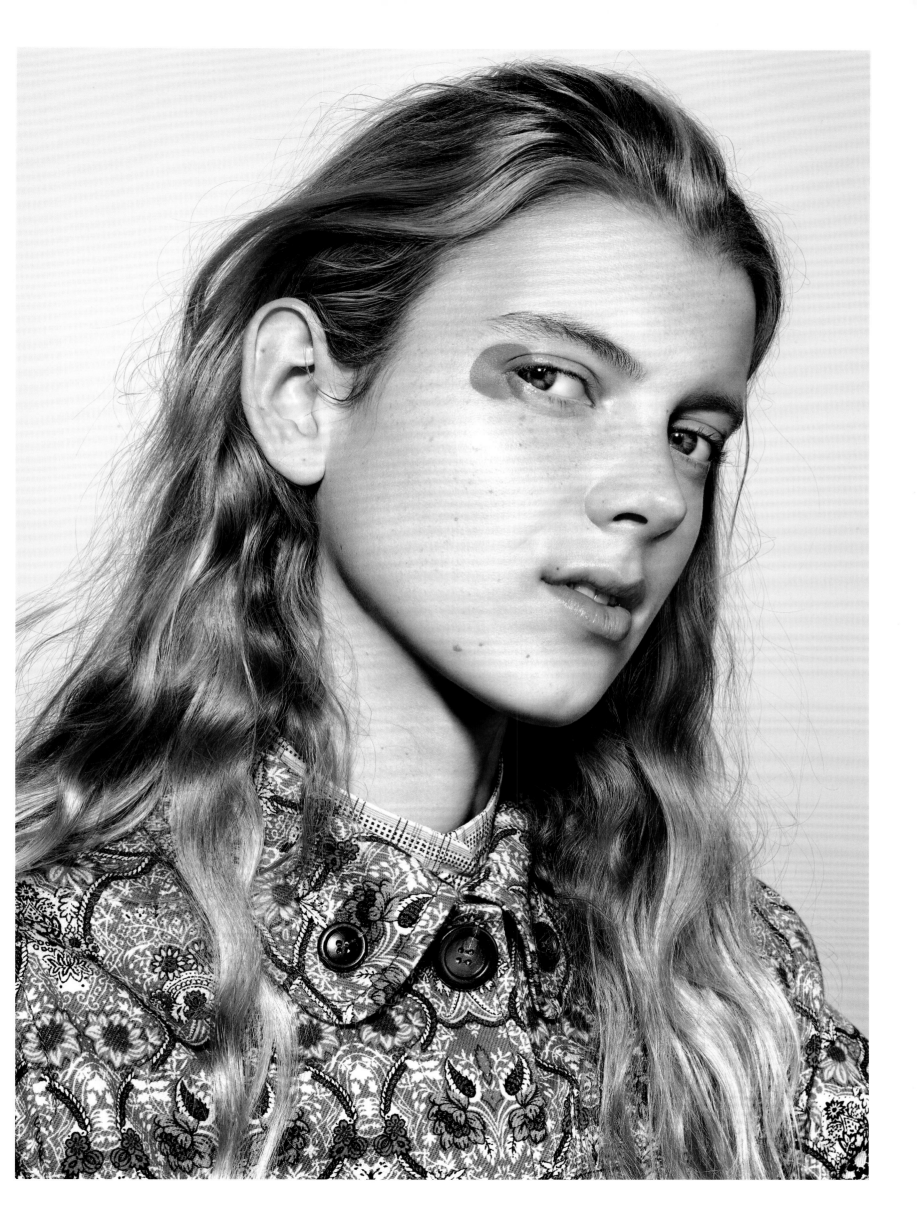

OPPOSITE PAGE: ROSHUMBA WILLIAMS, 1994

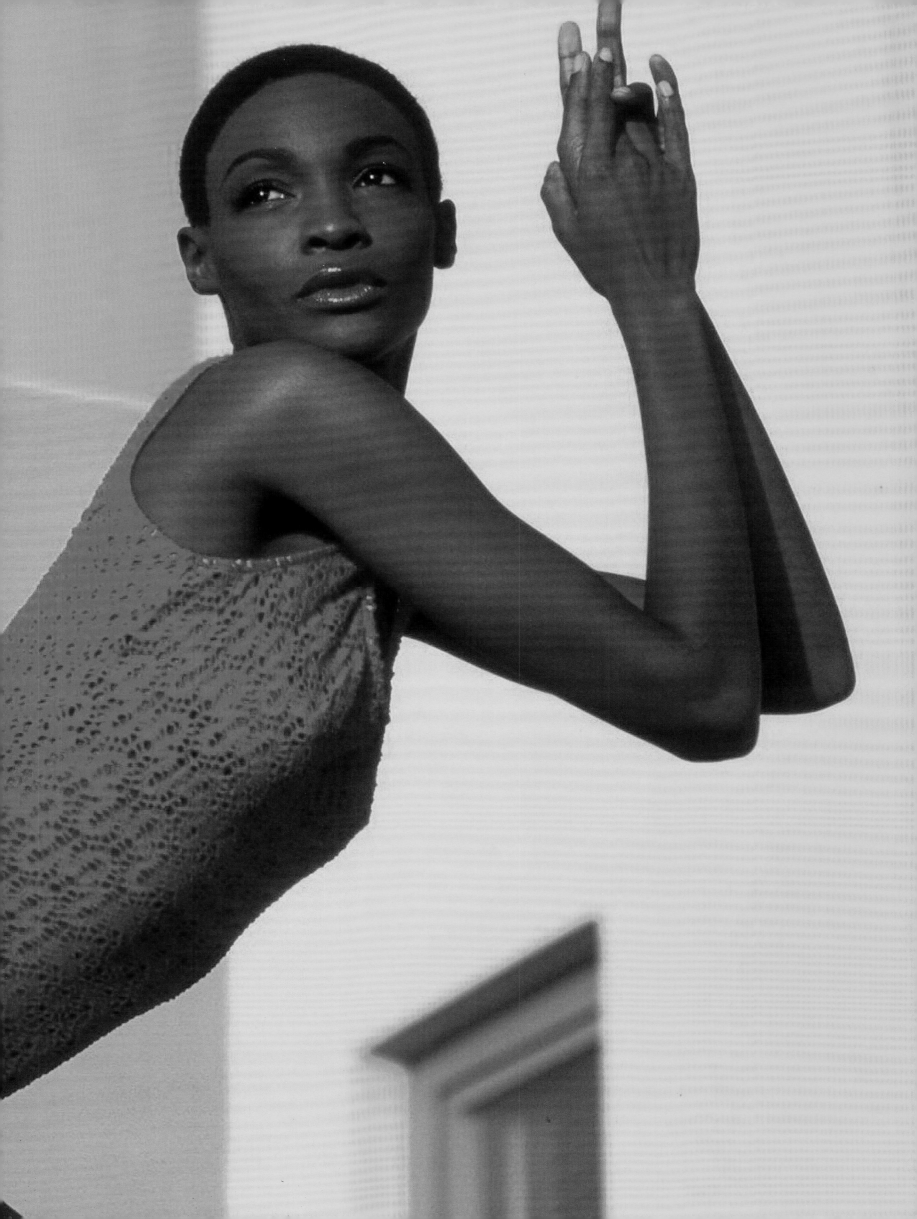

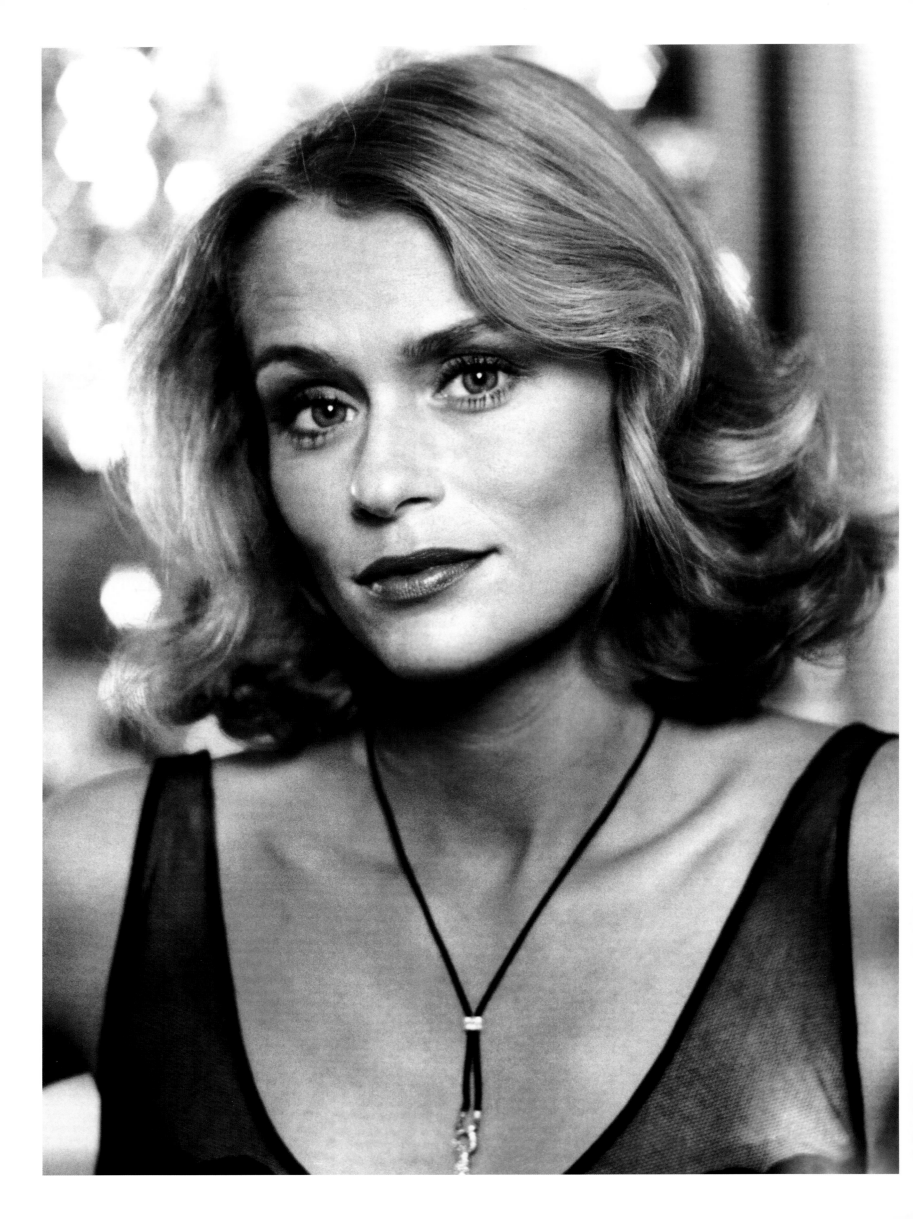

*"Fashion is what you're
offered four times a year by designers.
And style is what you choose."*

–Lauren Hutton

All About Power
THE DECADENTS

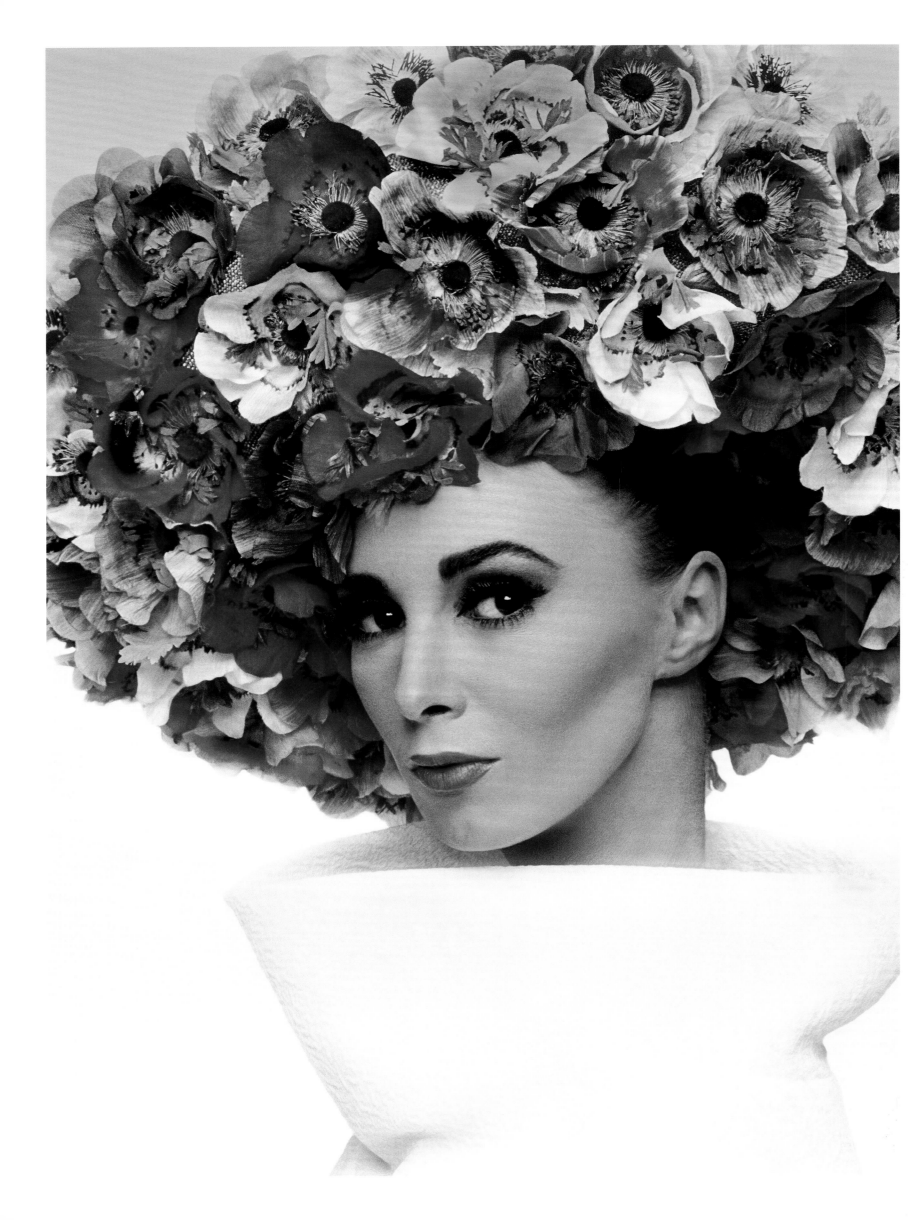

All About Power
THE DECADENTS

Ah, the wild ones.

The history of modeling is filled with stories of unbelievable decadence, a prize to some, and perhaps a price others had to pay. They are tales both dazzlingly fascinating and, at times, disturbing. But few have captivated the imagination more than Gia Carangi, whose brief career, marked by destructive behavior, drug addiction, and ultimately her death of AIDS in 1986, inspired an HBO television movie starring Angelina Jolie as Gia, and Faye Dunaway as Wilhelmina Cooper. Her story was also told in her own sadly poetic writings and a book, *Thing of Beauty*, by Stephen Fried, that recounted the jarring contrast of glamorous photo shoots followed by harrowing nights in heroin dens.

Carangi was a star from the moment she arrived in New York from Philadelphia, a favorite of photographers Francesco Scavullo and Chris von Wangenheim, but also held up as a symbol on a *20/20* interview as "both the bright side and the dark side of modeling," a precursor of the regretful episode known as "heroin chic" that led President Bill Clinton to speak out against the fashion industry in the 1990s. Carangi had dreams of becoming a photographer herself, but years of addiction reduced her to a shadow of her former beauty, until Carangi was gone at age twenty-six.

"When you're young," she once said, "it's hard to make the difference between what is real and what is not real, when you're innocent and there's a lot of vultures around you."

While Carangi may have represented a cautionary tale of that darker side of fashion's embrace, there are many legends born of it. Most powerful are those images of strong, uninhibited women embracing sexuality and femininity in ways that discredit the standard depictions of the male gaze—rather seeing the world from a feminine point of view, without restrictions. And fashion in more recent times has become an equal-opportunity offender, subjecting the male body to explicit objectification as well—think of the marketing history of Tom Ford at Gucci, or Calvin Klein's sex-sells underwear campaigns that fetishized both male and female beauty.

Ultimately, there is a fine line we see between what separates the bright side from the dark side, the desirous from the offensive, and it rarely falls in the same place from one viewer to another. My view is that the most successful images that are designed to provoke are also the ones that infer a message of empowerment, such as these that follow. That is, it is the subject who is in control of what we are seeing, rather than the photographer, the art director, the editor, or even the audience at home.

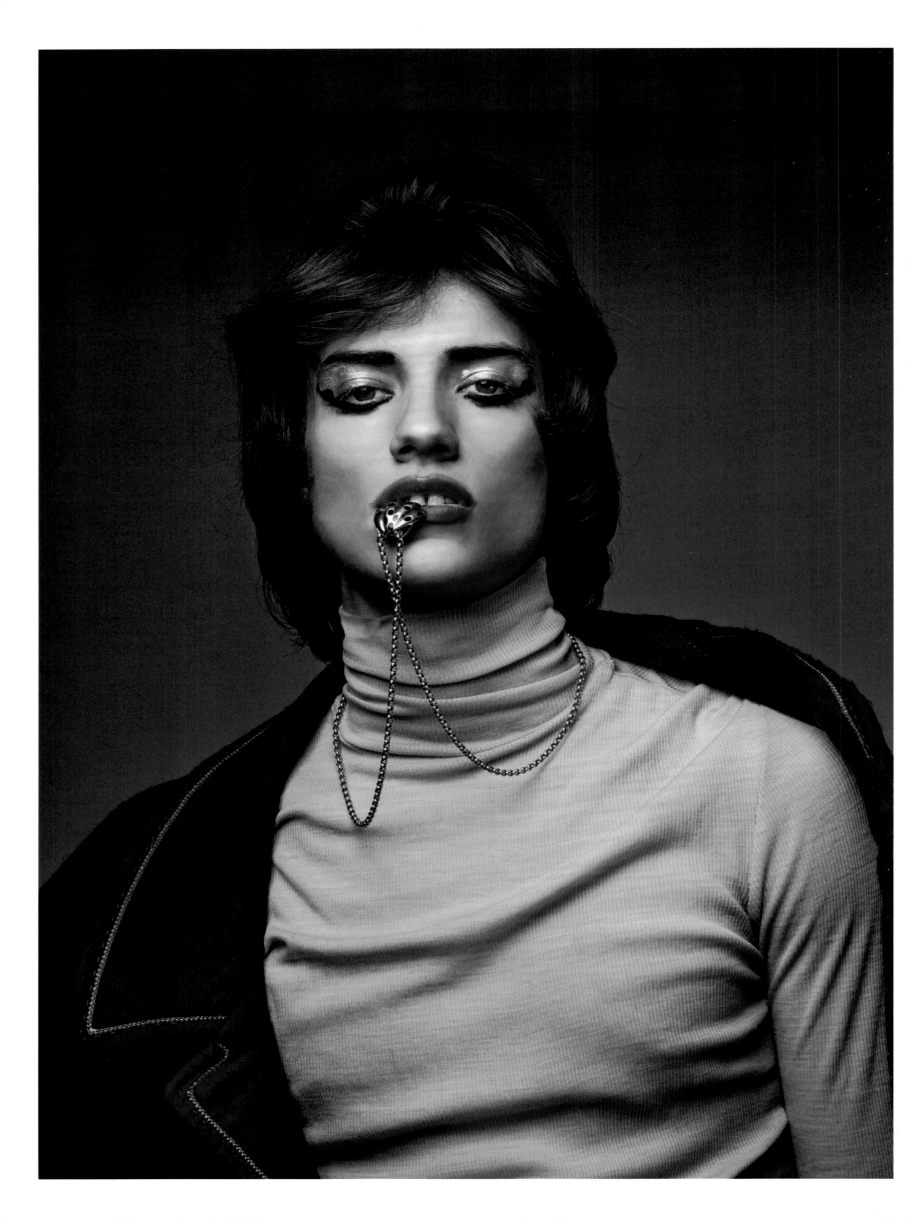

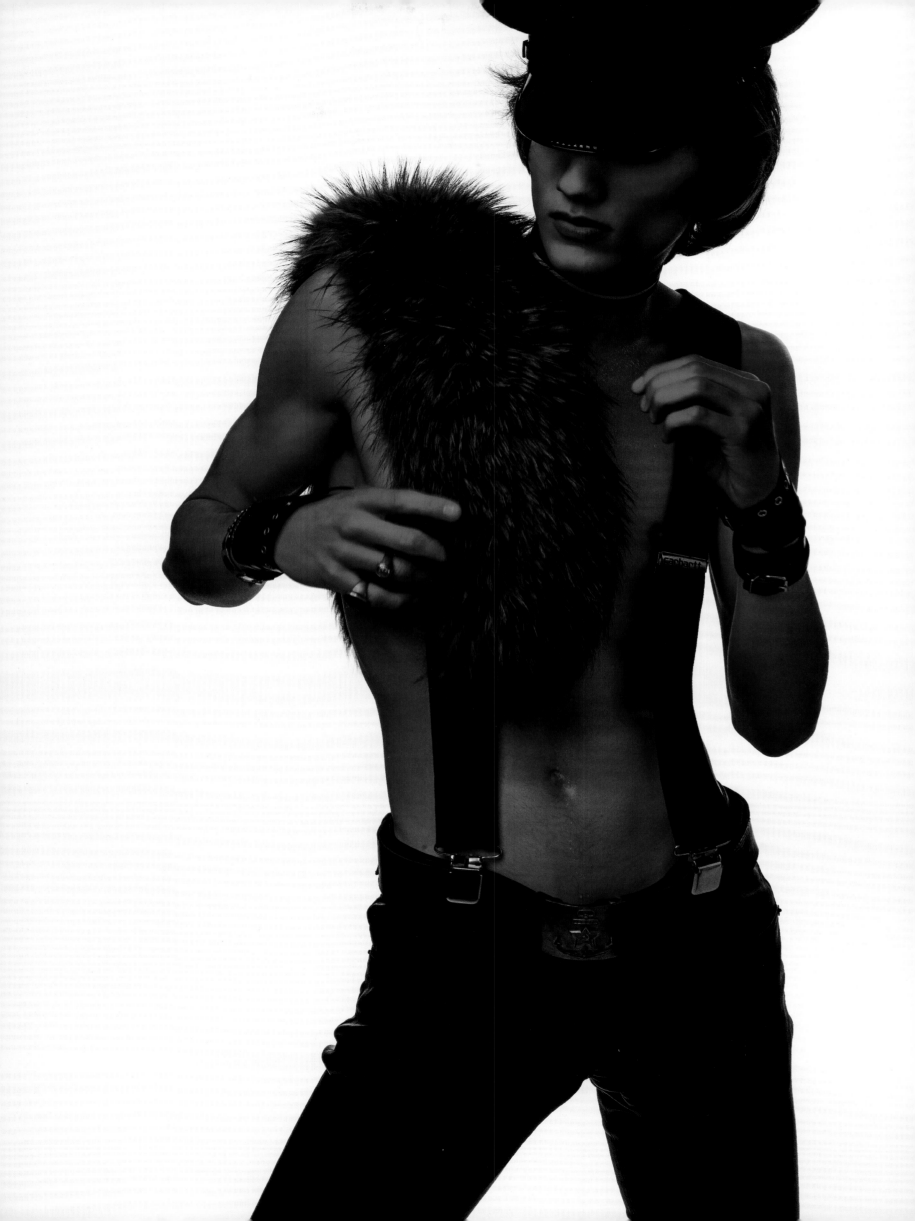

"Life and death, energy and peace, if I stop today it was still worth it. Even the terrible mistakes, that I have made and would have unmade if I could. The pains that have burned me and scarred my soul, it was worth it for having been allowed to walk where I've walked. Which was to hell on earth, heaven on earth, back again, into, under, far in between, through it, in it, and above."

—Gia Carangi

PREVIOUS SPREAD: SERGE RIGVAVA, 2016
OPPOSITE PAGE: GIA CARANGI, 1979

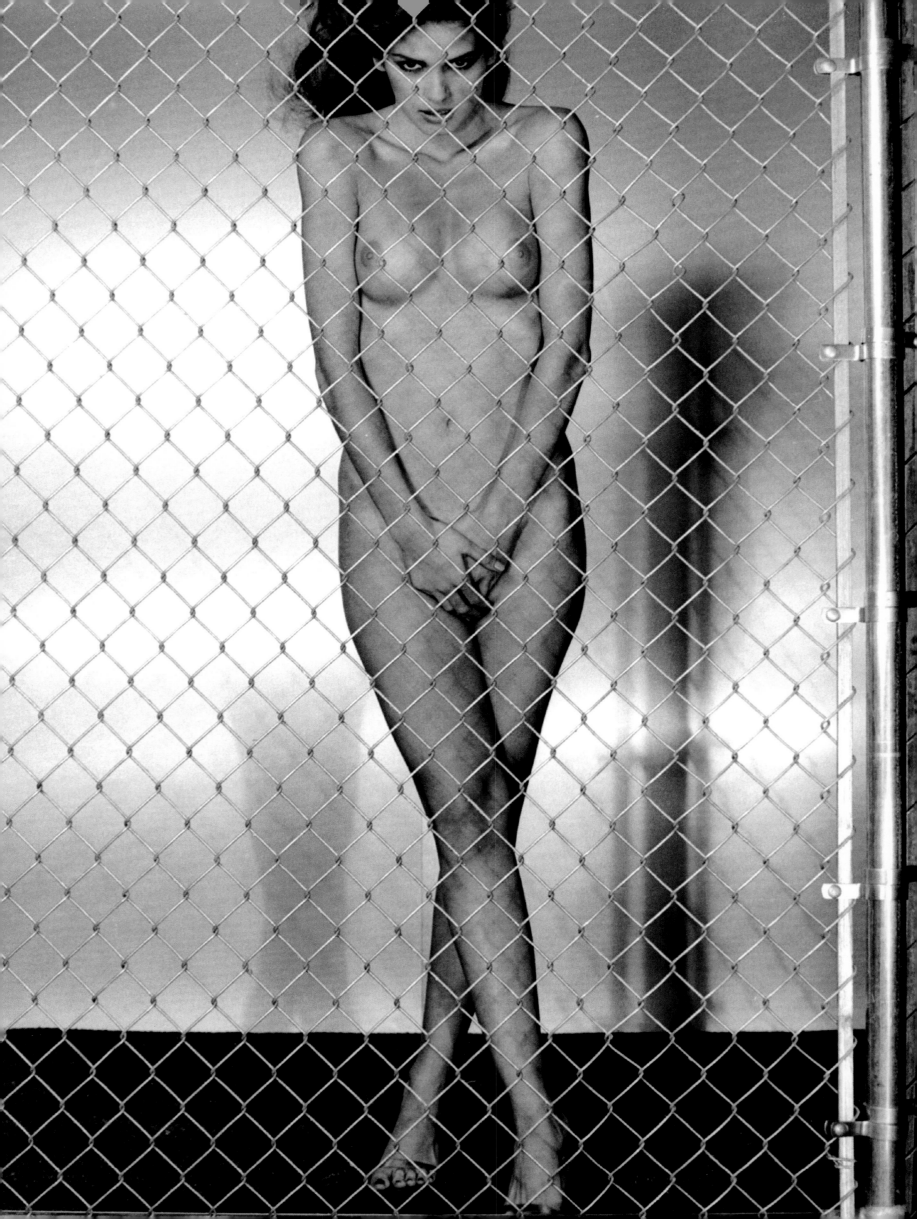

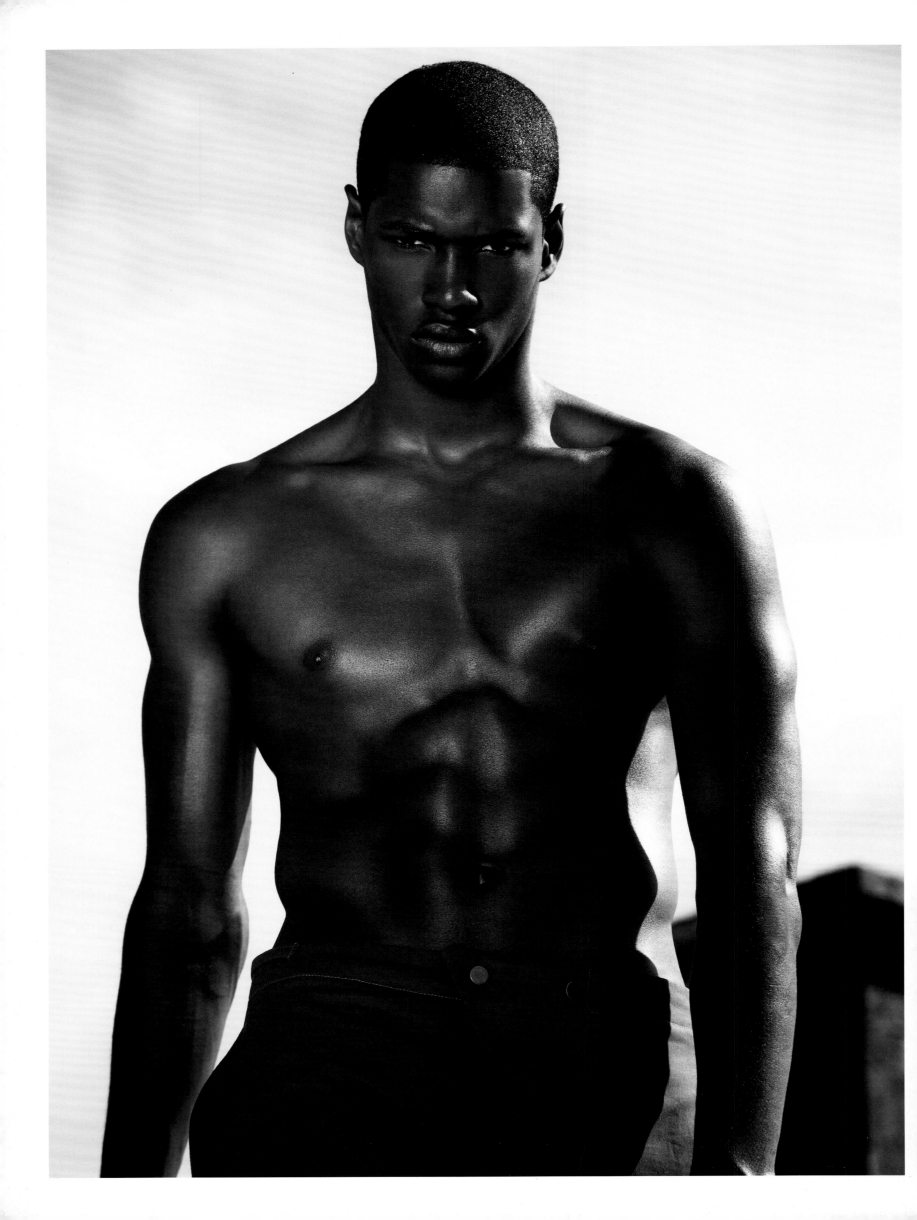

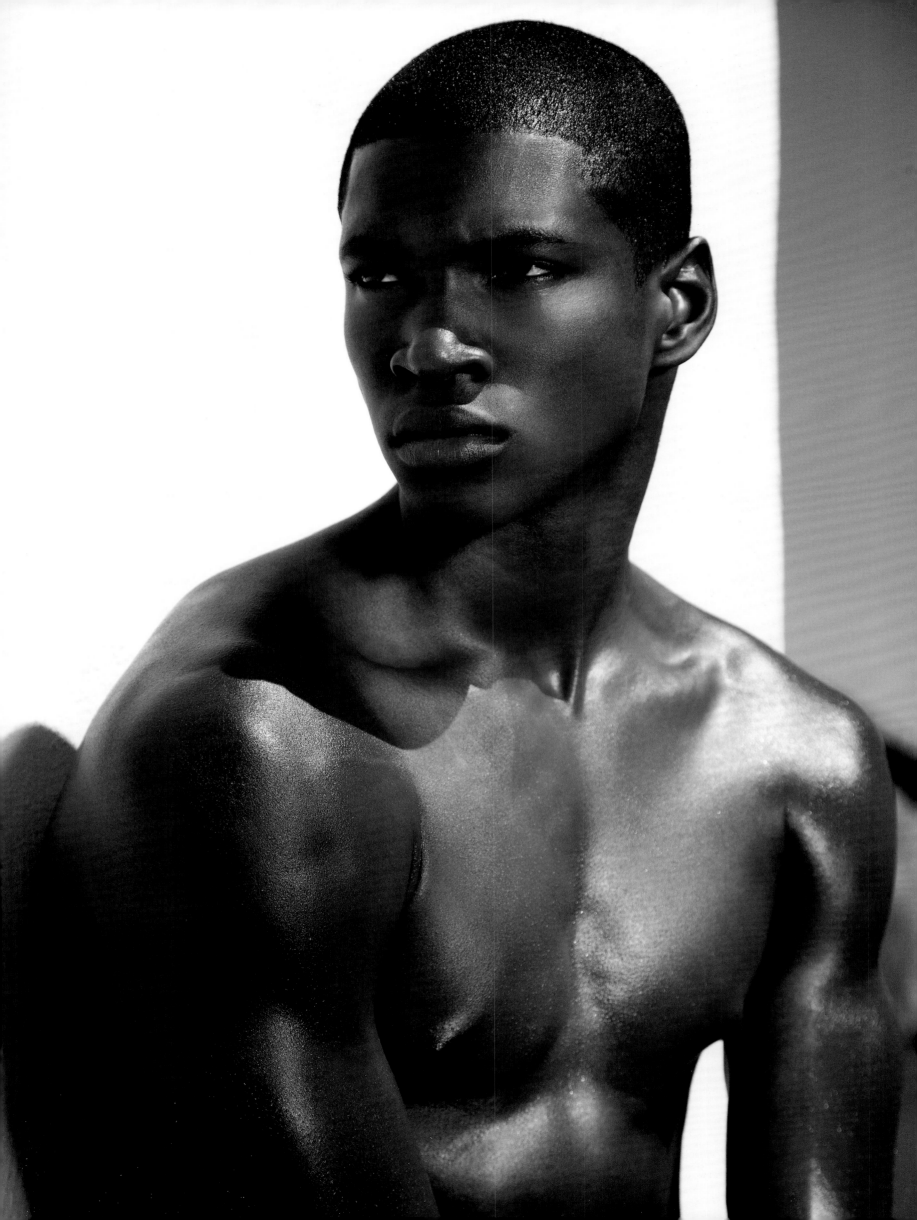

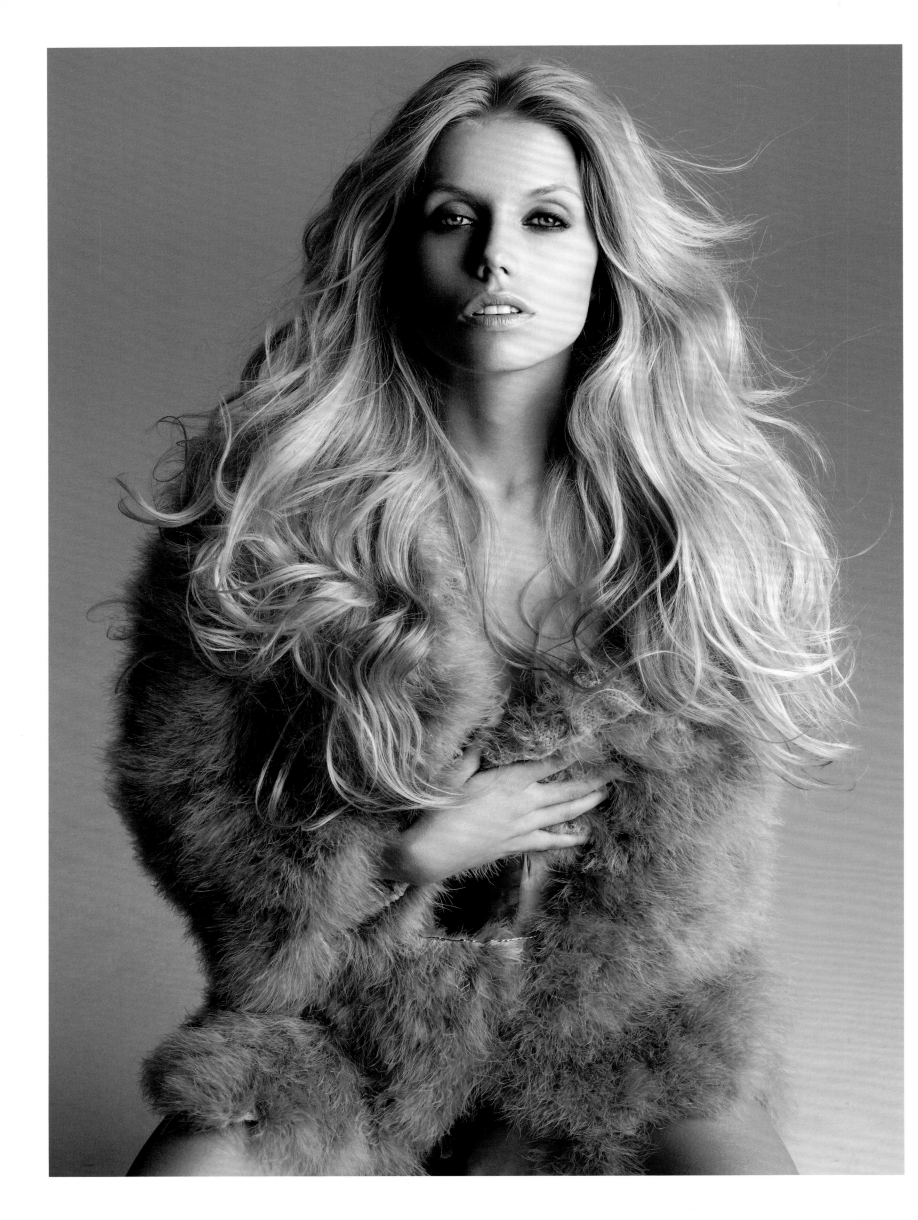

*"Dress like you are going to meet
your worst enemy today."*

–Coco Chanel

PREVIOUS SPREAD: RONALD EPPS, 2016
OPPOSITE PAGE: THEODORA RICHARDS, 2006

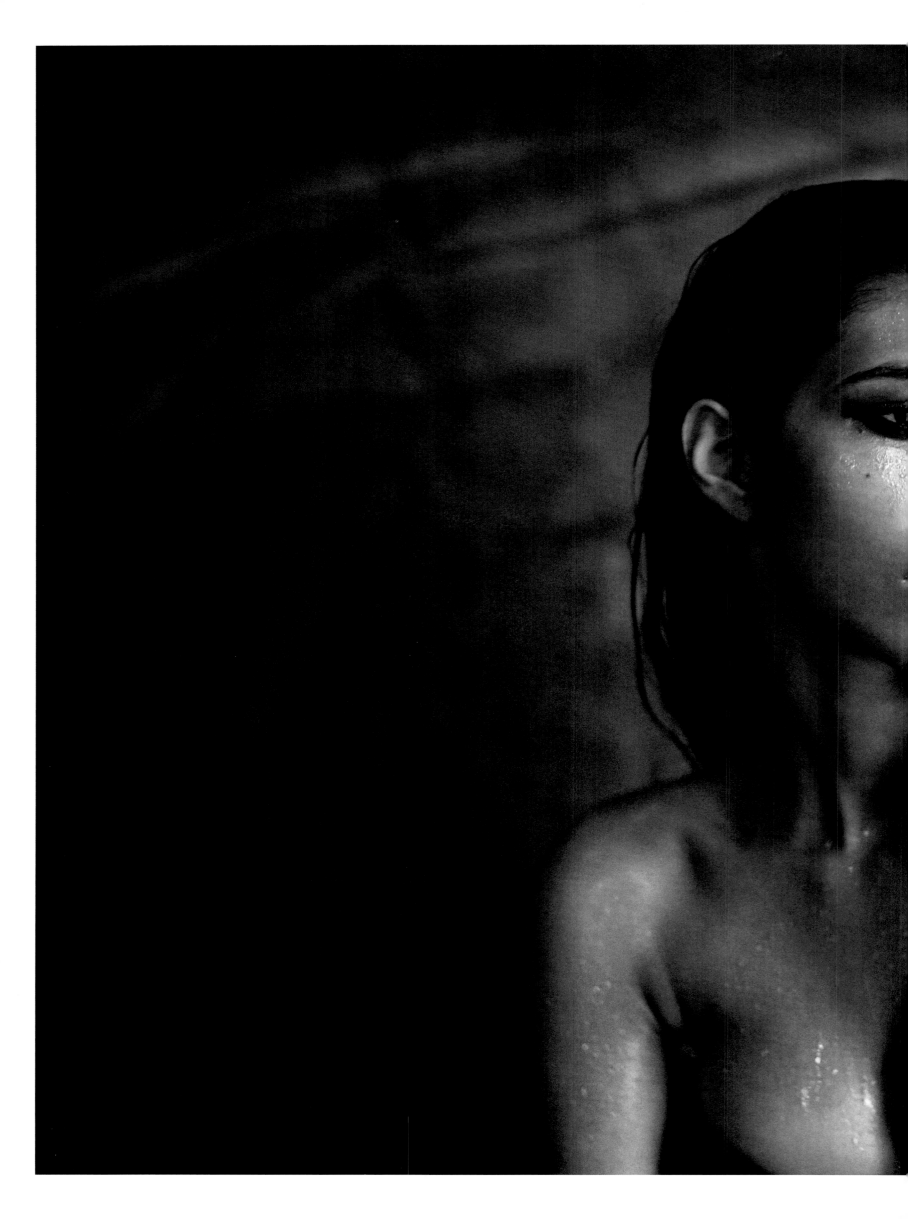

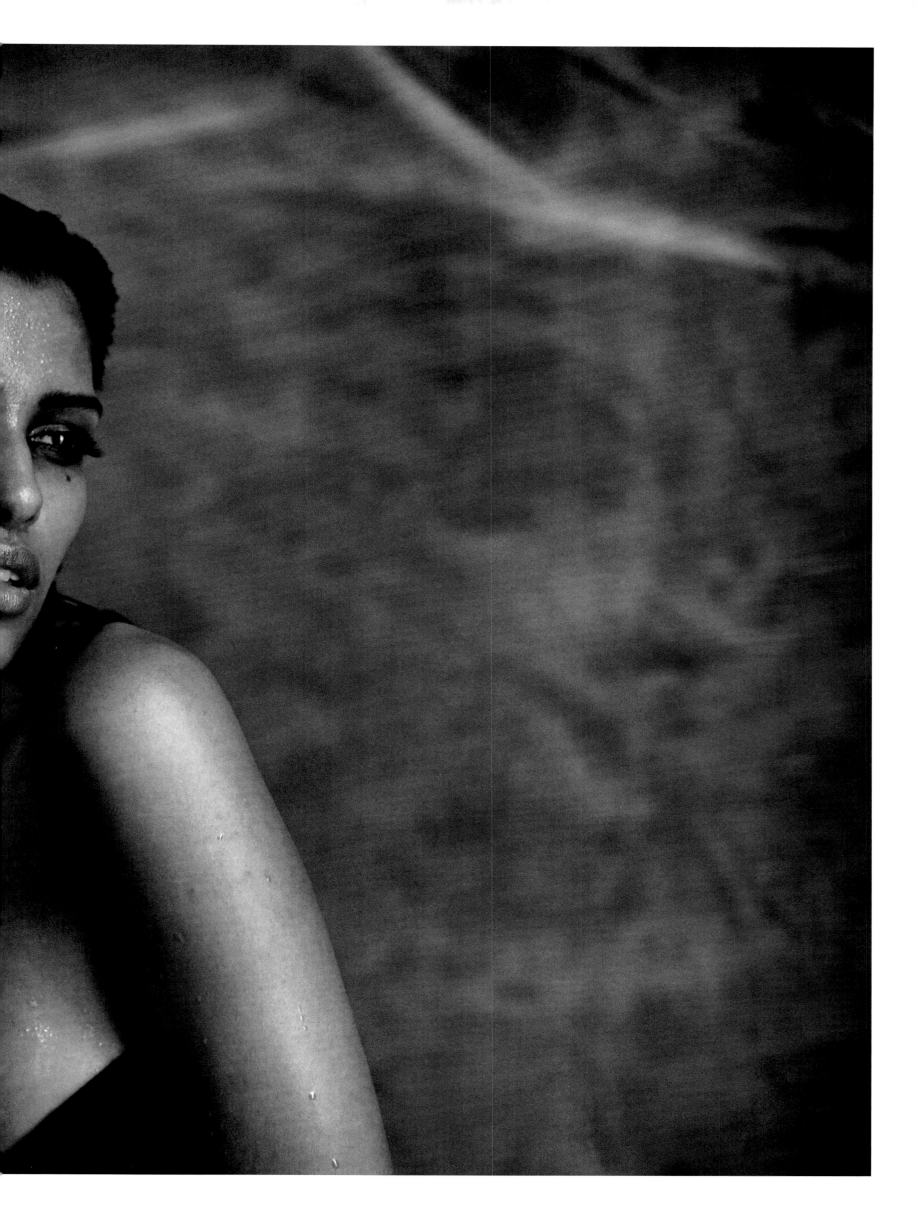

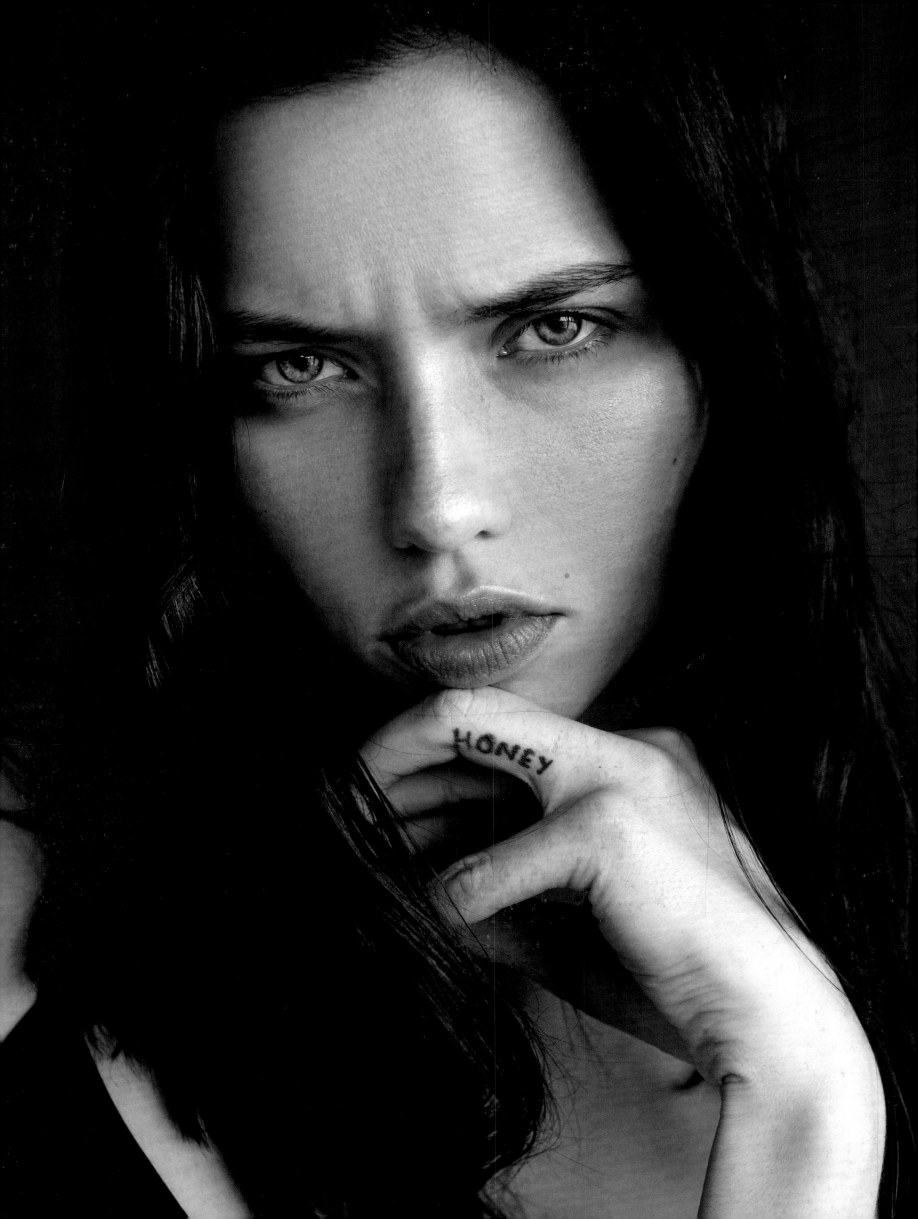

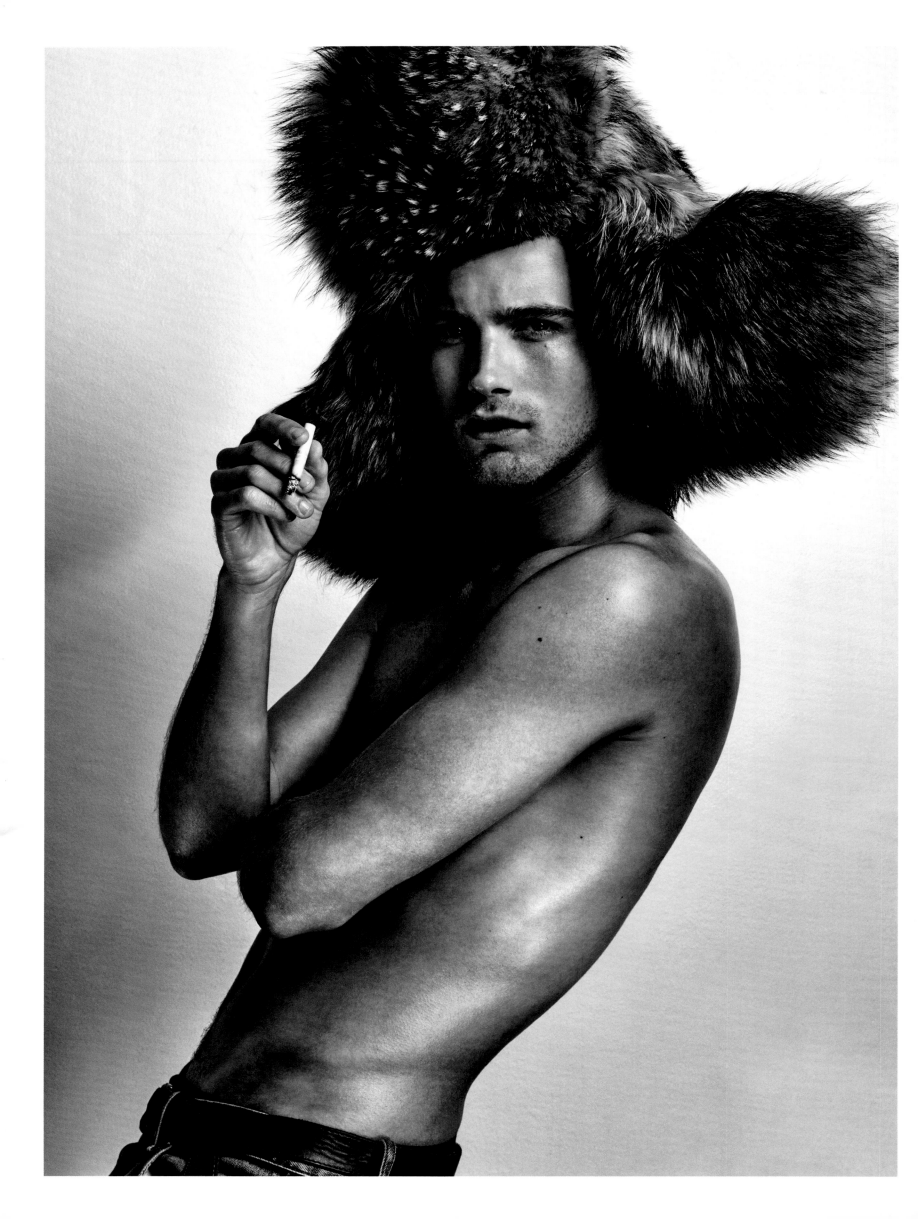

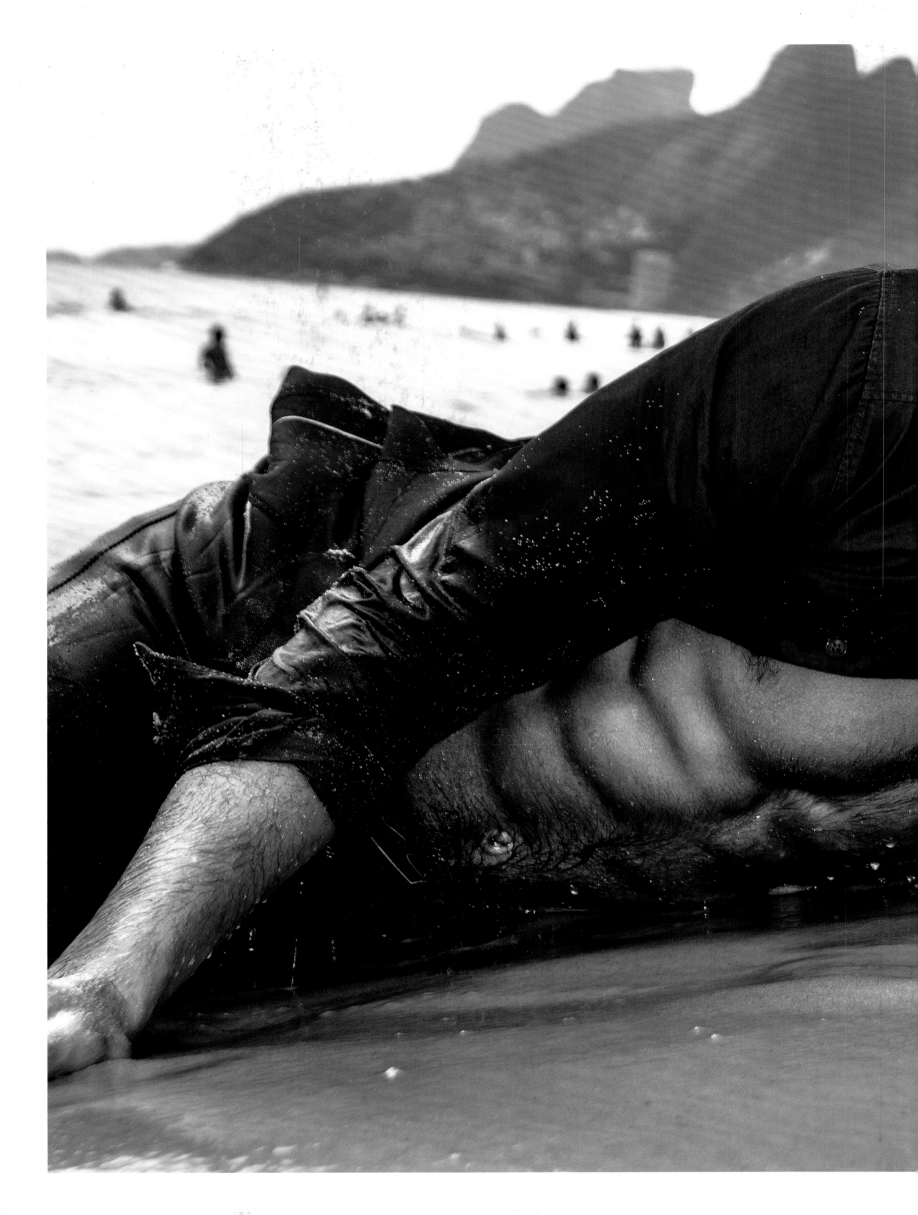

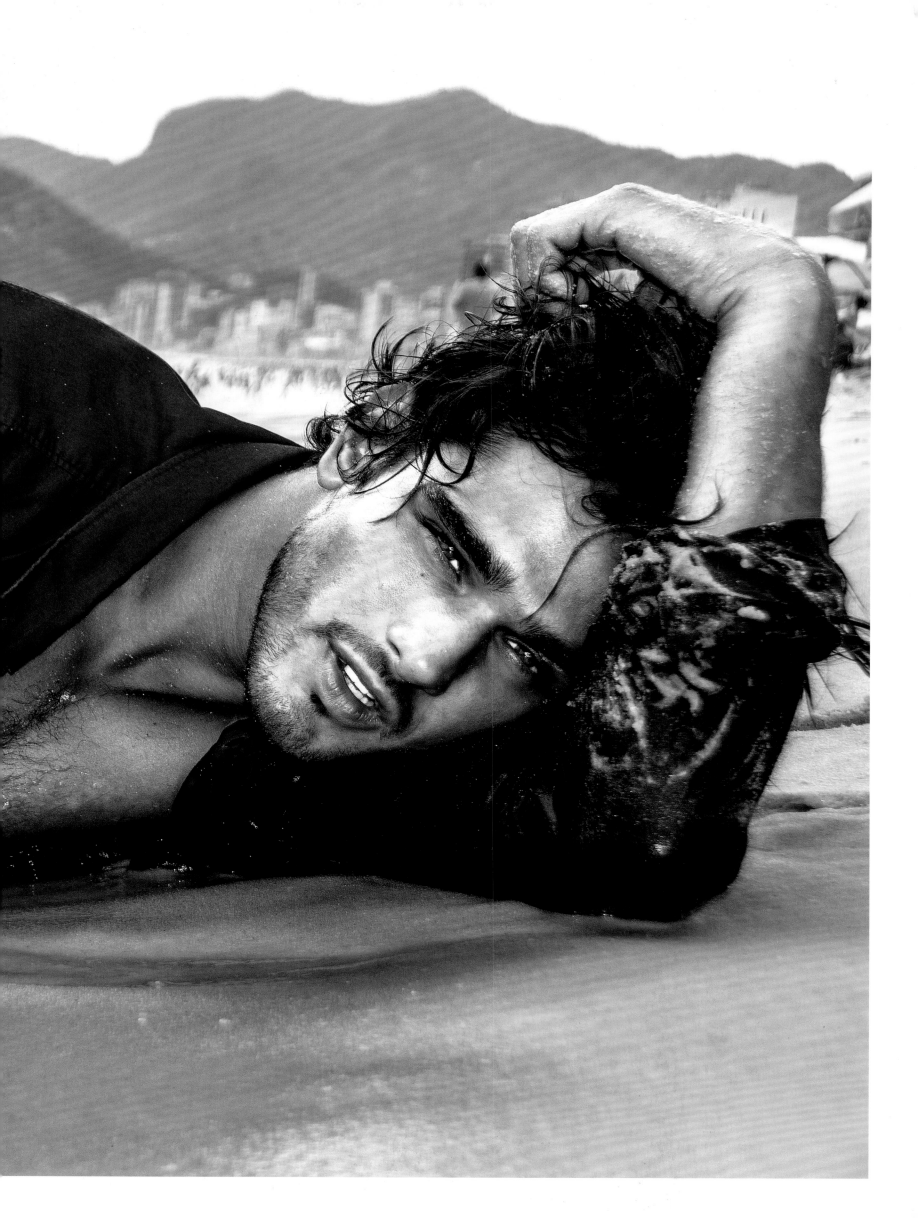

"I loved when my boyfriends would call me their Amazon girl."

–Patti Hansen

OPPOSITE PAGE: PATTI HANSEN, 1976
FOLLOWING SPREAD: JANICE DICKINSON, 1976

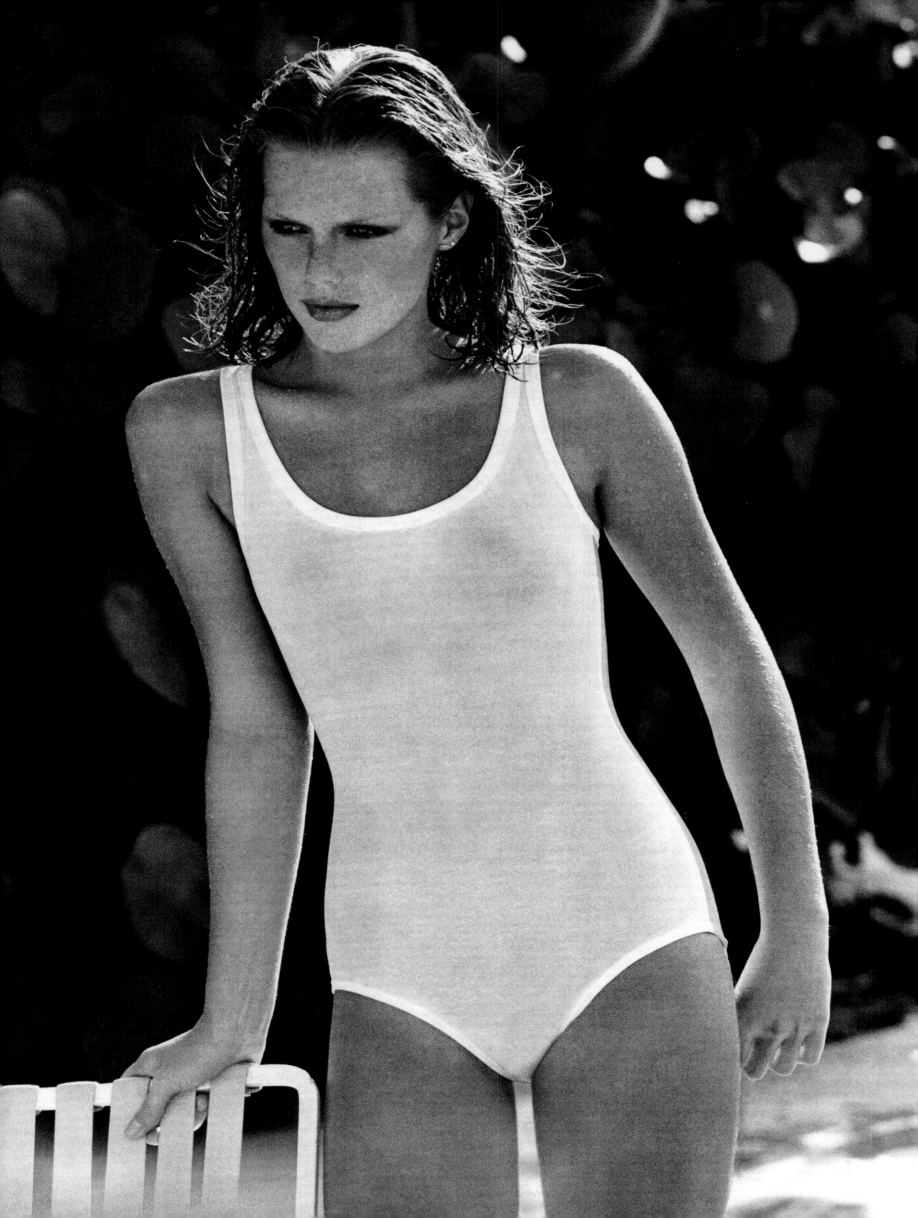

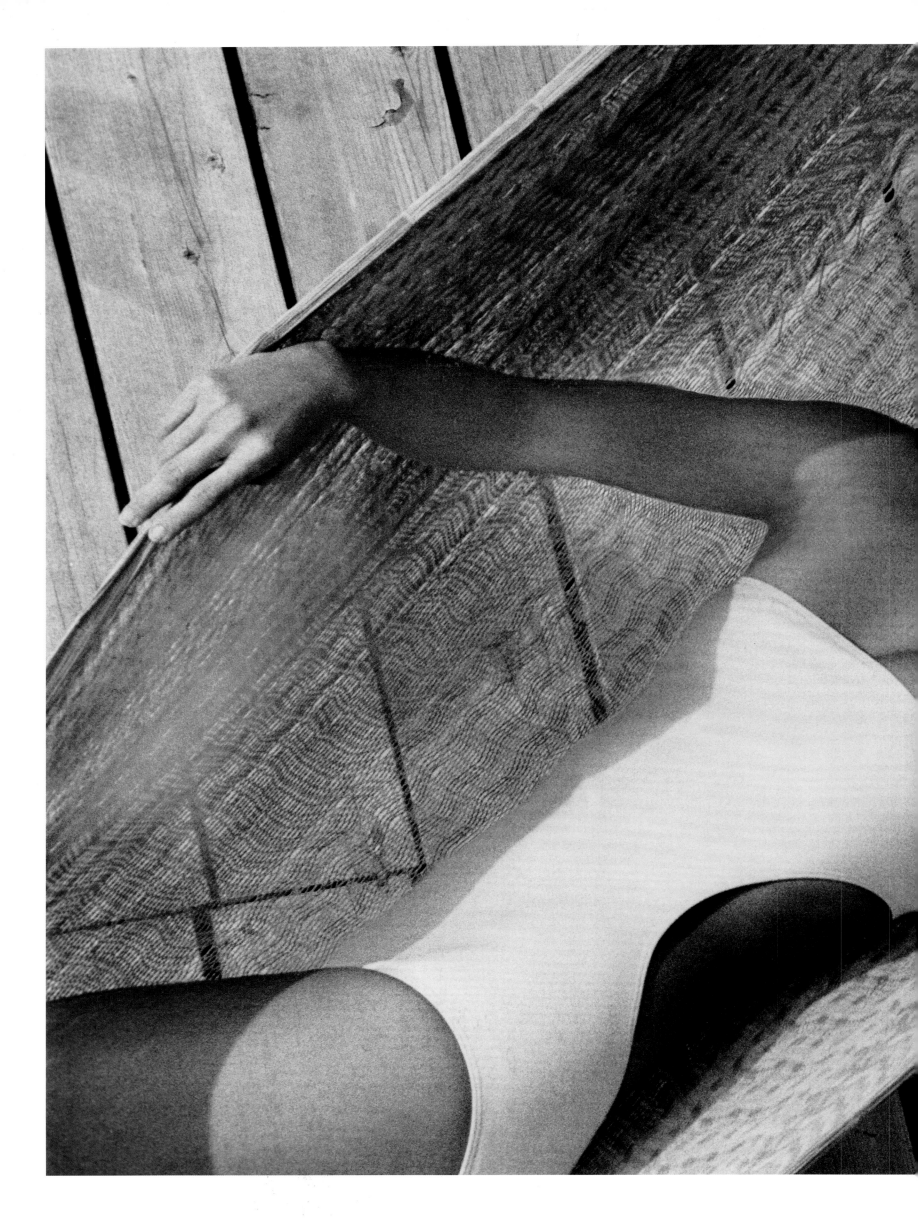

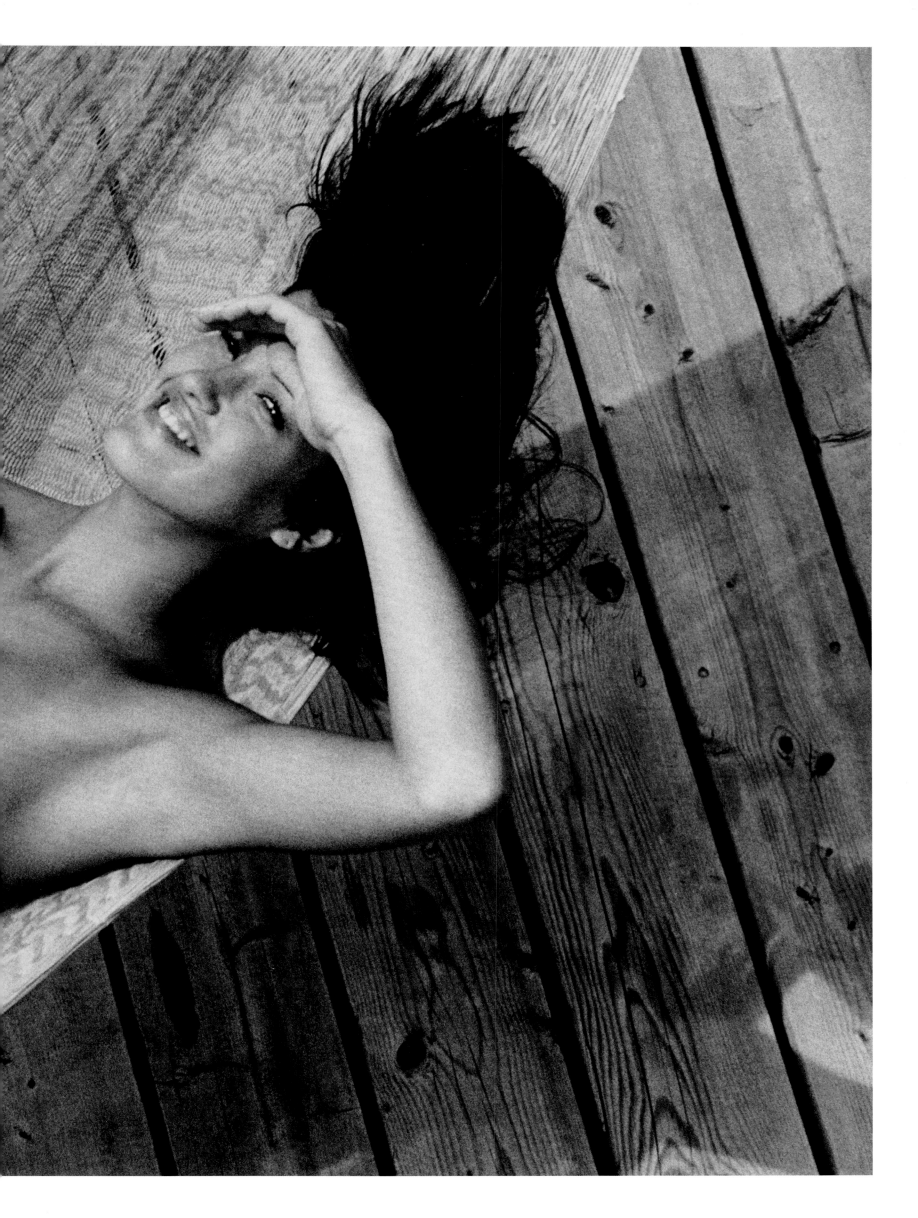

OPPOSITE PAGE: KEVIN HUBSMITH, 2015
FOLLOWING SPREAD: HUNTER MCGRADY, 2016

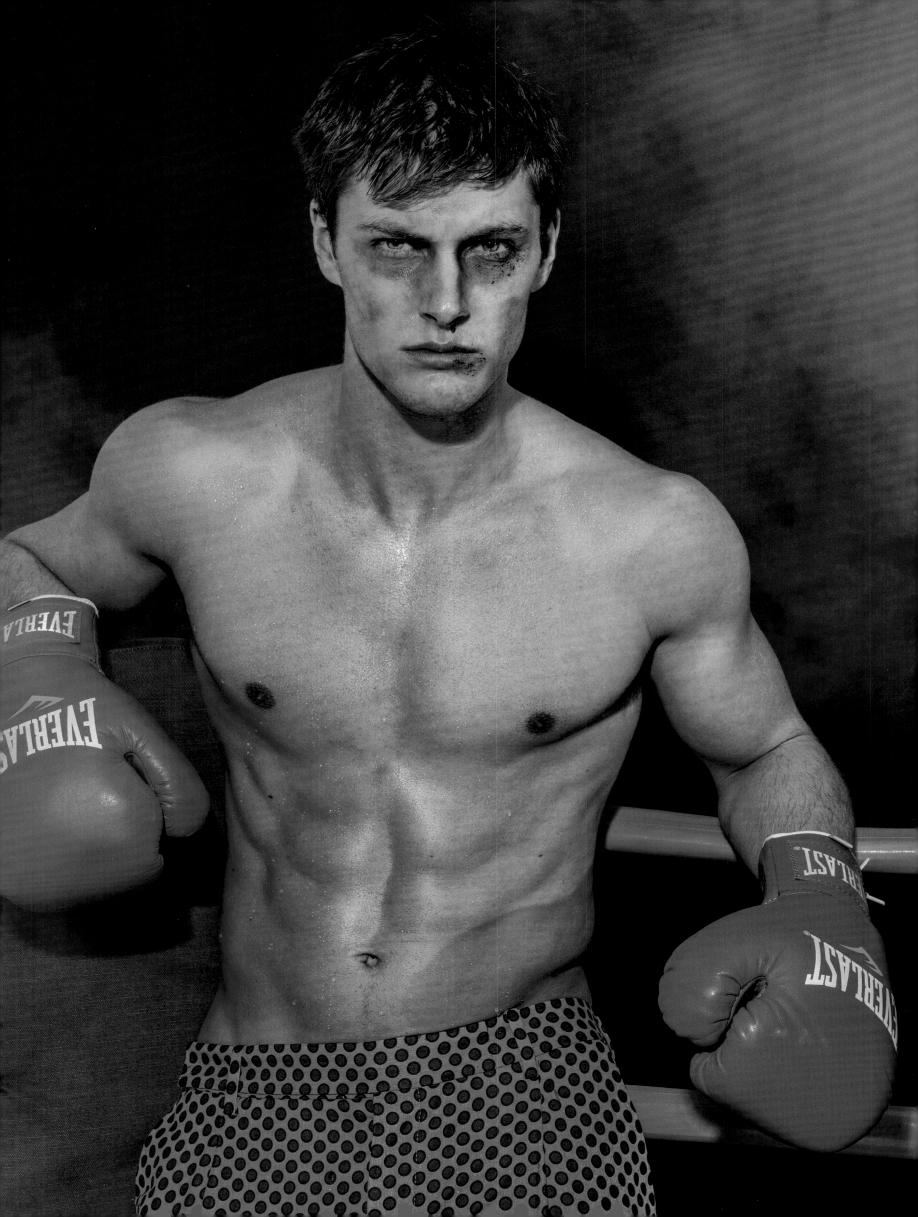

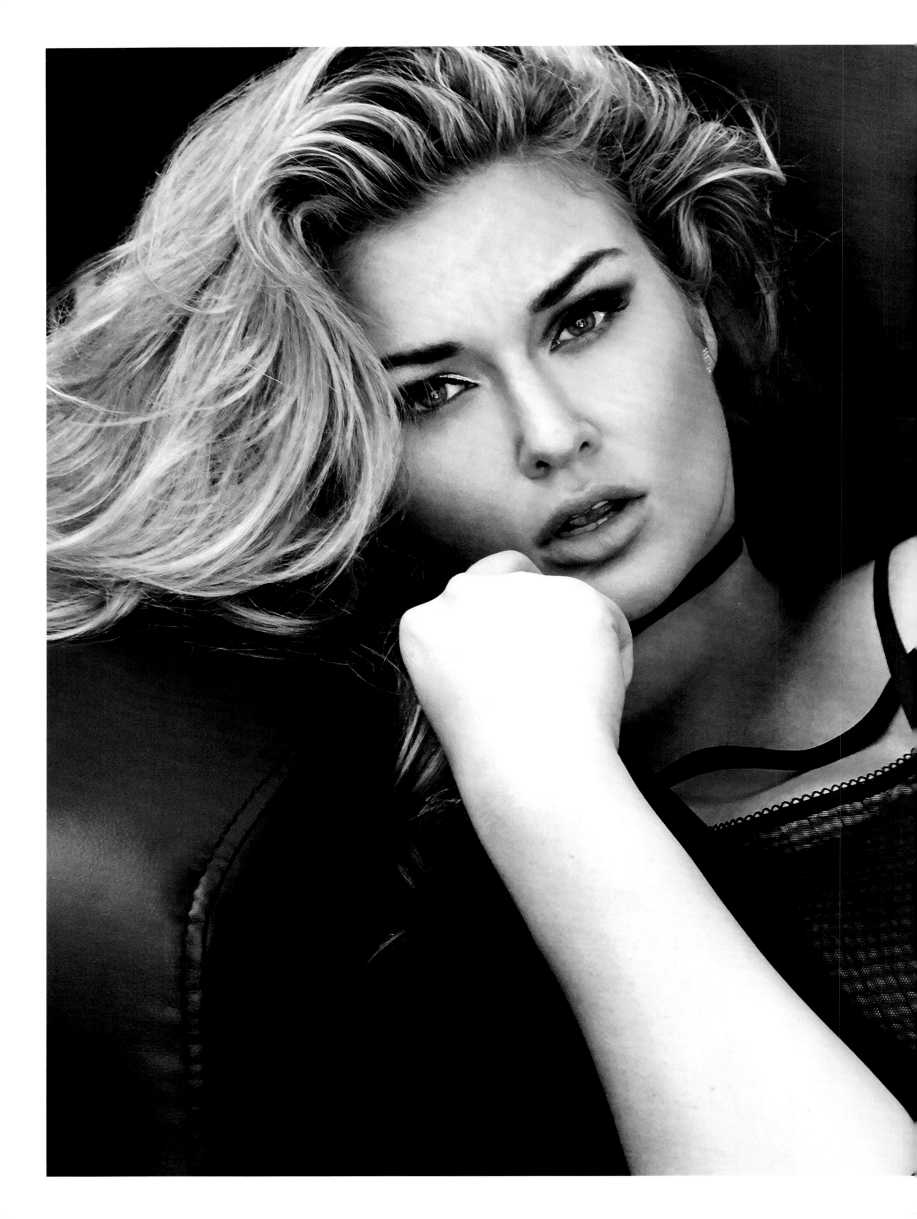

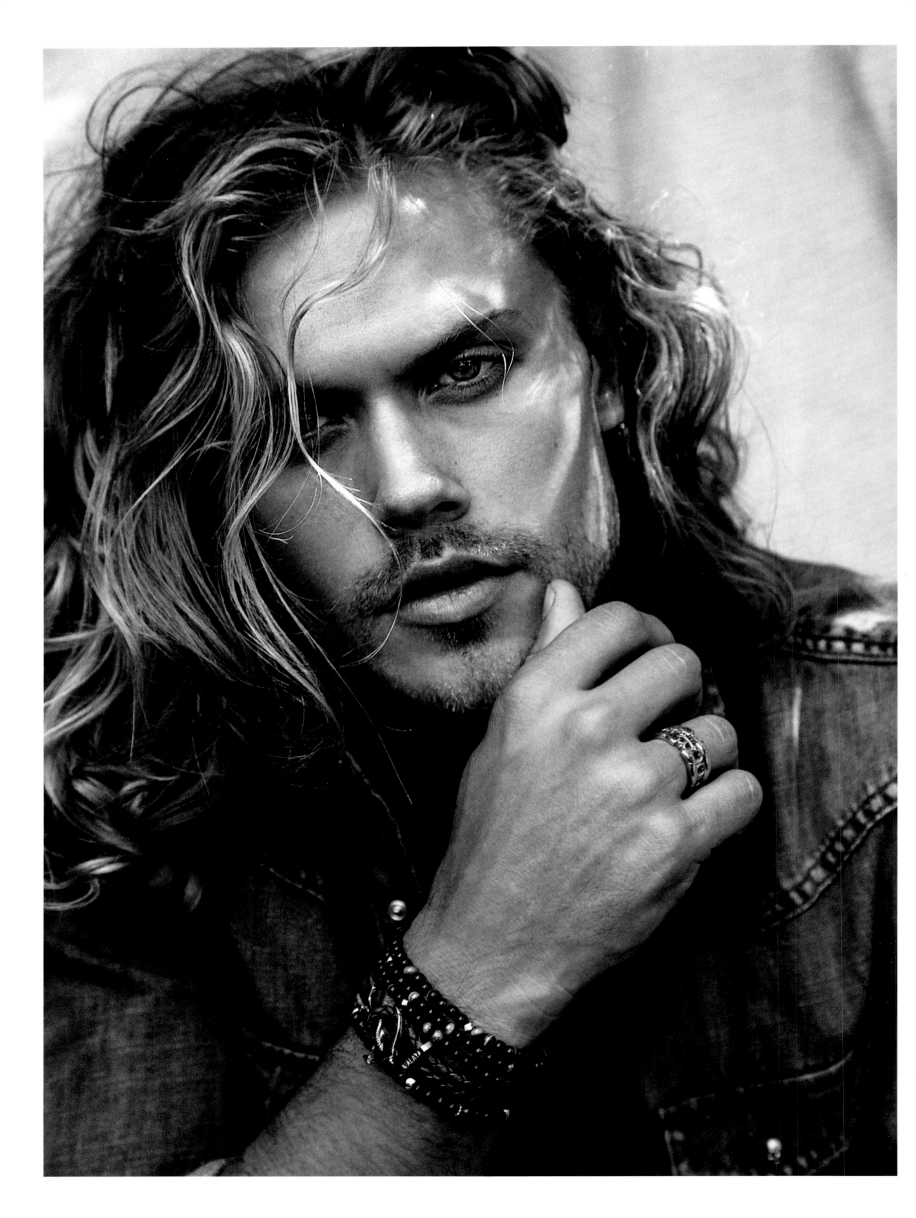

*"No fashion is ever
a success unless it is used as
a form of seduction."*

–Christian Dior

OPPOSITE PAGE: CLARK BOCKELMAN, 2014

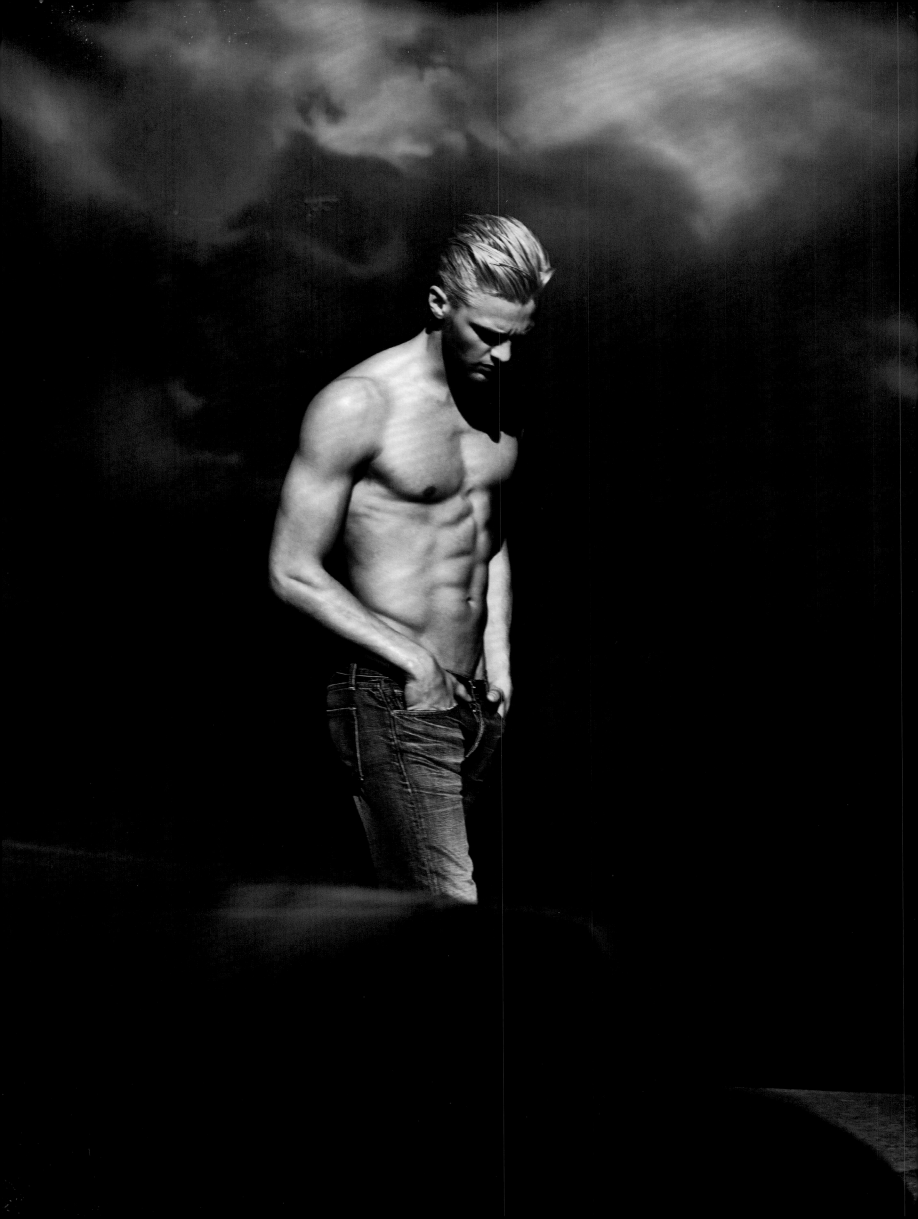

OPPOSITE PAGE: KACY HILL, 2017
FOLLOWING SPREAD: MICHELE HICKS, 2016

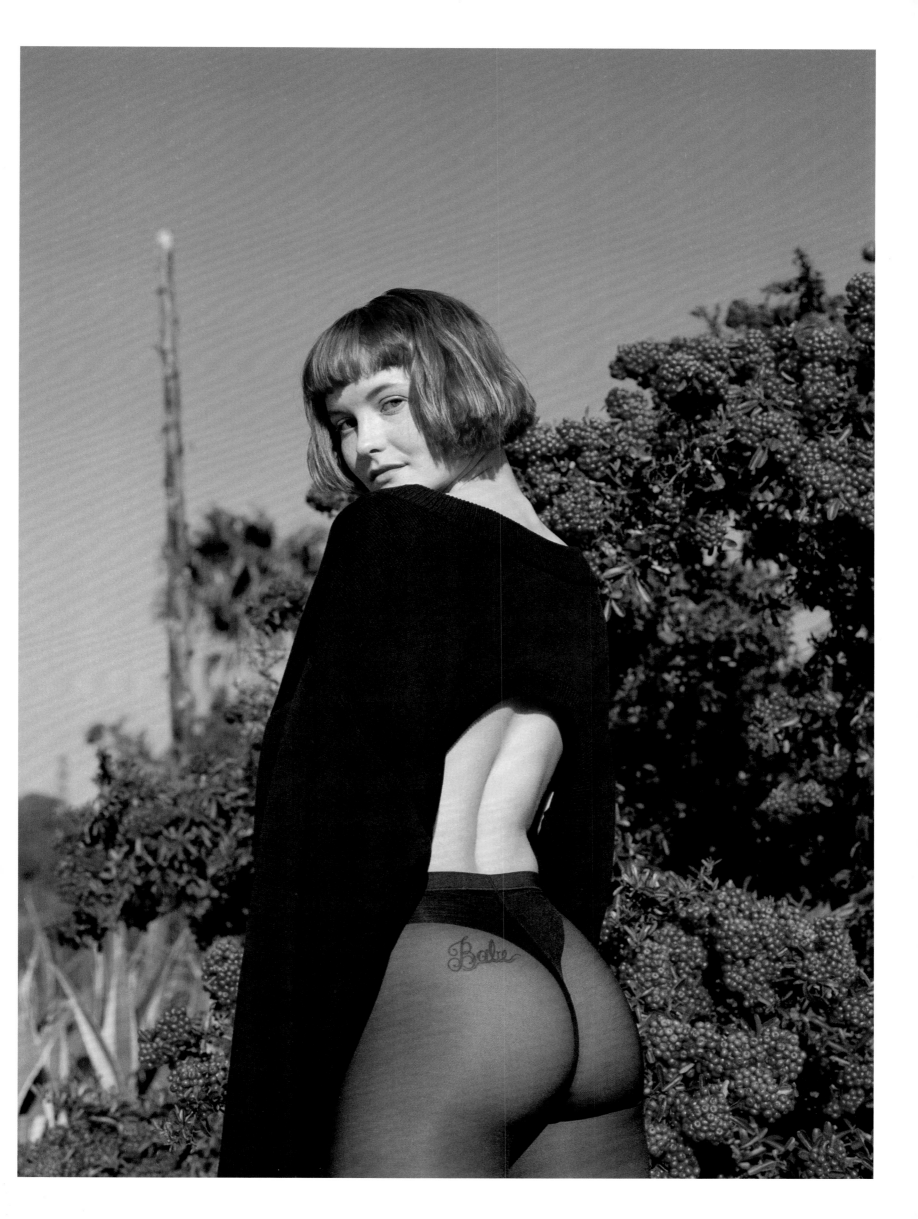

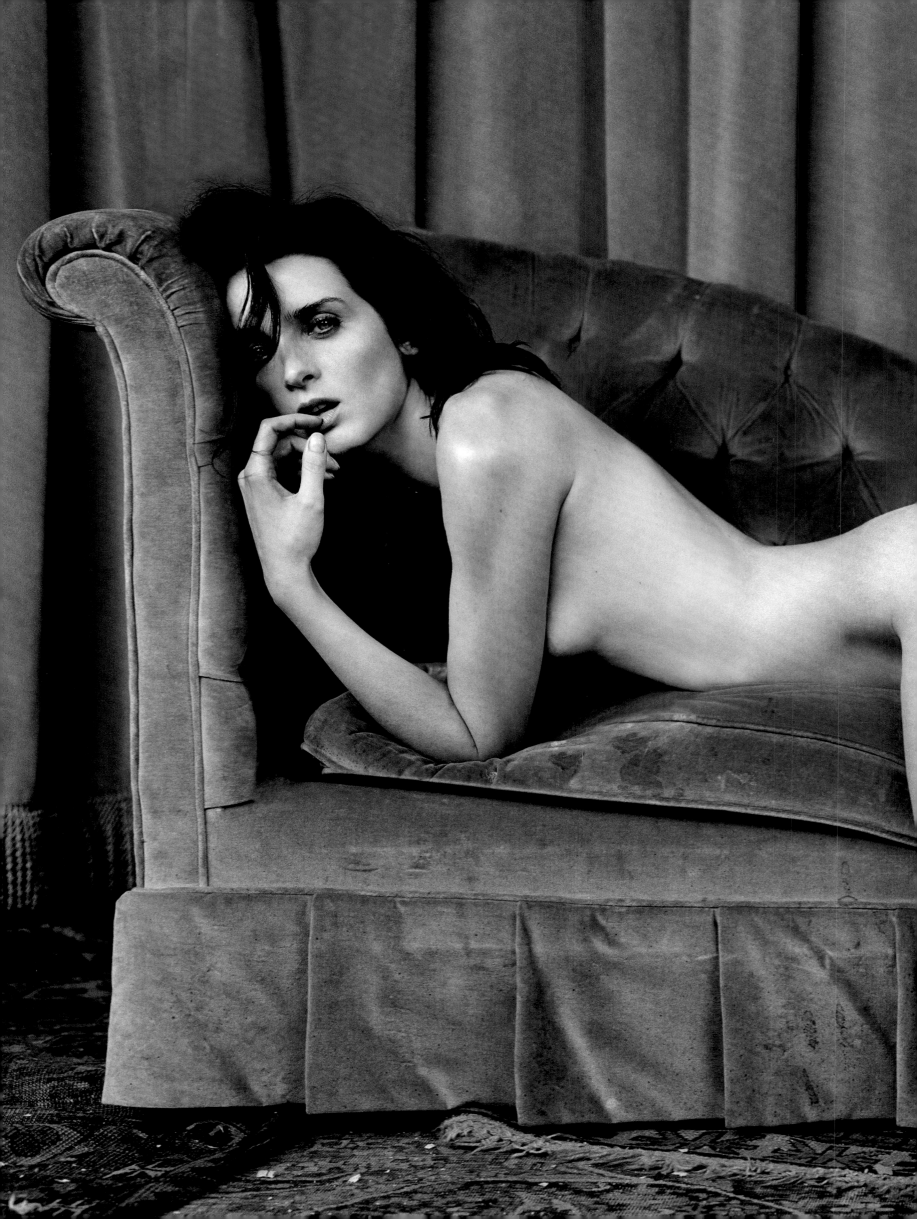

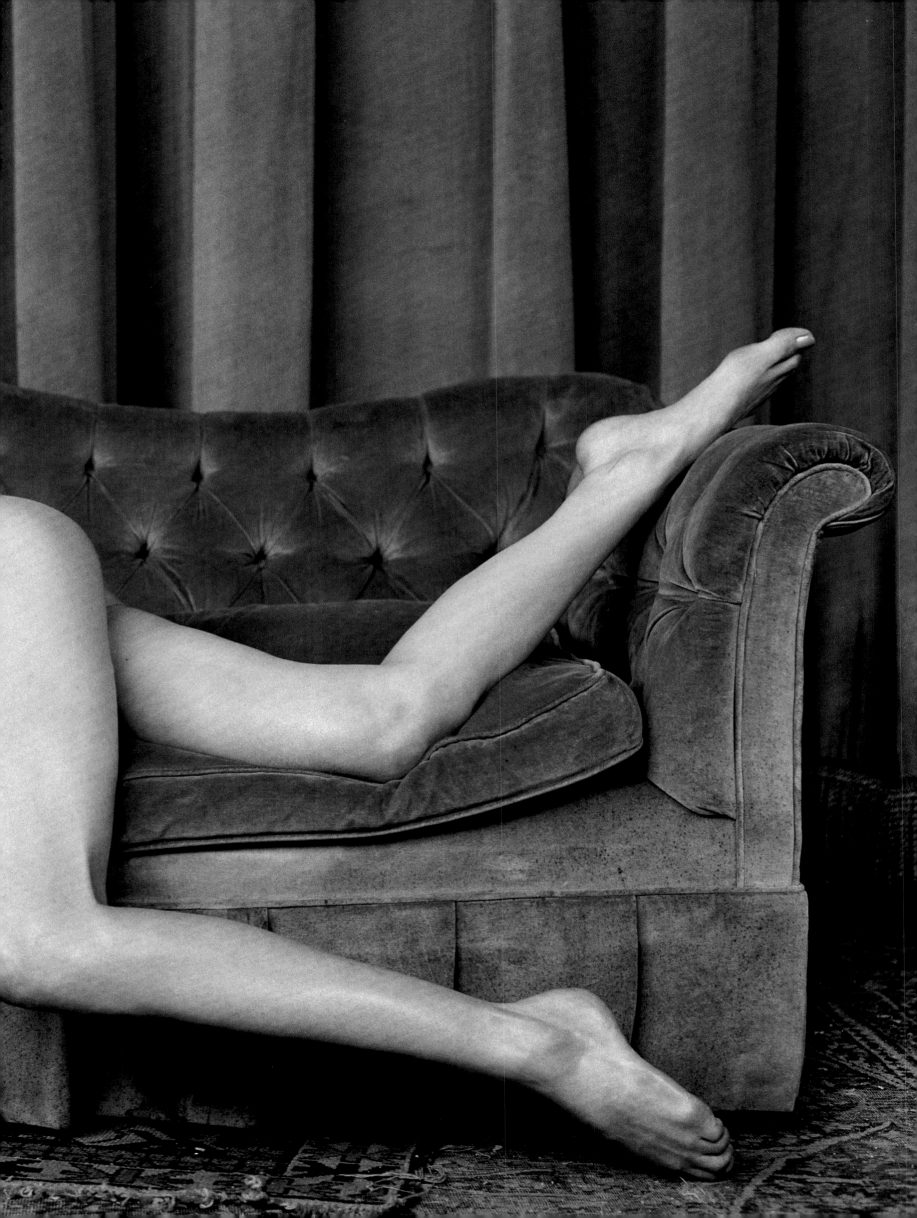

All About Spirit
THE INDIVIDUALS

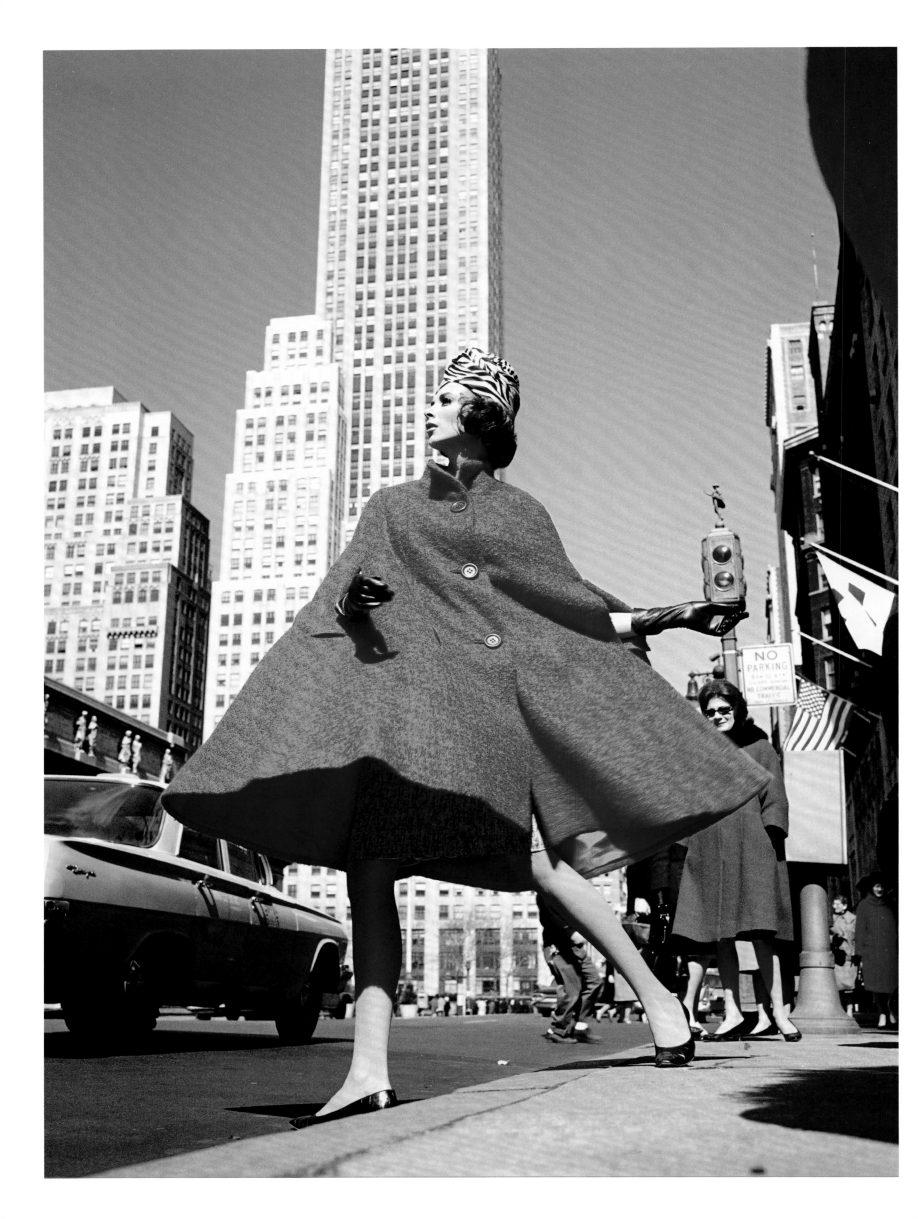

All About Spirit

THE INDIVIDUALS

"As long as I can remember," Beyoncé Knowles told the audience at the CFDA Awards in June 2016, when she was revealed as the night's surprise Fashion Icon honoree, "fashion has been part of my life."

At first glance, the relationship between a global musical superstar and the New York rag trade might seem superficial, at best, but in fact, Beyoncé saw that connection as a critical thread in the tapestry of her life. Her grandmother was a seamstress who sewed clothes for the priests and nuns of a Catholic school in order to pay for her children's education, and she passed those skills onto Beyoncé's mother, Tina, who in turn designed Beyoncé's wedding dress, her prom dress, and eventually her first CFDA Awards dress once she became a big star.

"This to me is the true power and potential of fashion," Beyoncé said onstage as she accepted her award. "It's a tool for finding your own identity. It transcends style, and it's a time capsule of all of our greatest milestones."

Wilhelmina has a long tradition of uniting these worlds with its representation of musicians, actors, and athletes in addition to models who have gone on to become movie stars or performers. In some ways, this recognizes that a successful image is a critical component for a rock star in any profession. Over the years, Wilhelmina has opened its doors to talents as diverse as Beyoncé, Demi Lovato, Machine Gun Kelly, Nick Jonas, Cyndi Lauper, and many more—a cross-current portfolio of styles and personalities that come through as clearly in photographs as words. These are performers who are also recognizable for idiosyncratic styles in their own rights.

And in other ways, this convergence recognizes the ever-growing fascination with celebrity in our culture. What constitutes fame, of course, changes from decade to decade, leading to the more contemporary phenomenon of stars whose claim to fame derives from their recognition on social media or reality television. But what remains the same is a laser-sharp focus on image in order to reach the next level—in other words, building a brand. For one example, there is Olivia Palermo, who parlayed a 2009 turn on *The City* into a media empire with fashion collections for Nordstrom and Banana Republic, along with a particularly jet-set lifestyle.

"You know what—in the line of work that I'm in, and everything that I do, it is a complete business," Palermo told *PopSugar* in 2016, "And I love it."

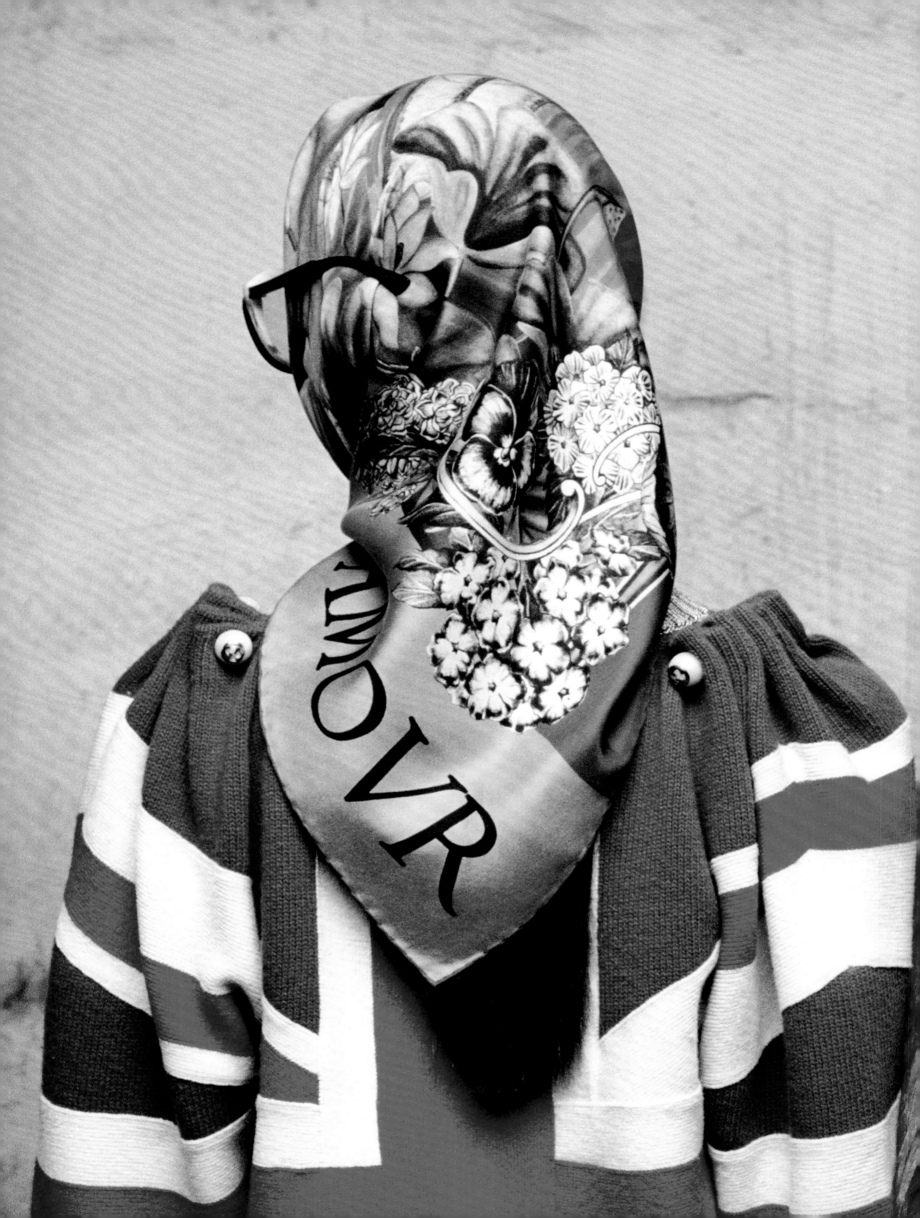

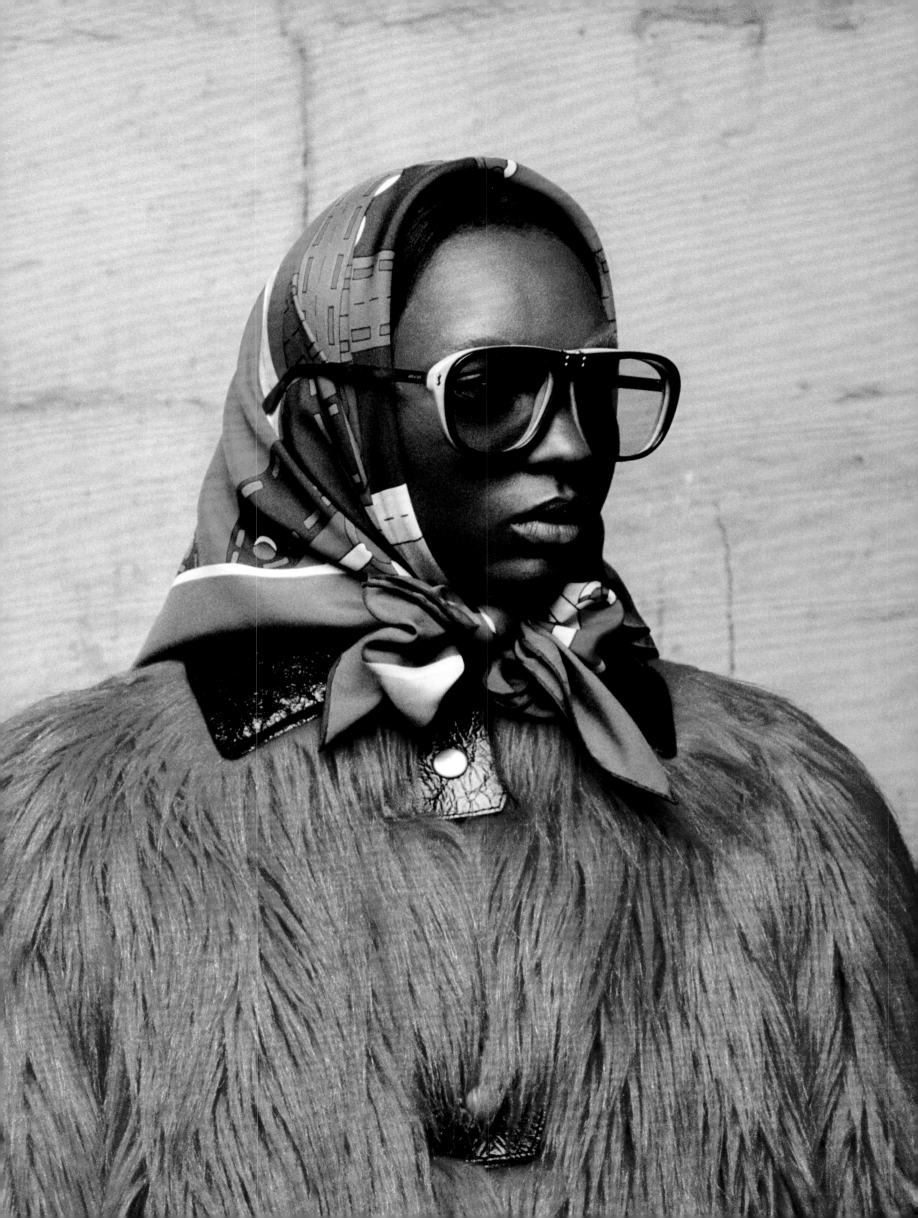

PREVIOUS SPREAD: NICOLE ATIENO, 2016
OPPOSITE PAGE: DEMI LOVATO, 2017

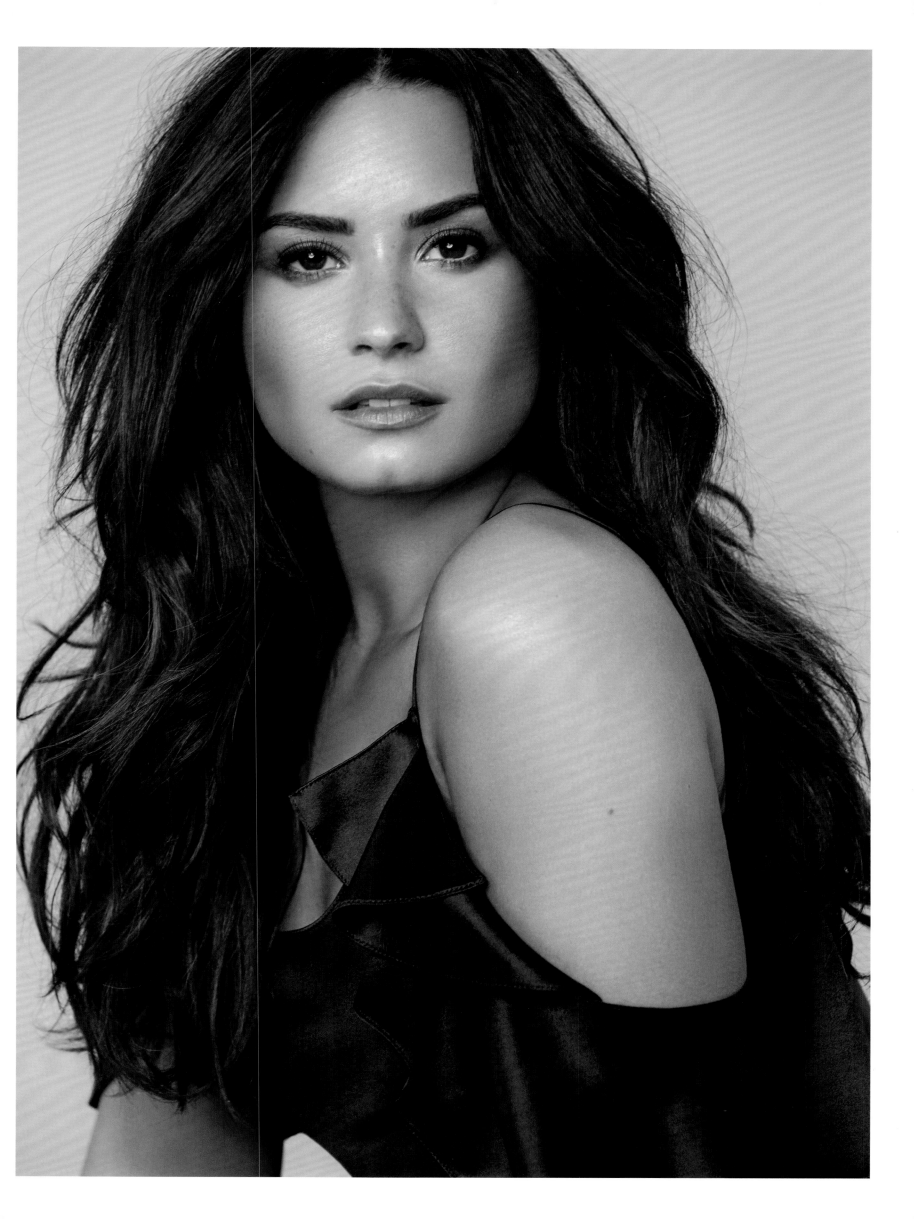

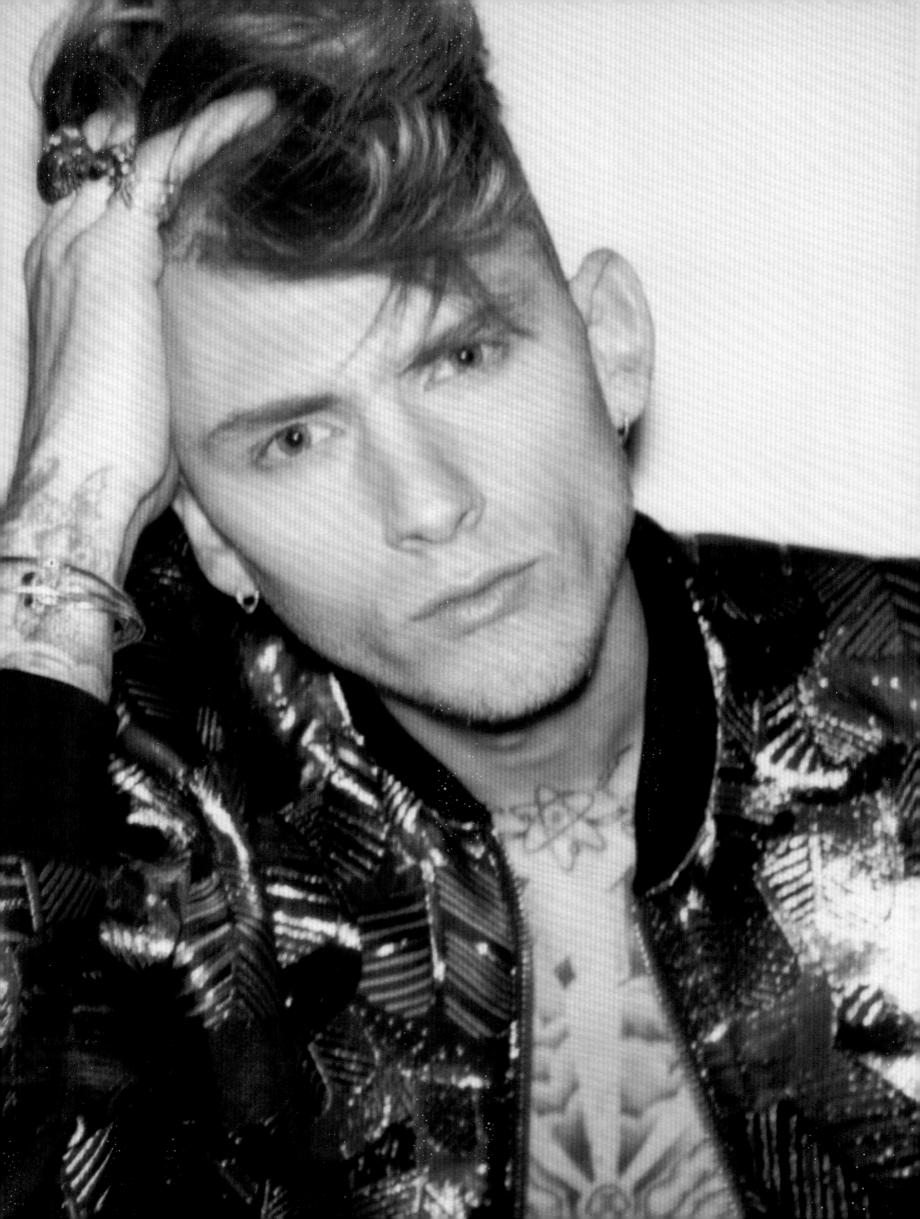

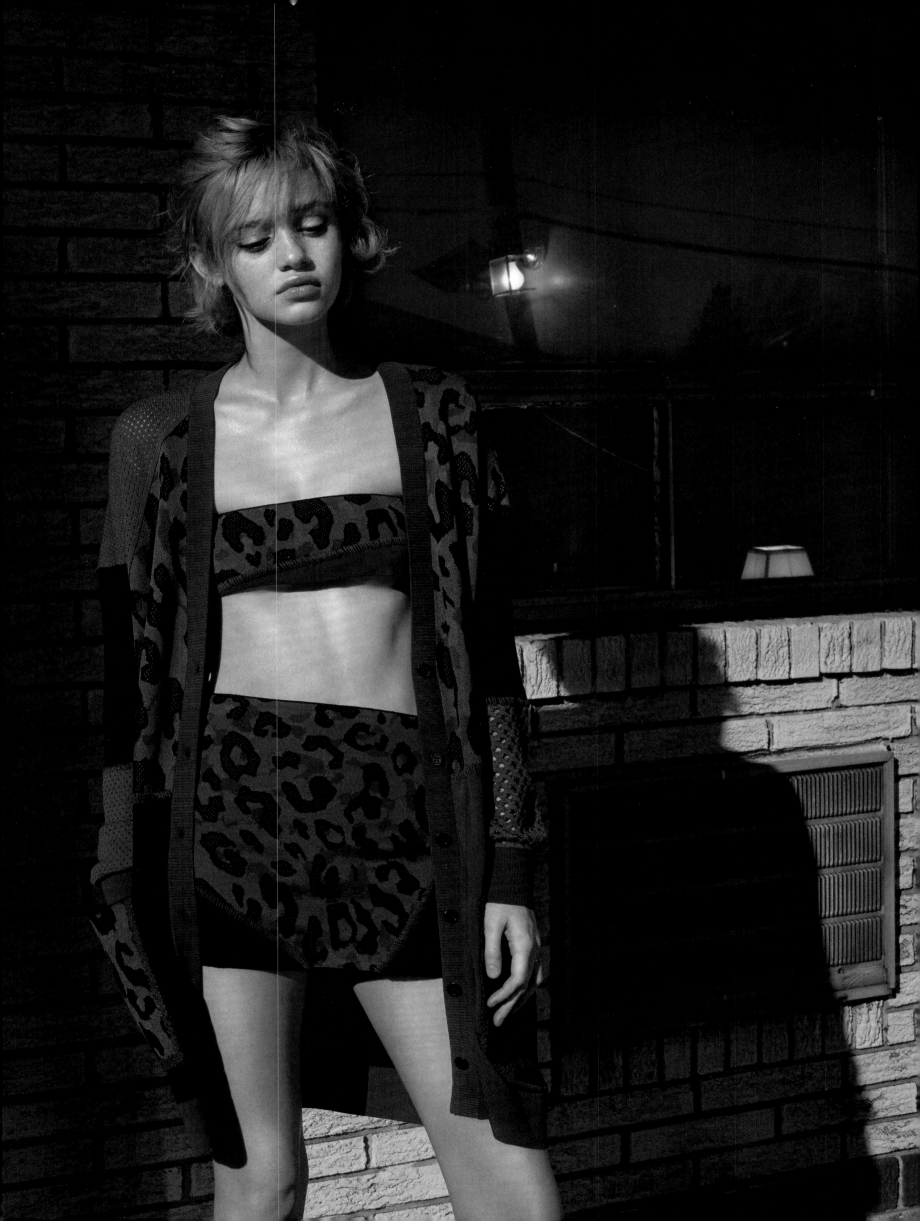

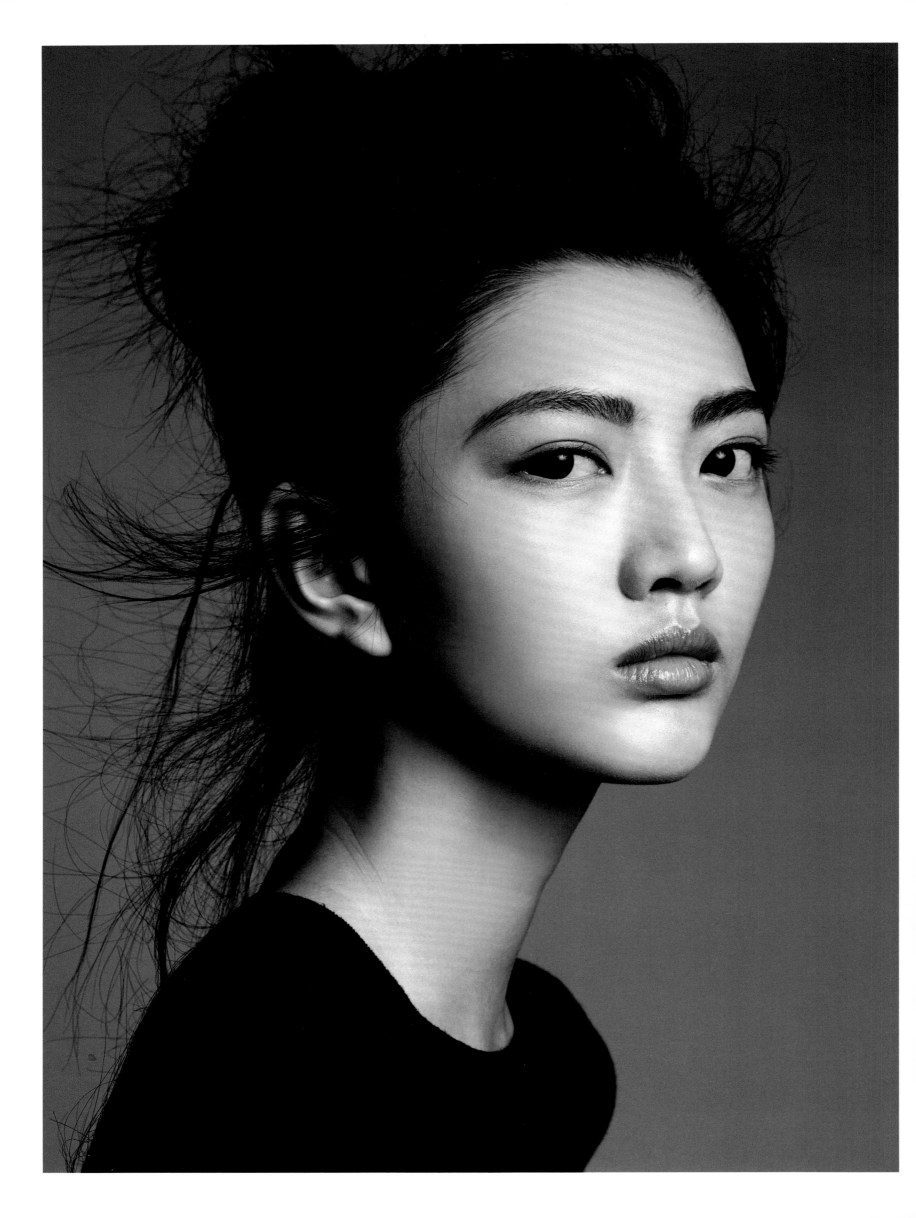

*"Don't be into trends.
Don't make fashion own you,
but you decide what you
are, what you want to express
by the way you dress and
the way you live."*

–Gianni Versace

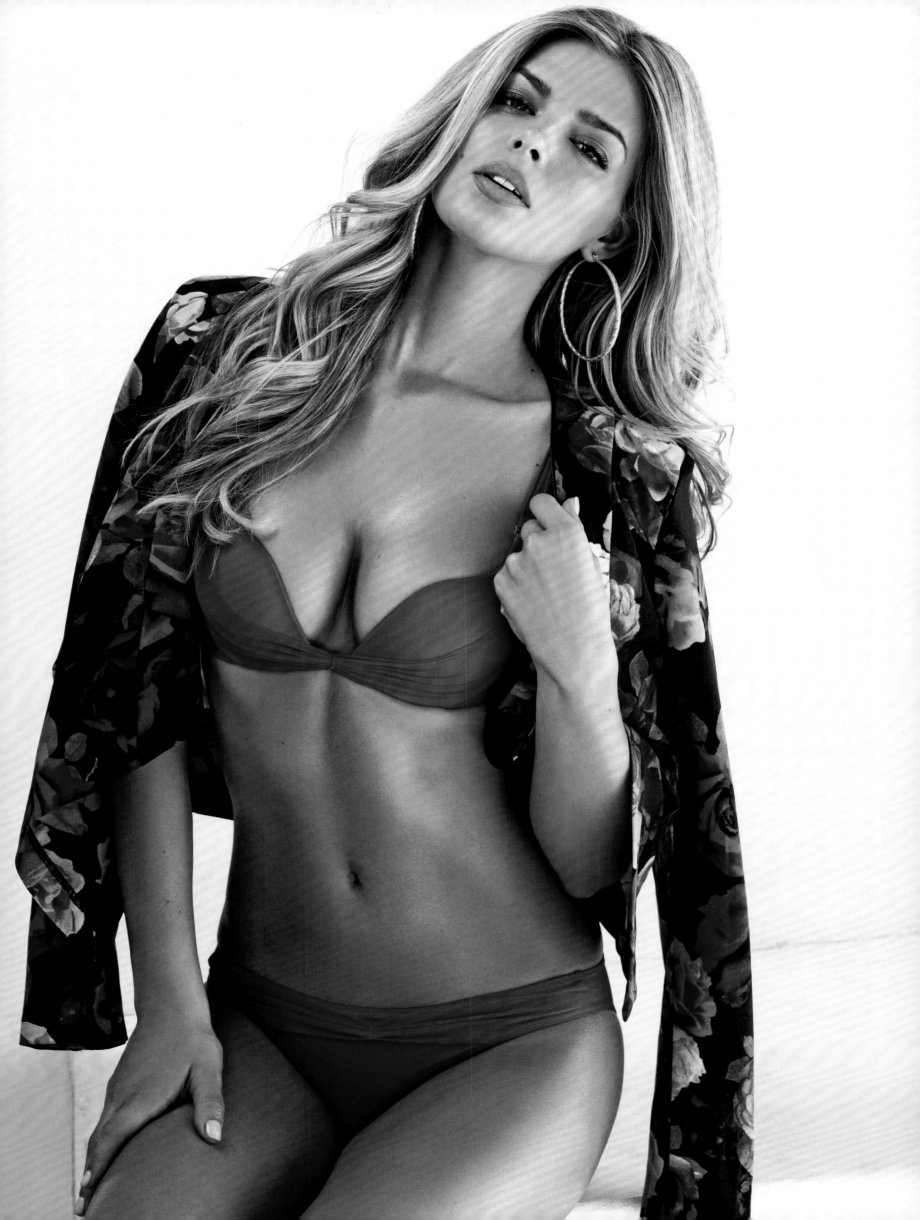

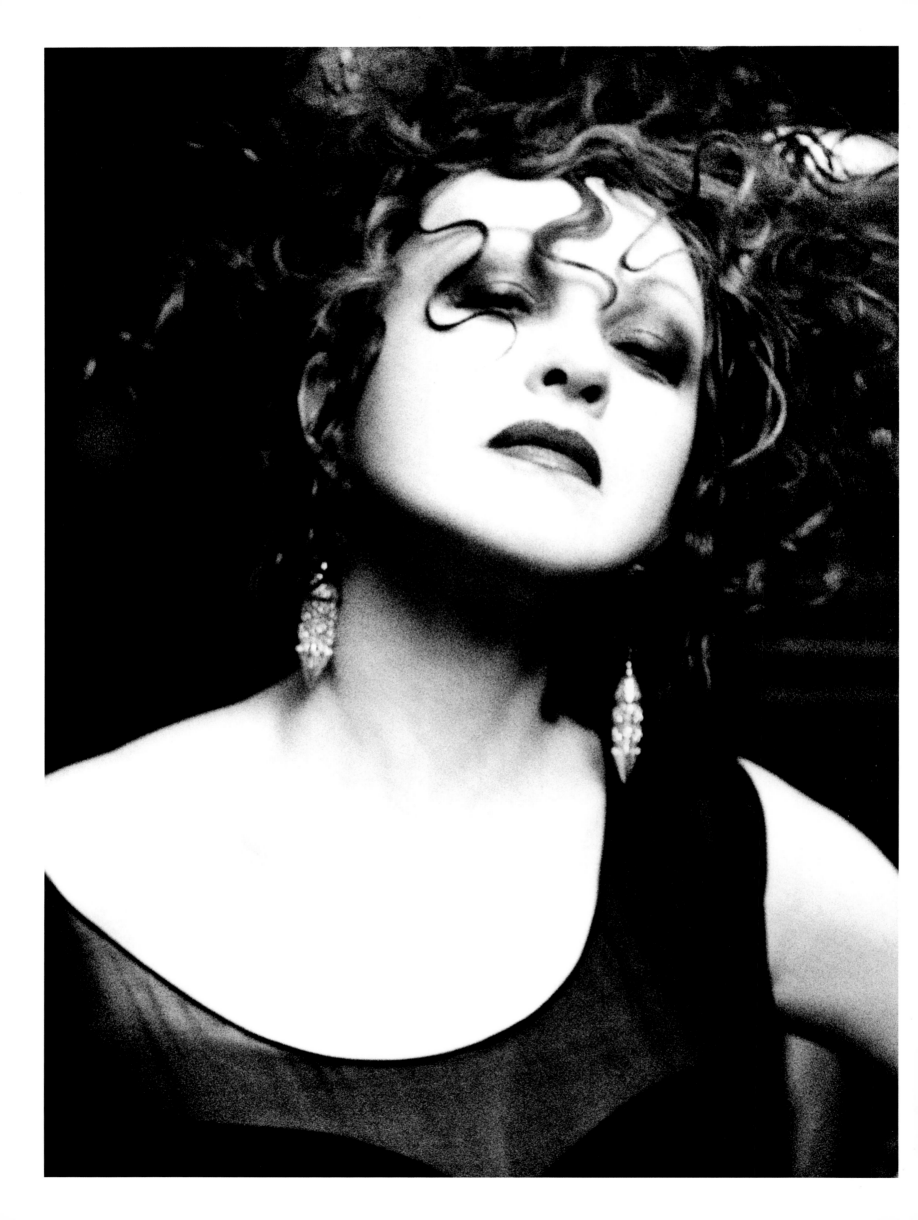

*"On my darkest days,
I wear my brightest colors."*

–Cyndi Lauper

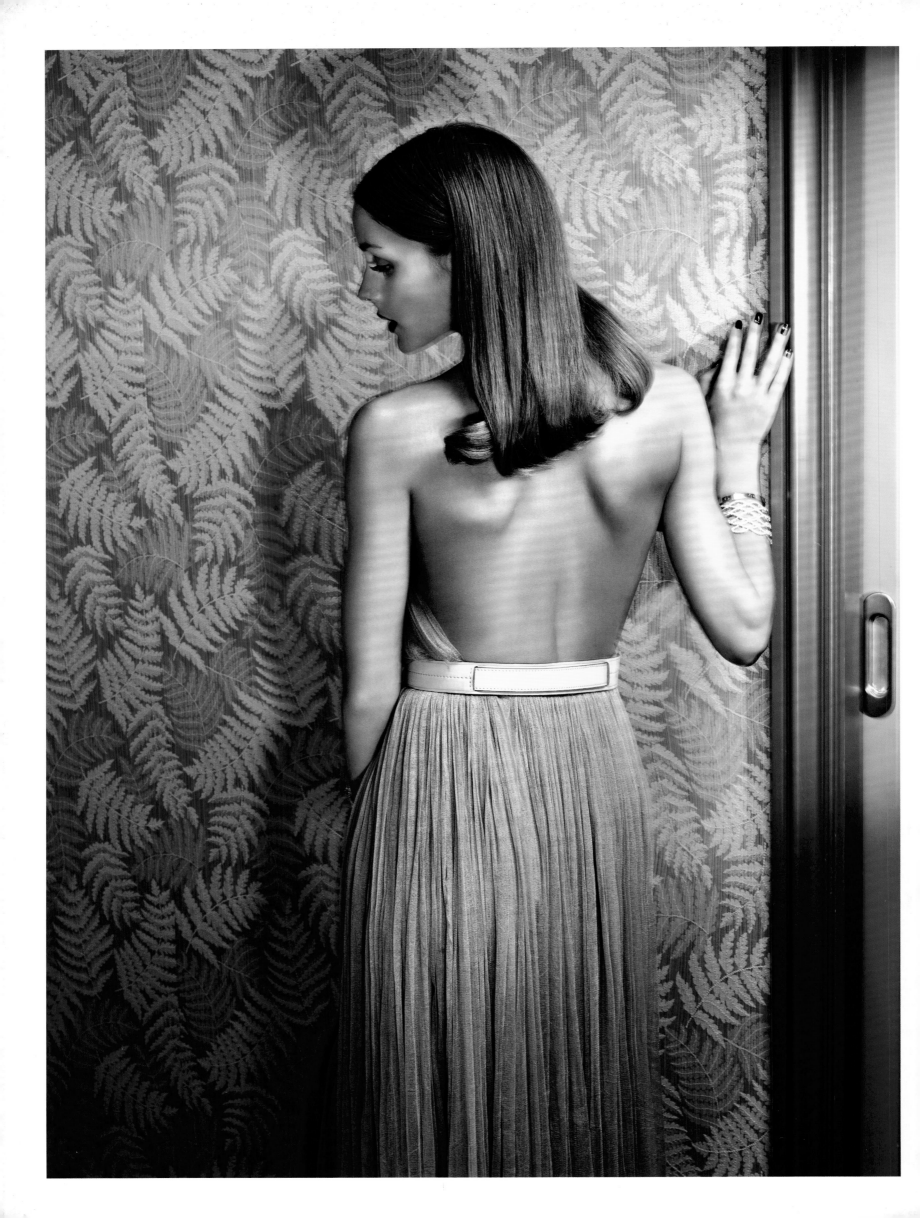

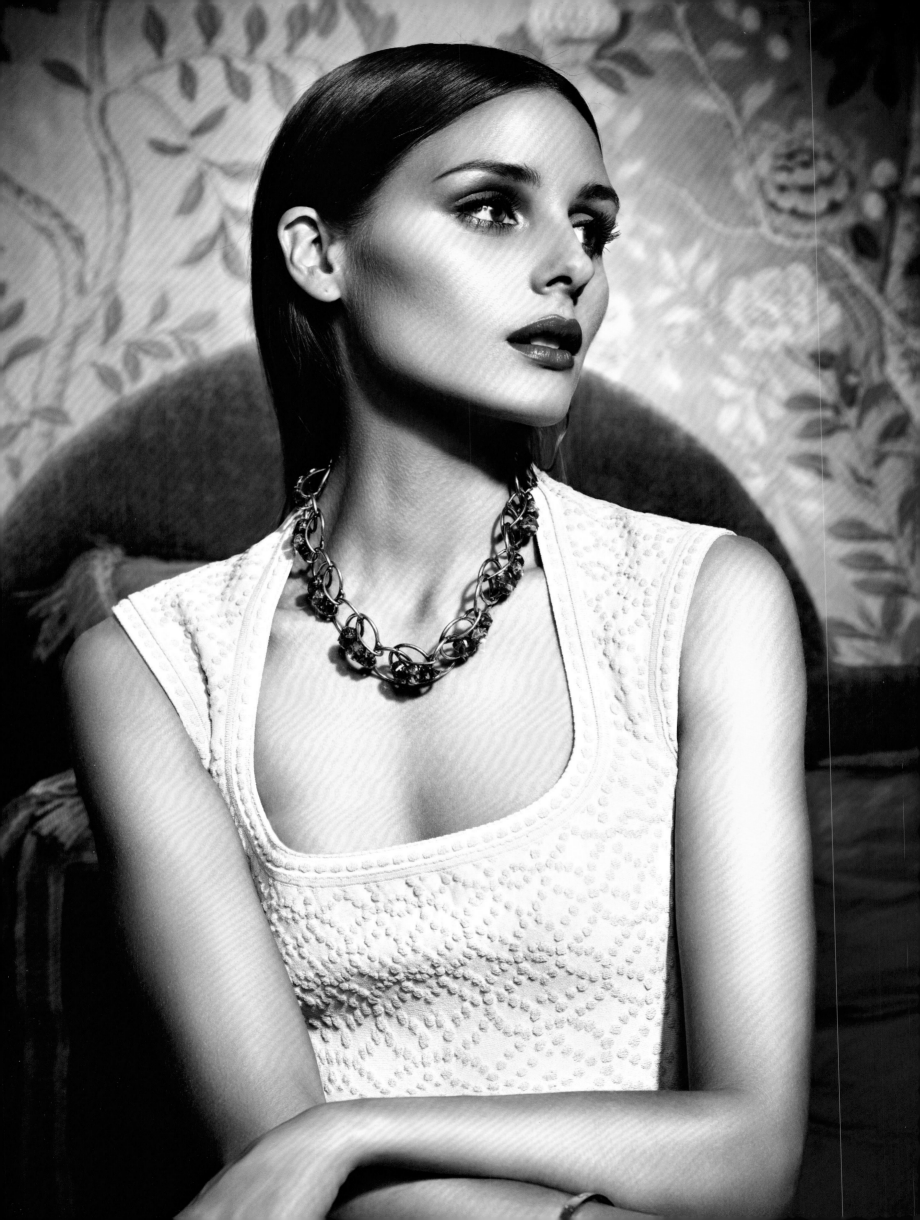

*"I don't like standard beauty—
there is no beauty without strangeness."*

–Karl Lagerfeld

OPPOSITE PAGE: SUNG JIN PARK, 2014
FOLLOWING SPREAD: SOO JOO PARK, 2004 AND 2013

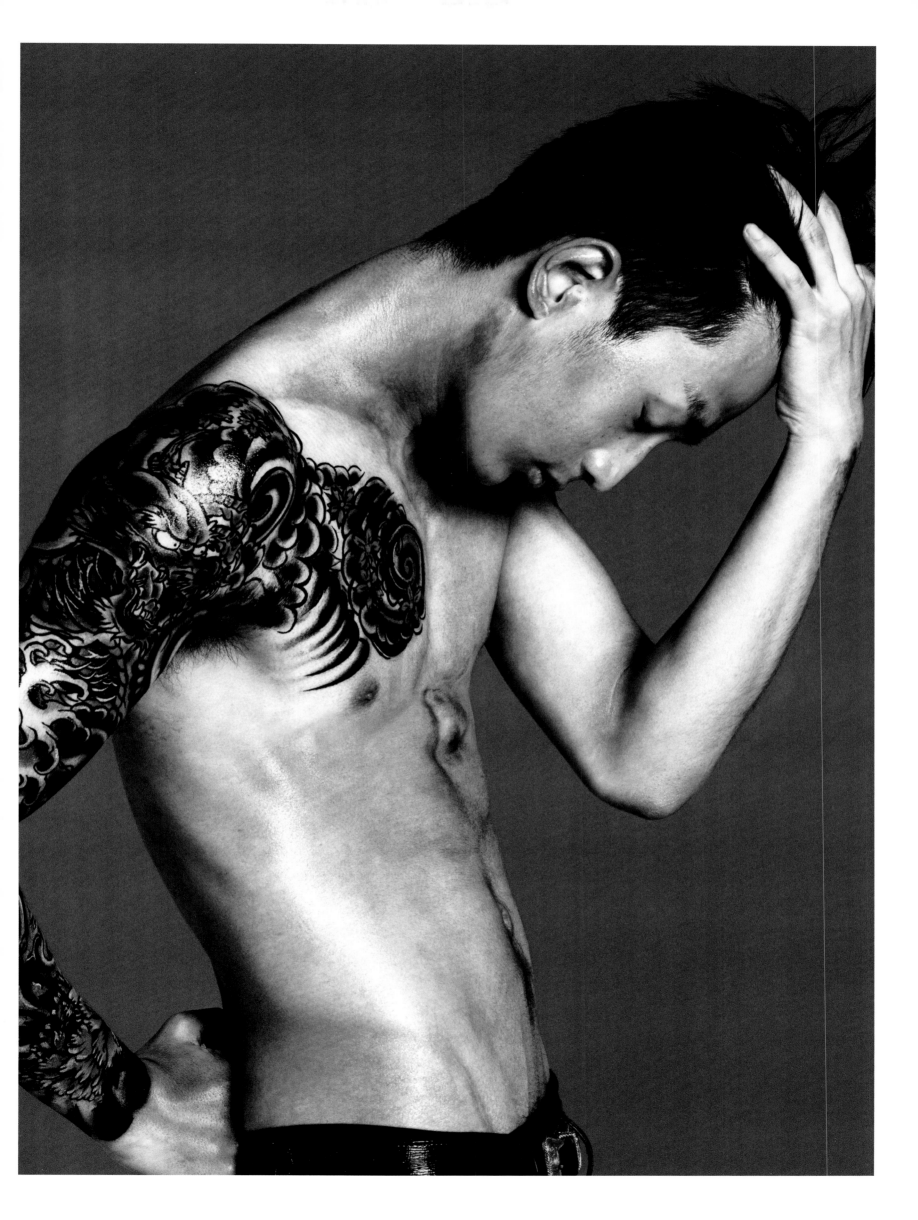

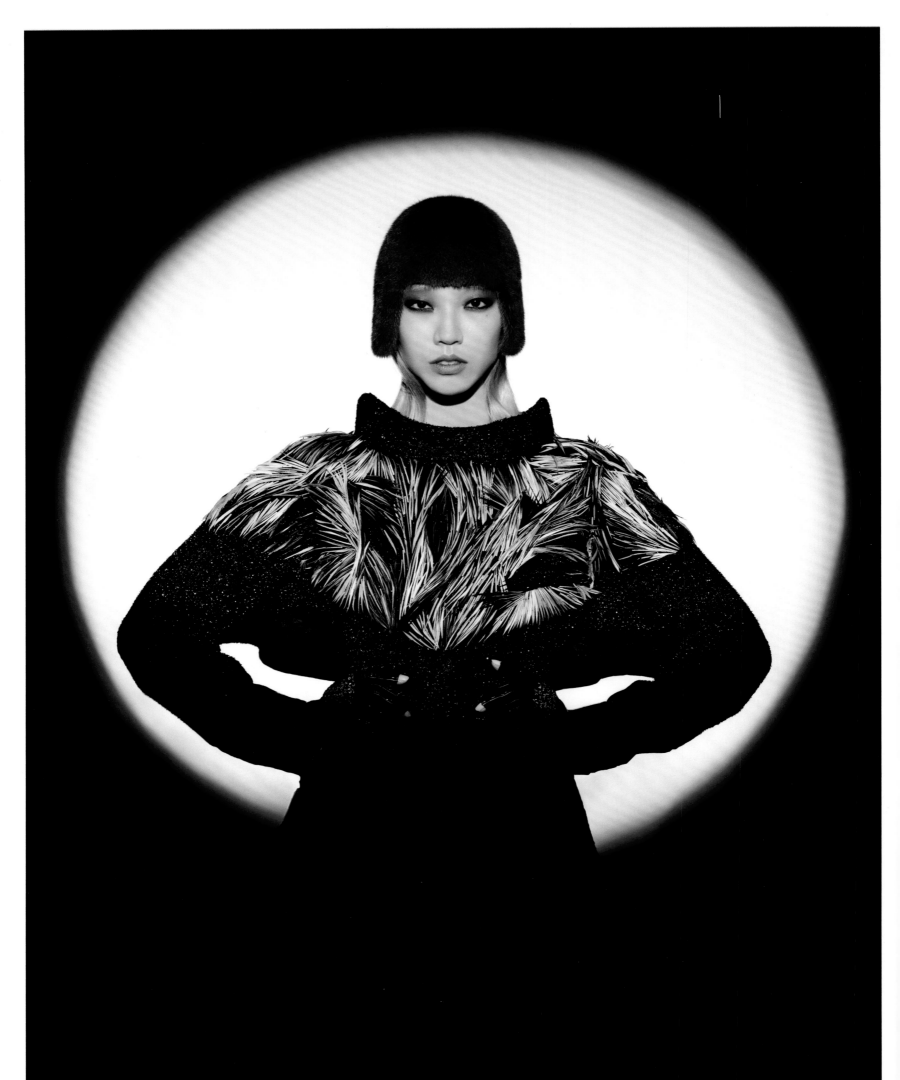

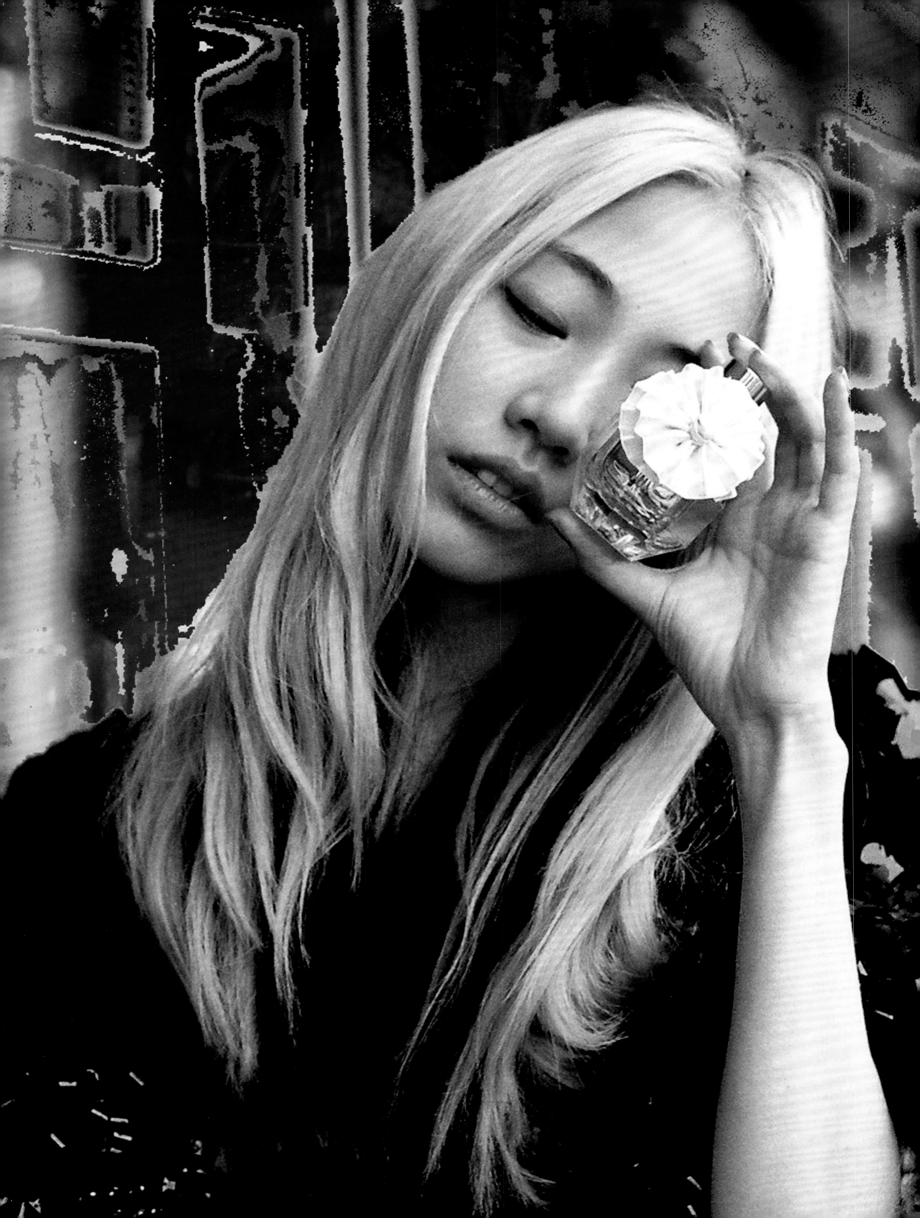

"*I think there is beauty in everything. What 'normal' people perceive as ugly, I can usually see something of beauty in it.*"

—*Alexander McQueen*

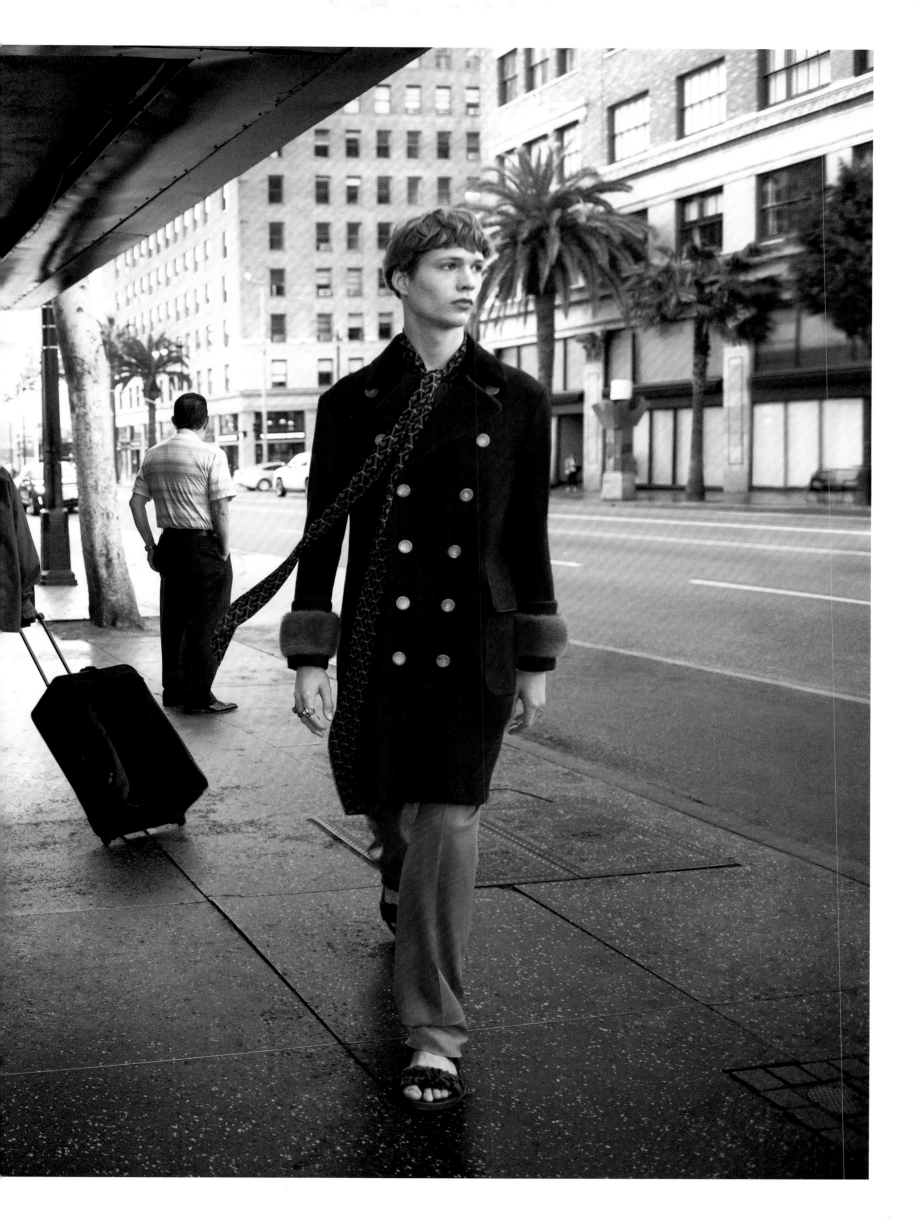

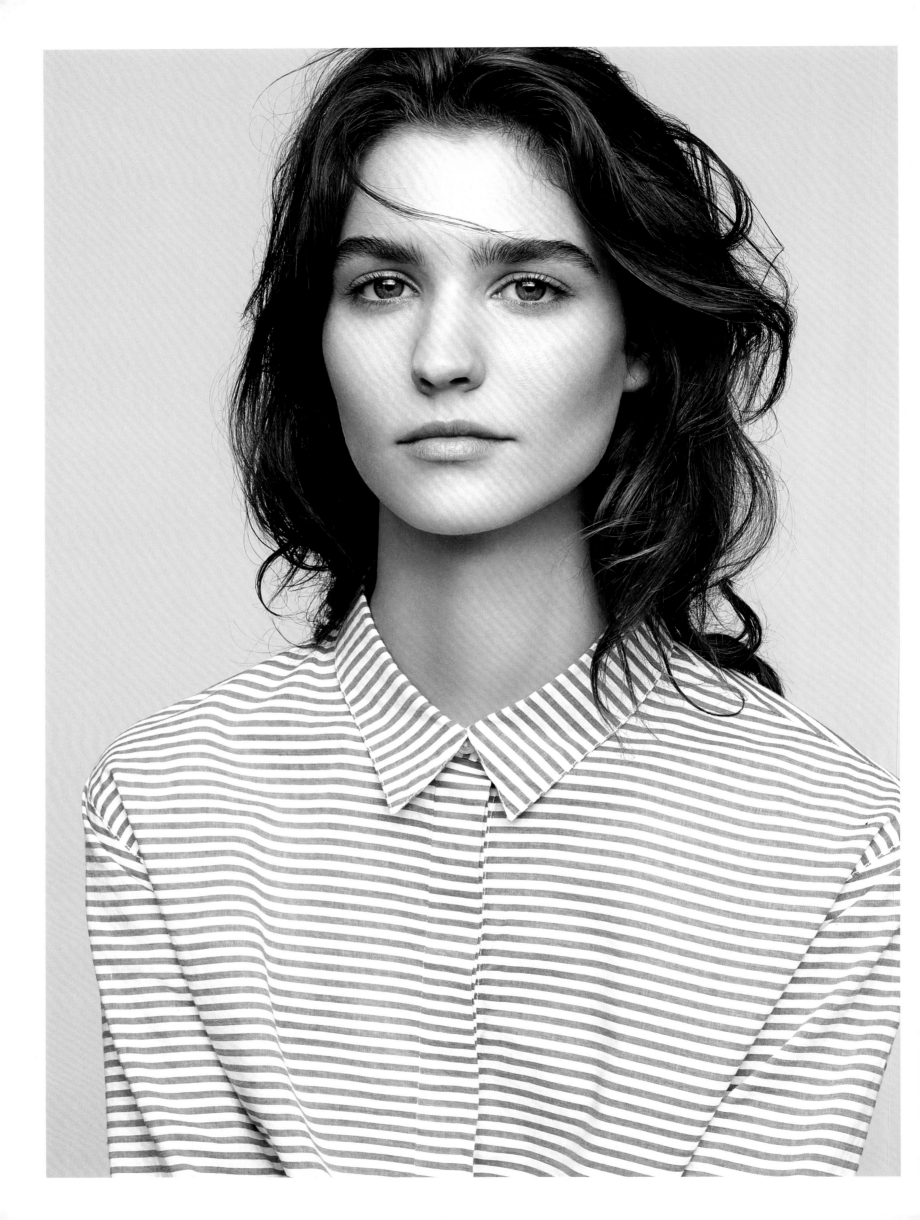

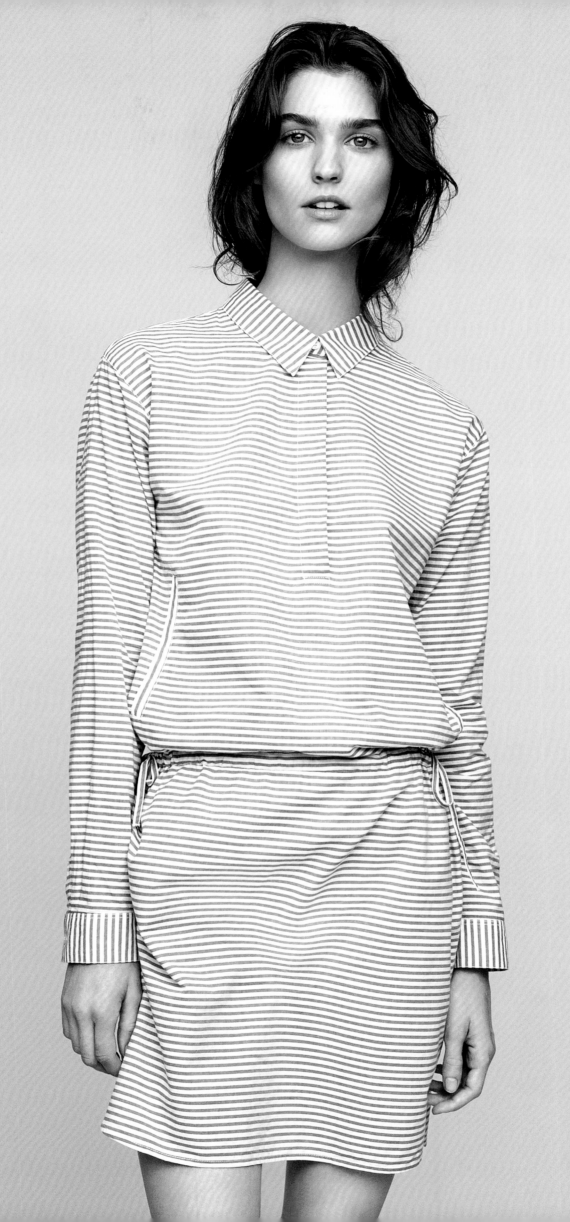

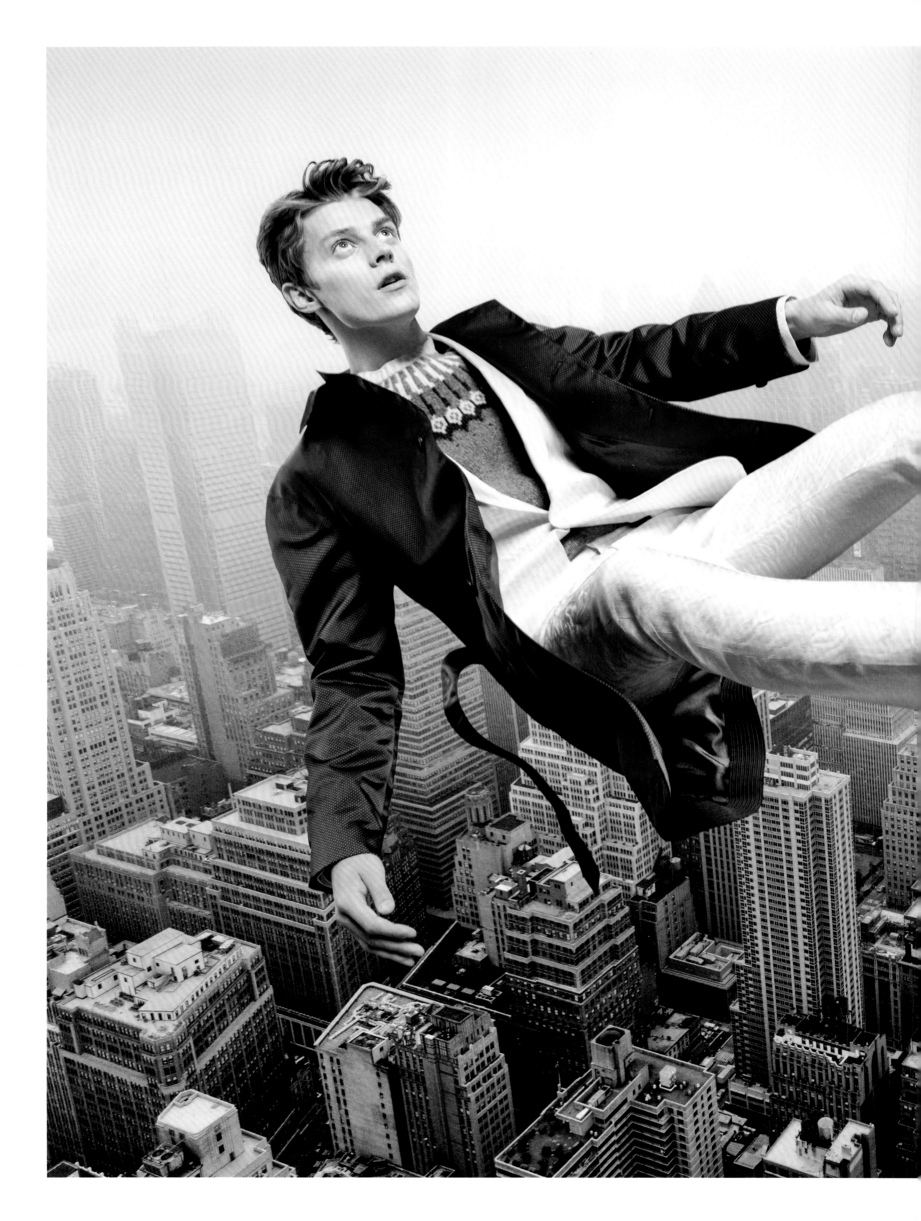

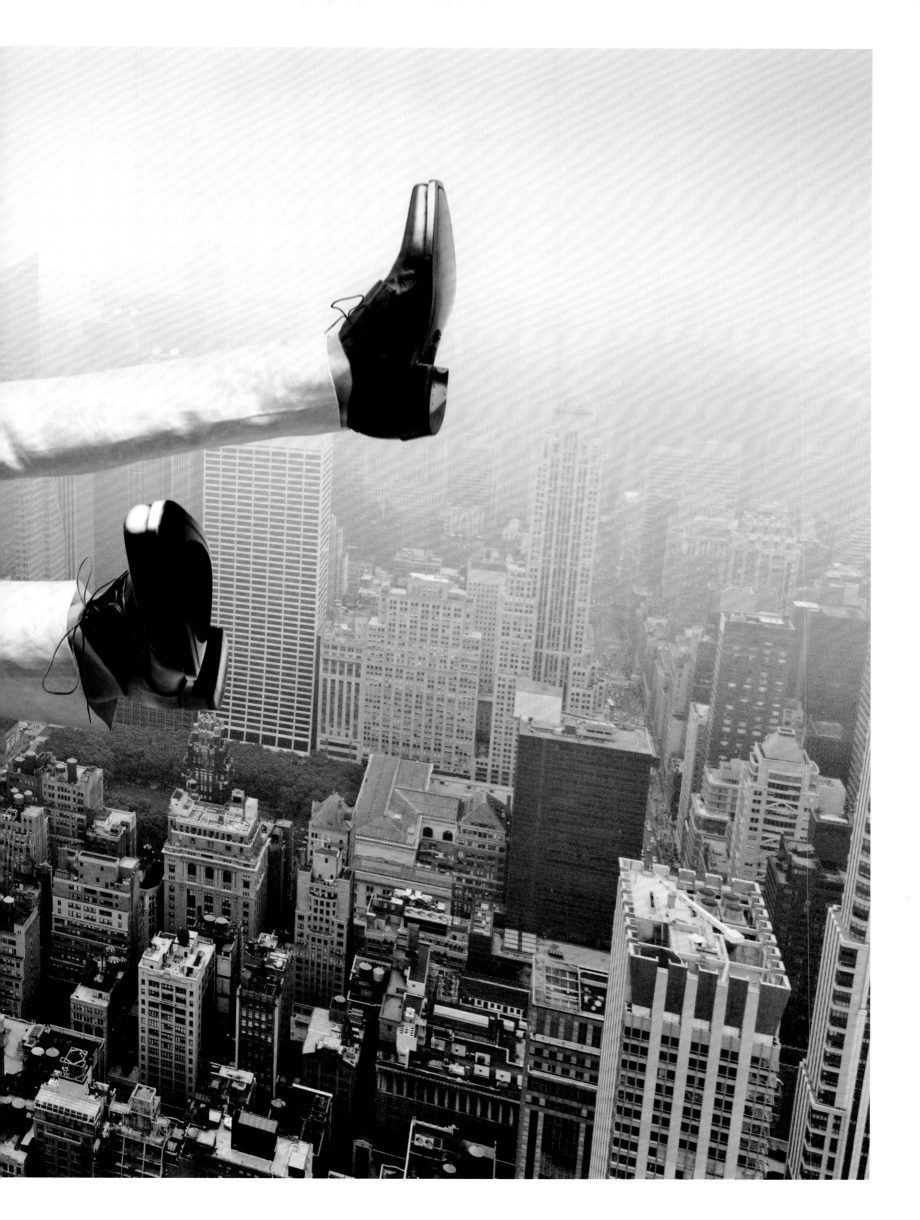

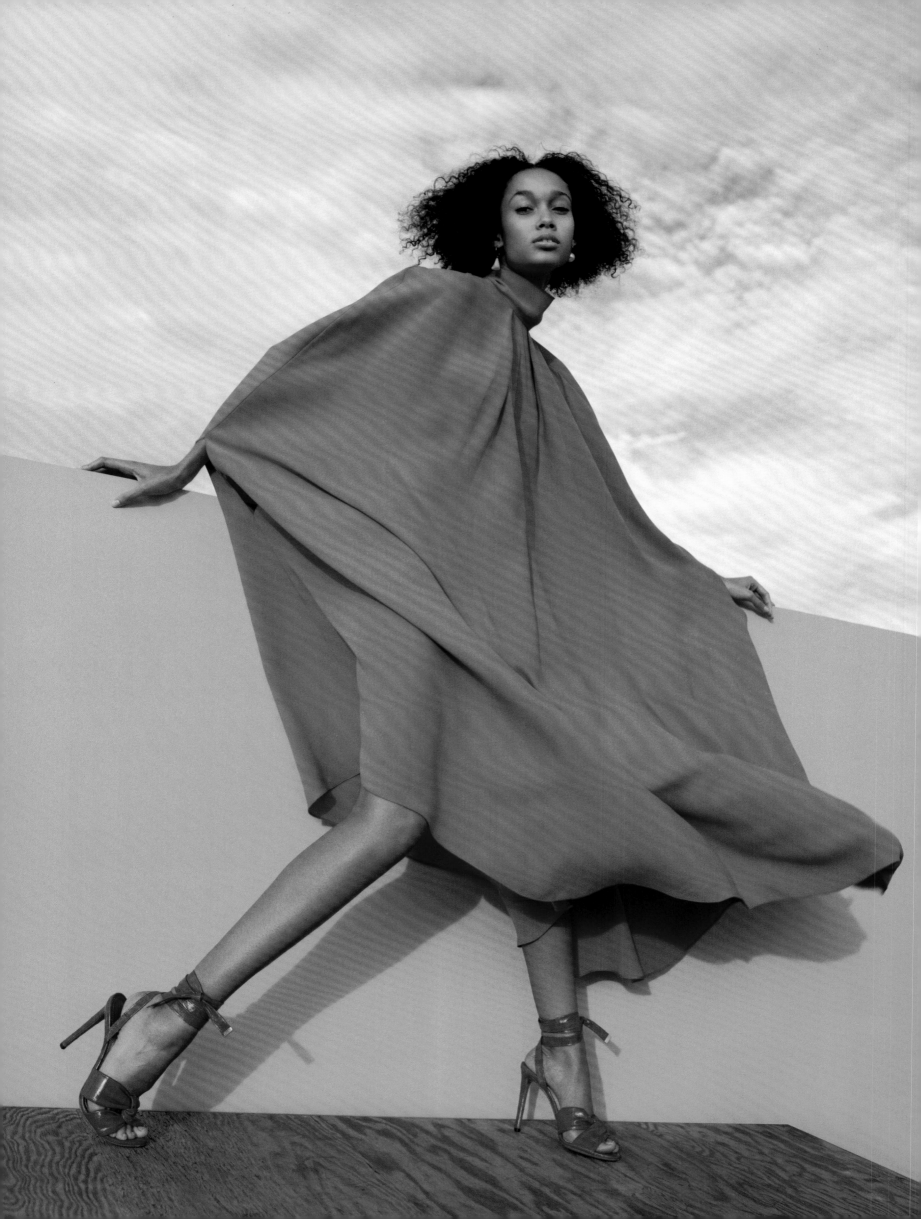

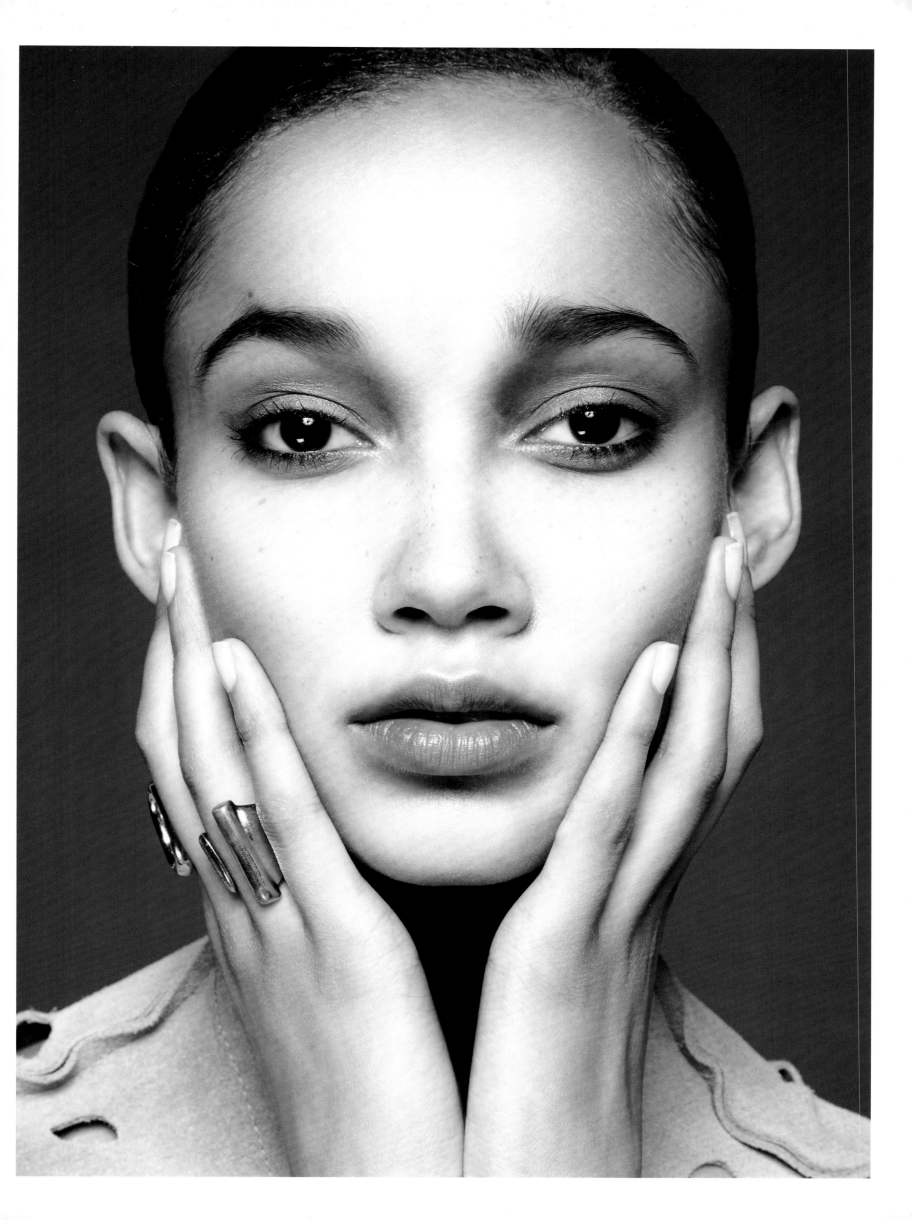

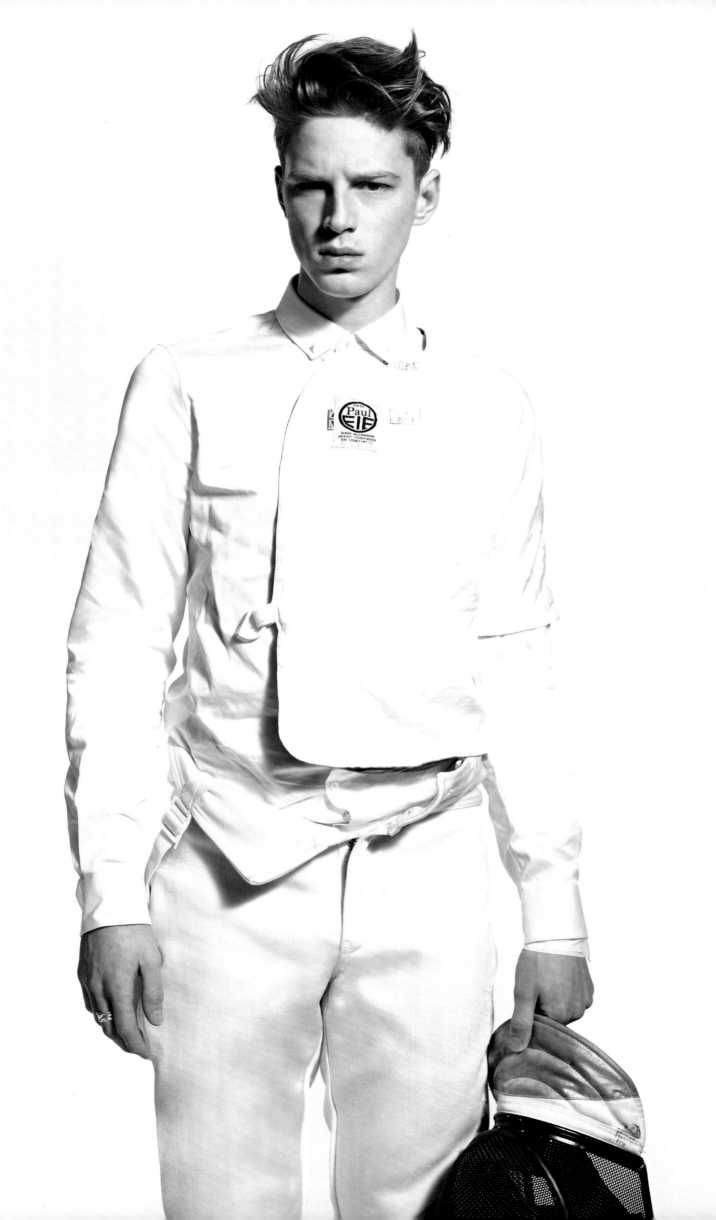

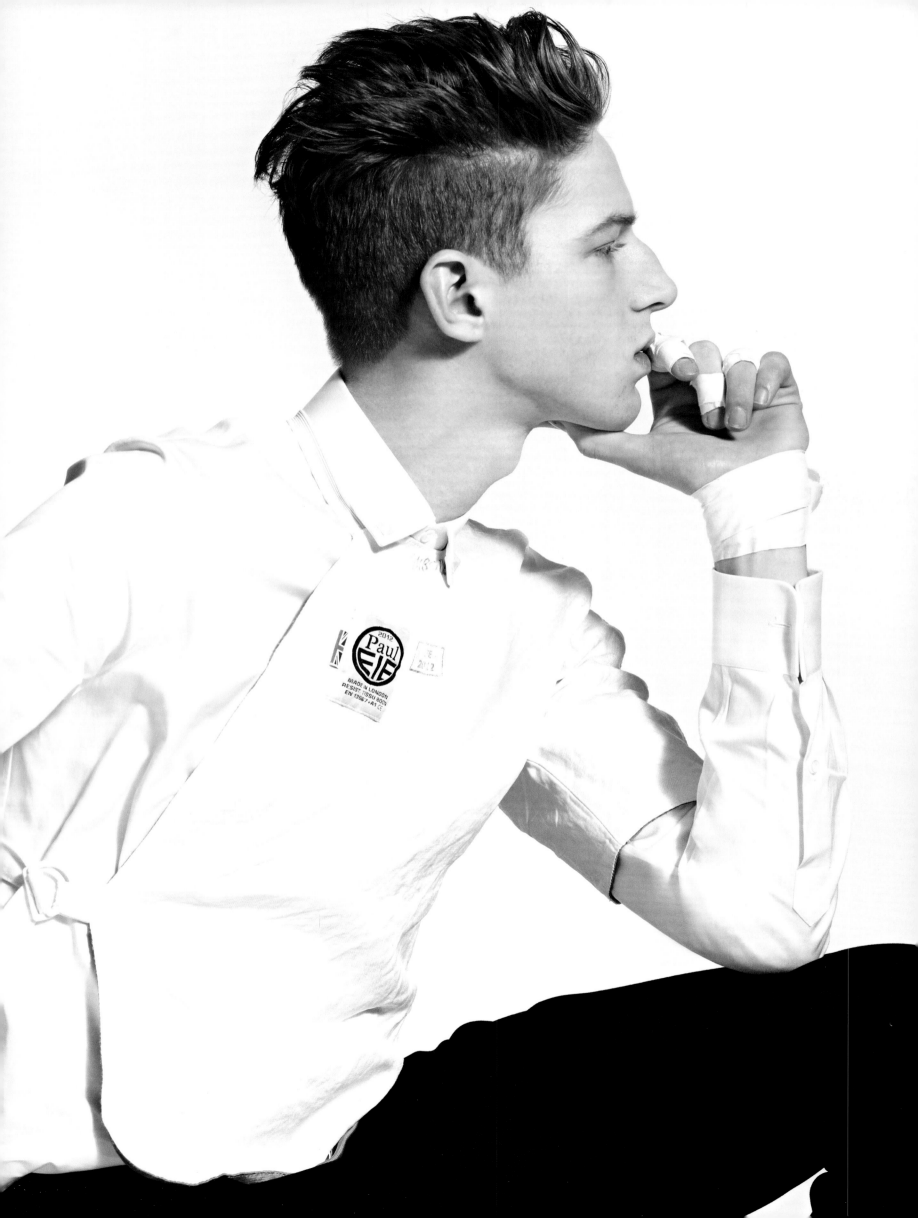

PAGES 128-129: WALLETTE WATSON, 2017 AND 2016
PREVIOUS SPREAD: RACE IMBODEN, 2013
OPPOSITE PAGE: ELIZABETH ERM, 2013
FOLLOWING SPREAD: SORA CHOI, 2016
PAGES 136-139: SOFIA T., 2016
PAGES 140-141: CLARA MCGREGOR, 2017

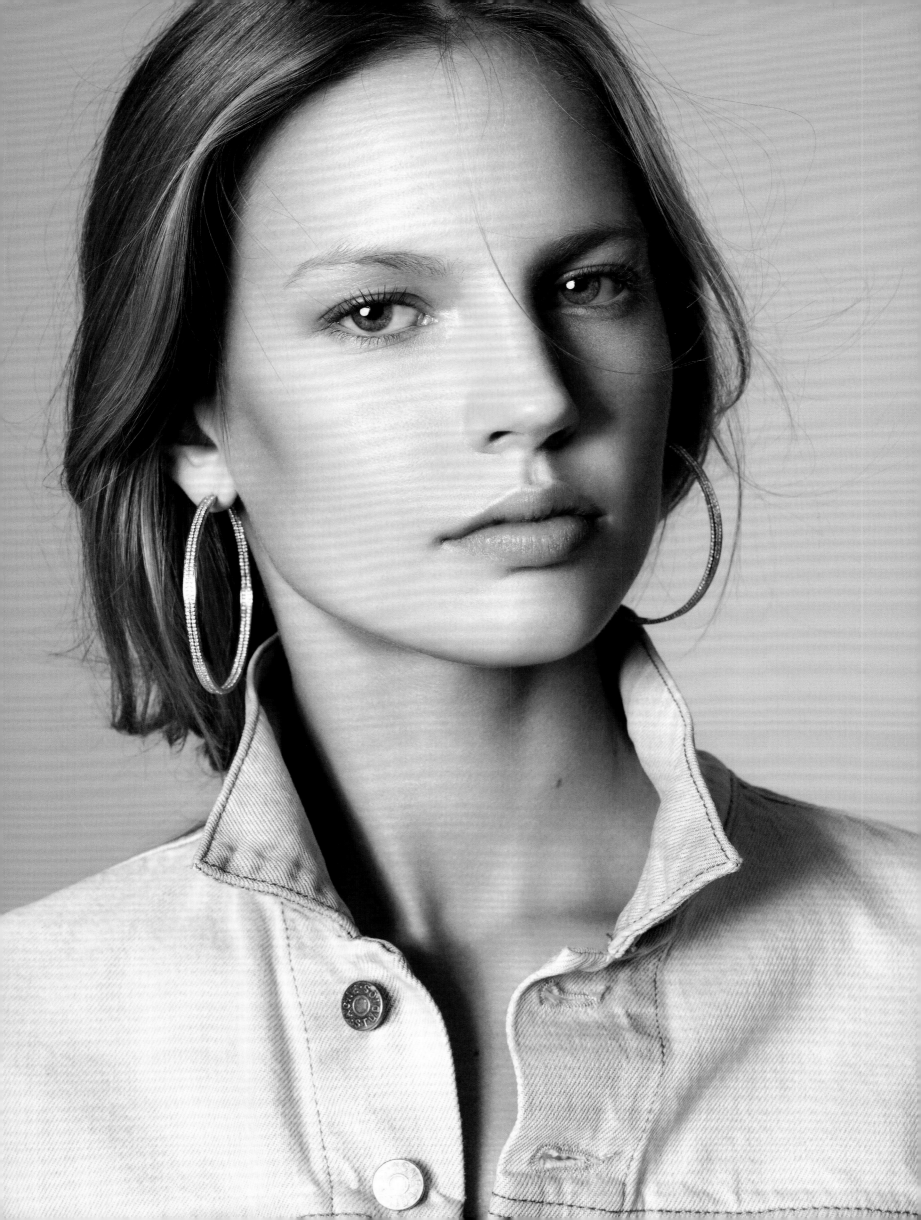

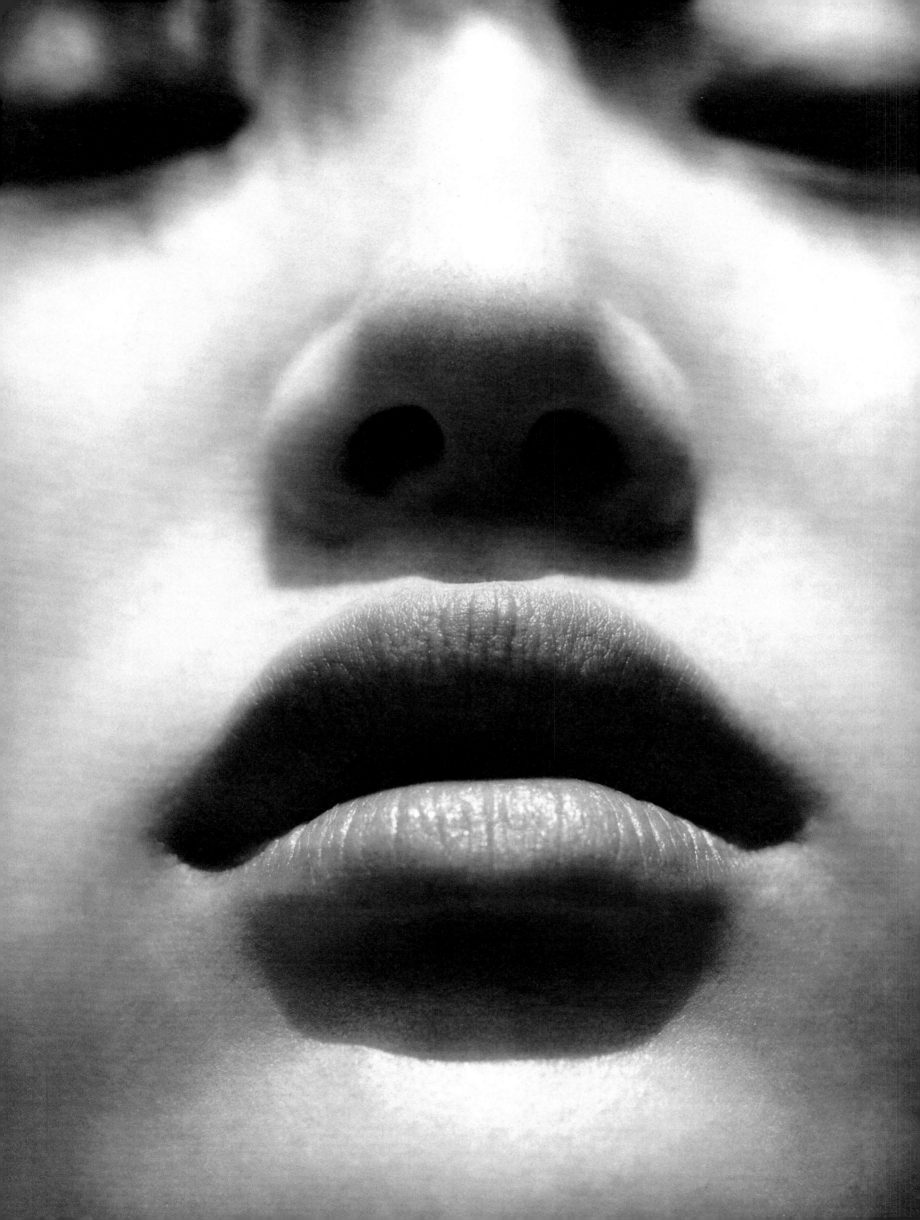

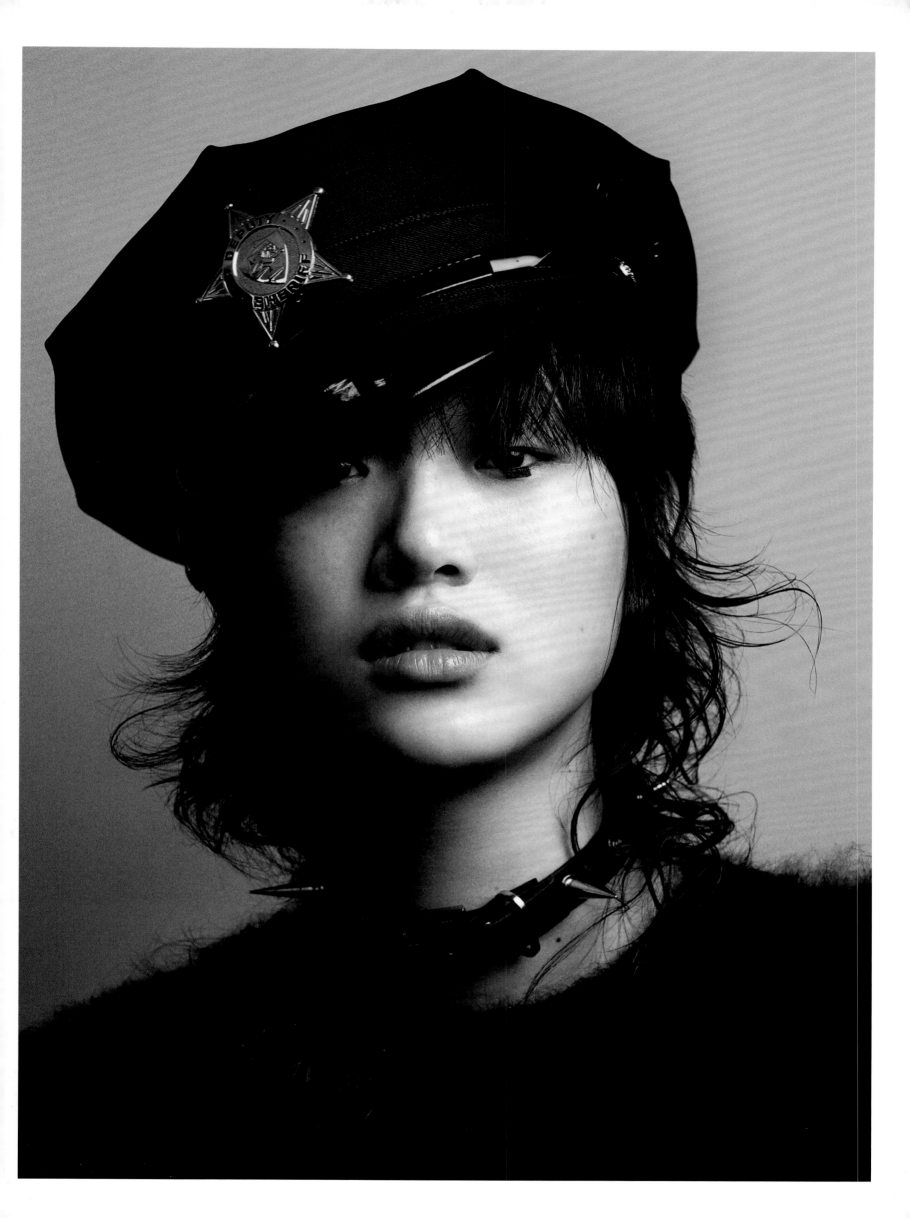

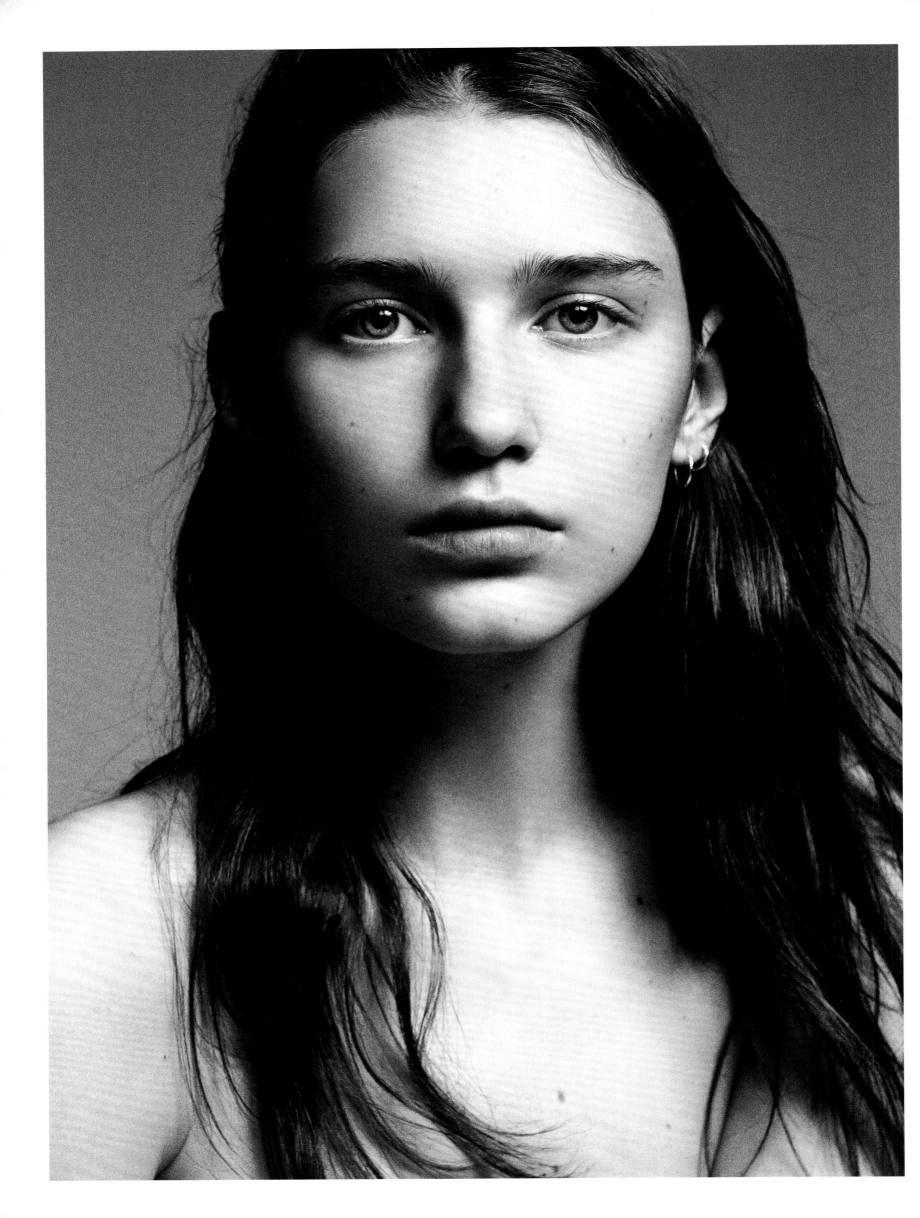

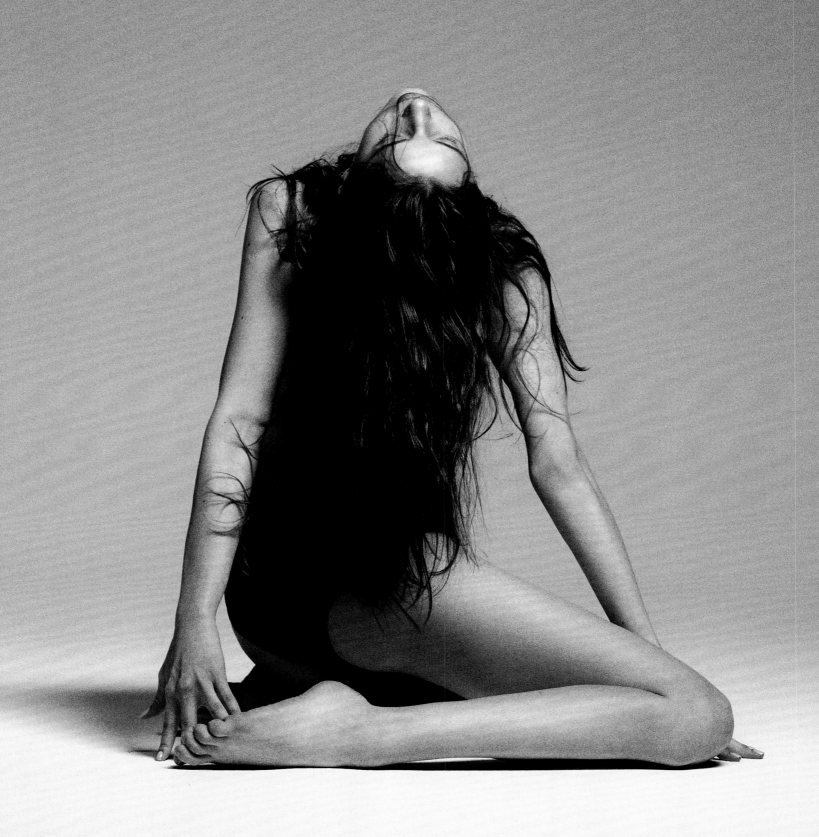

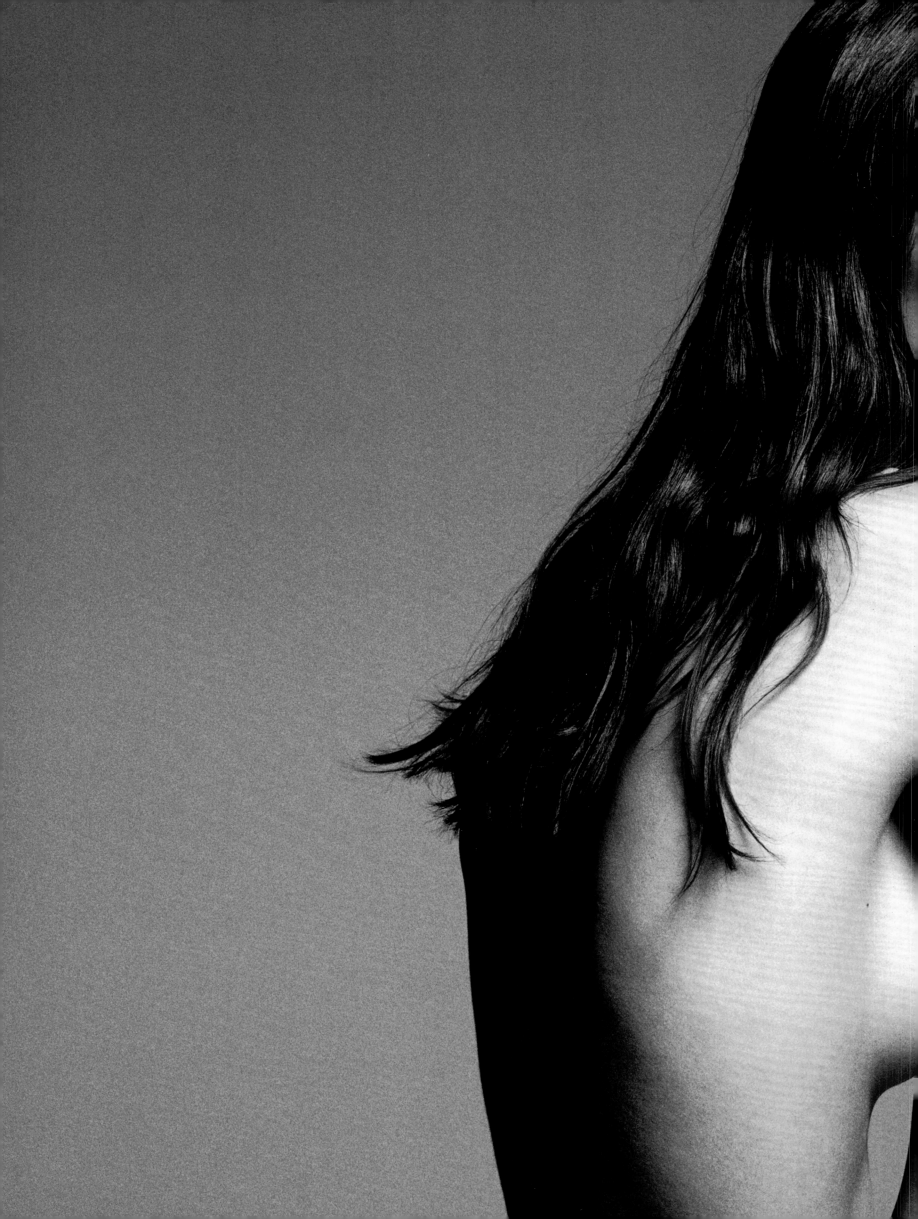

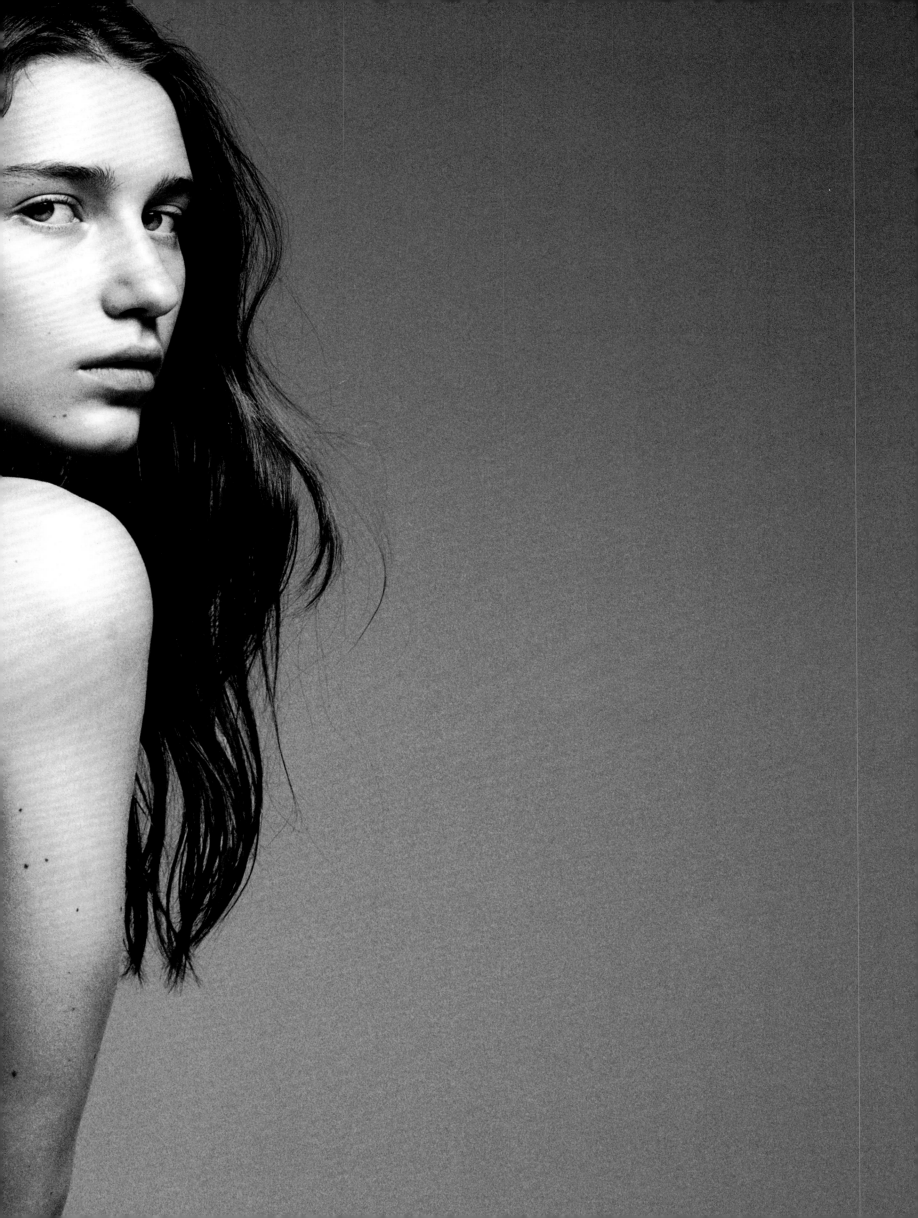

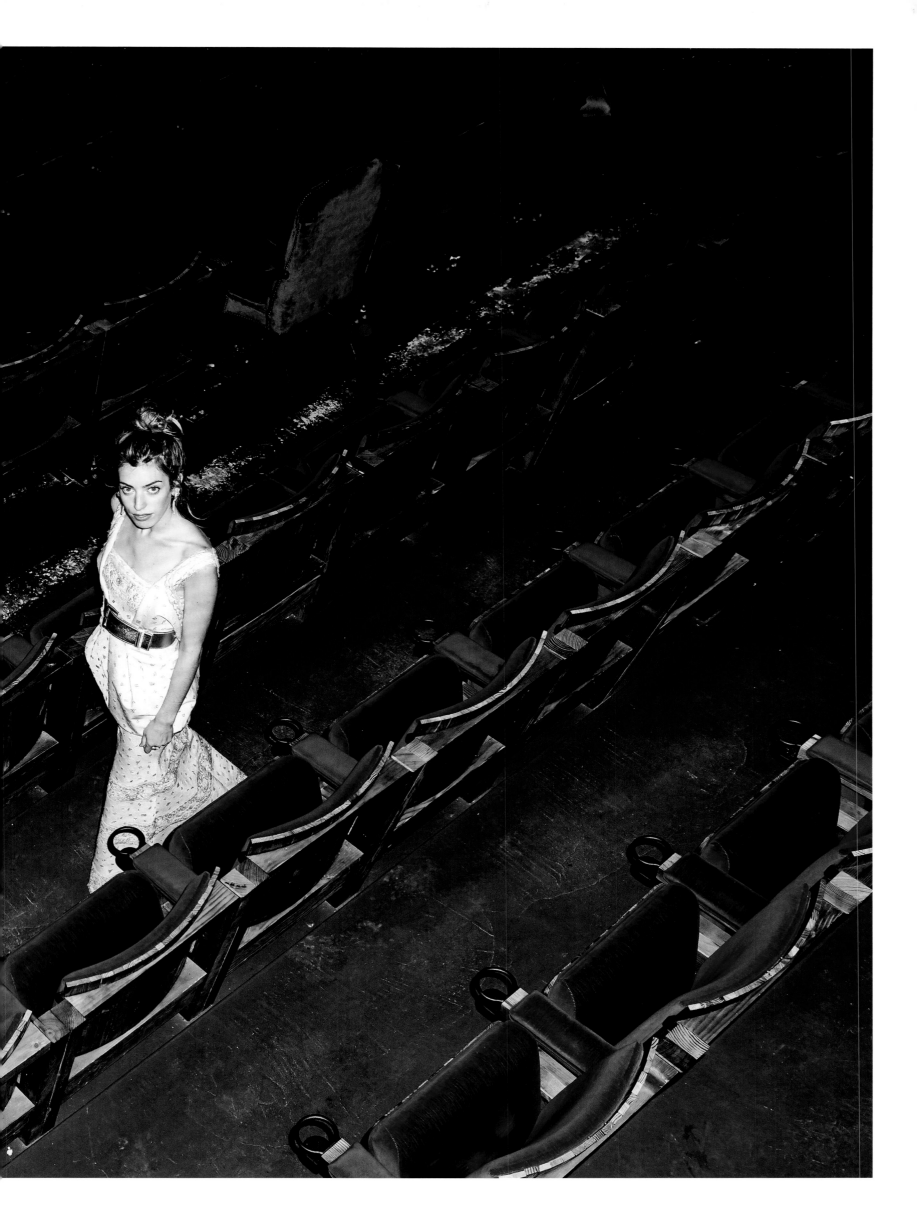

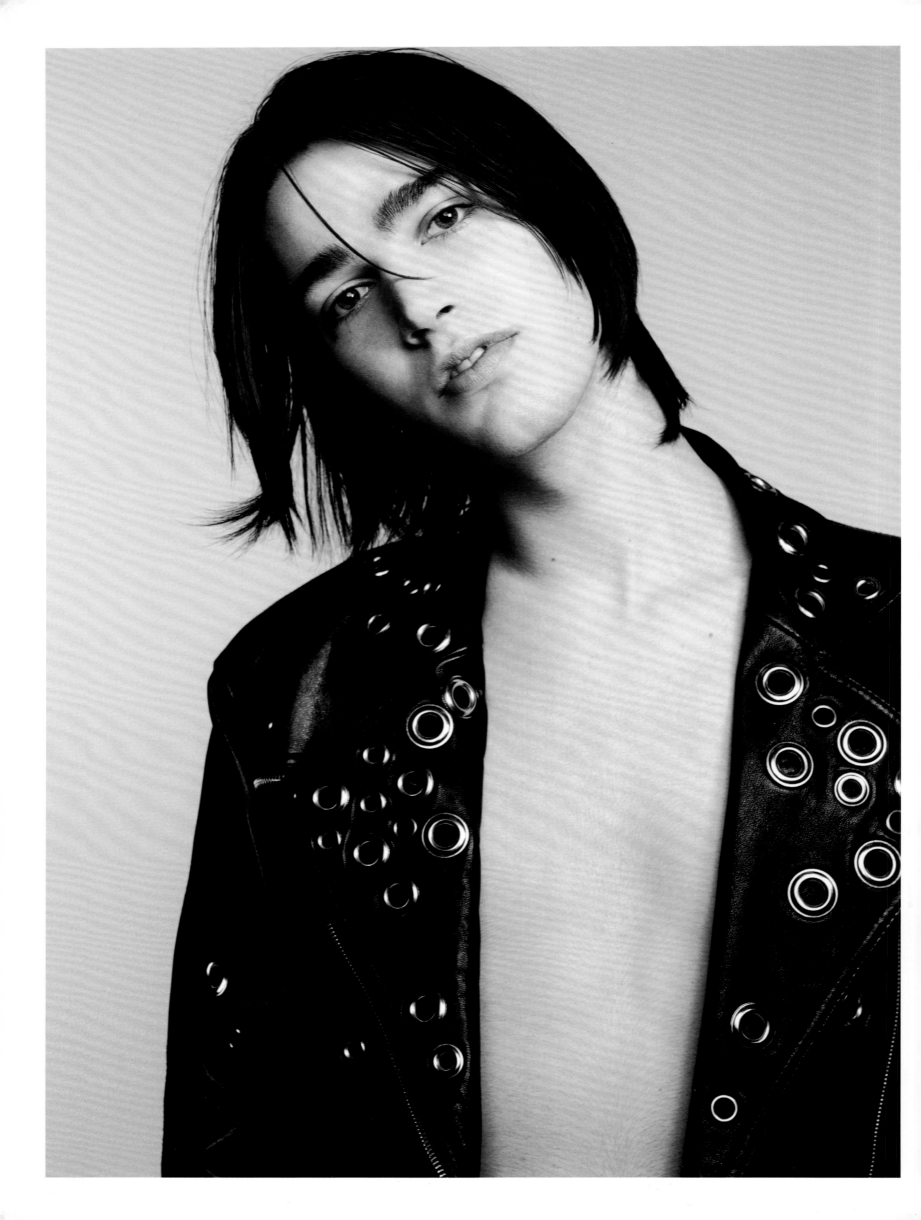

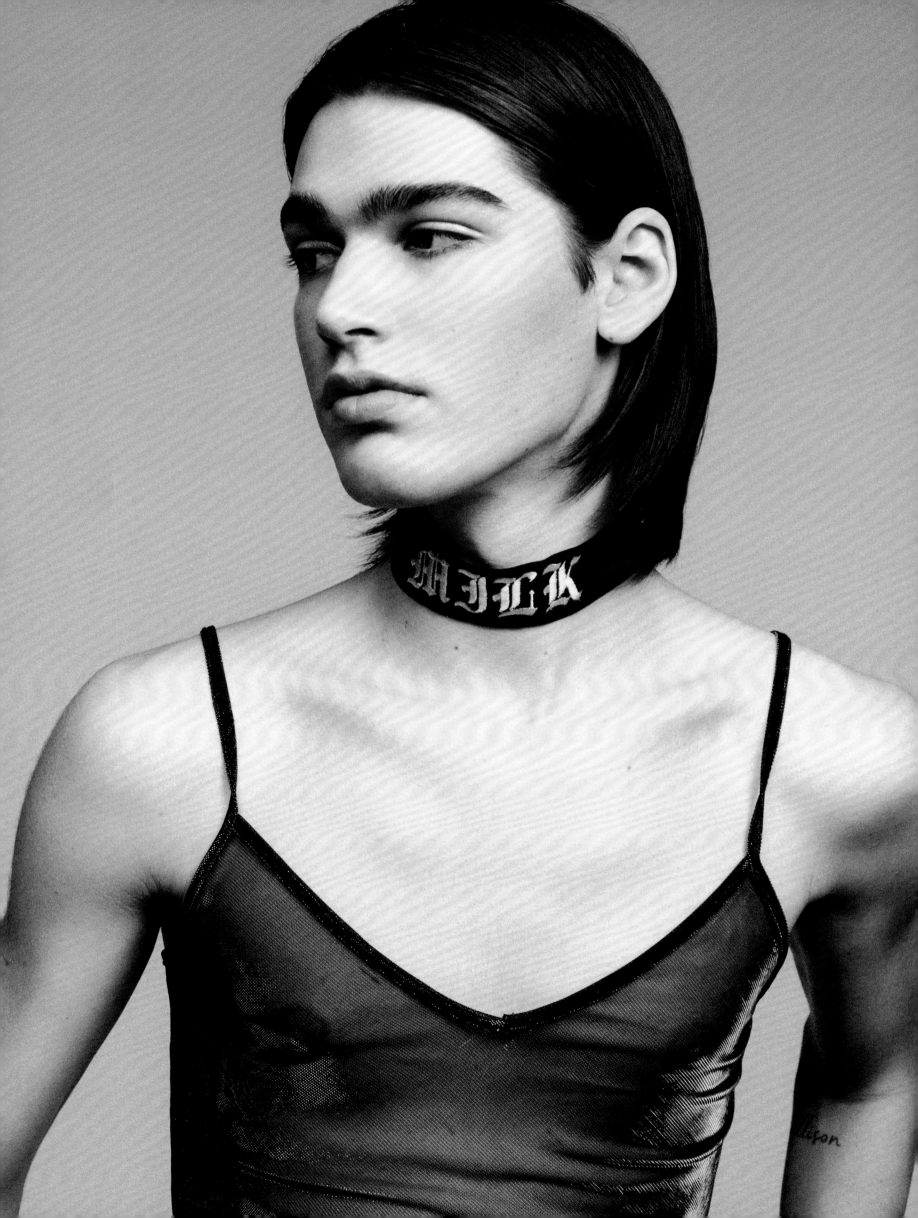

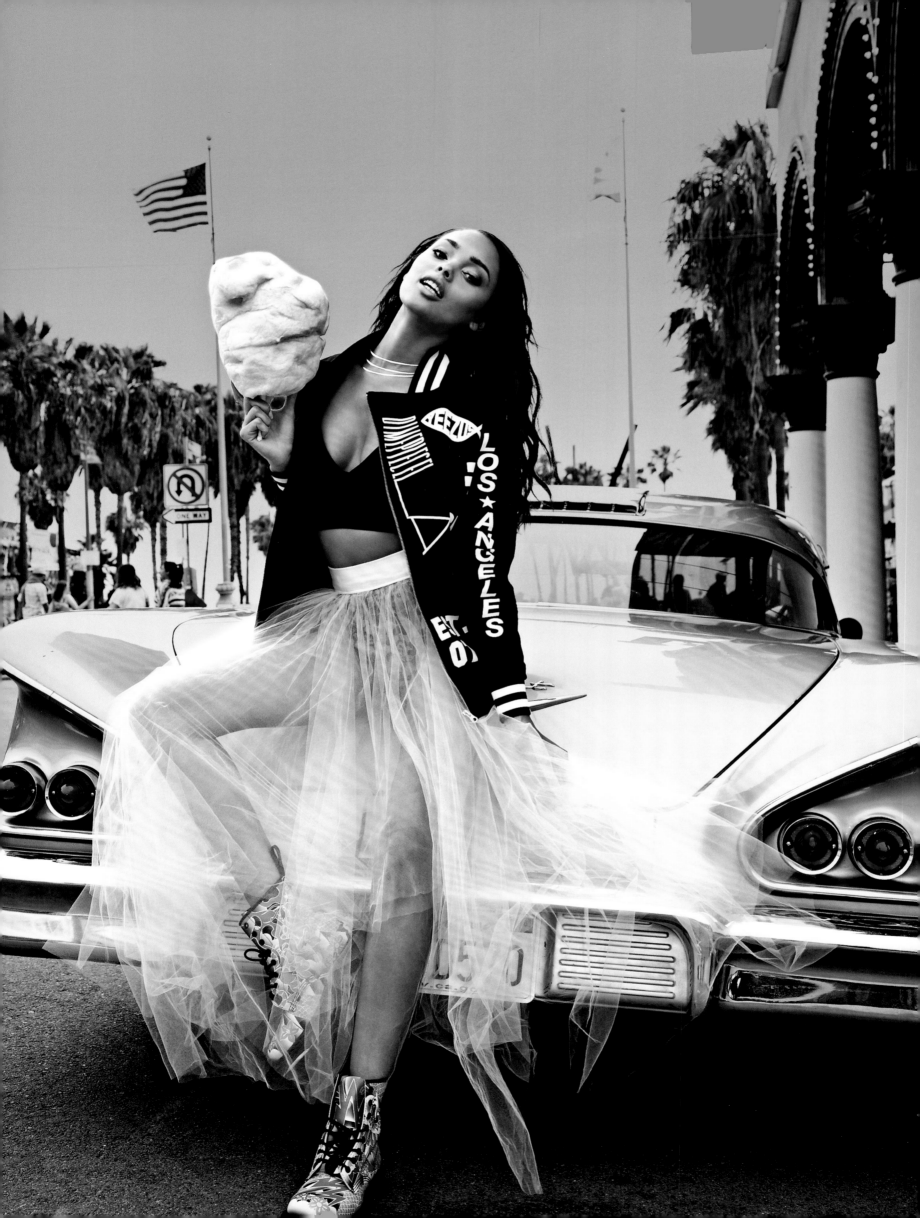

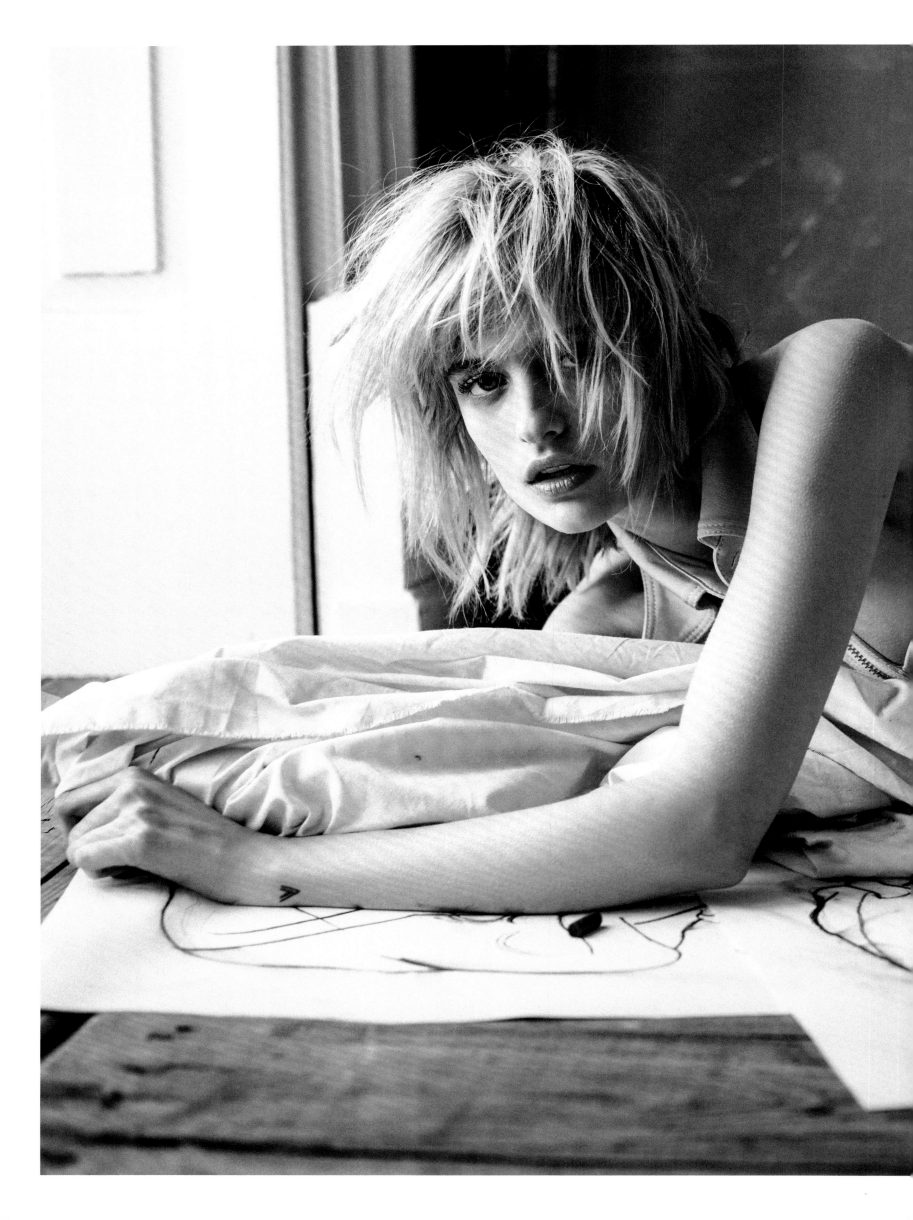

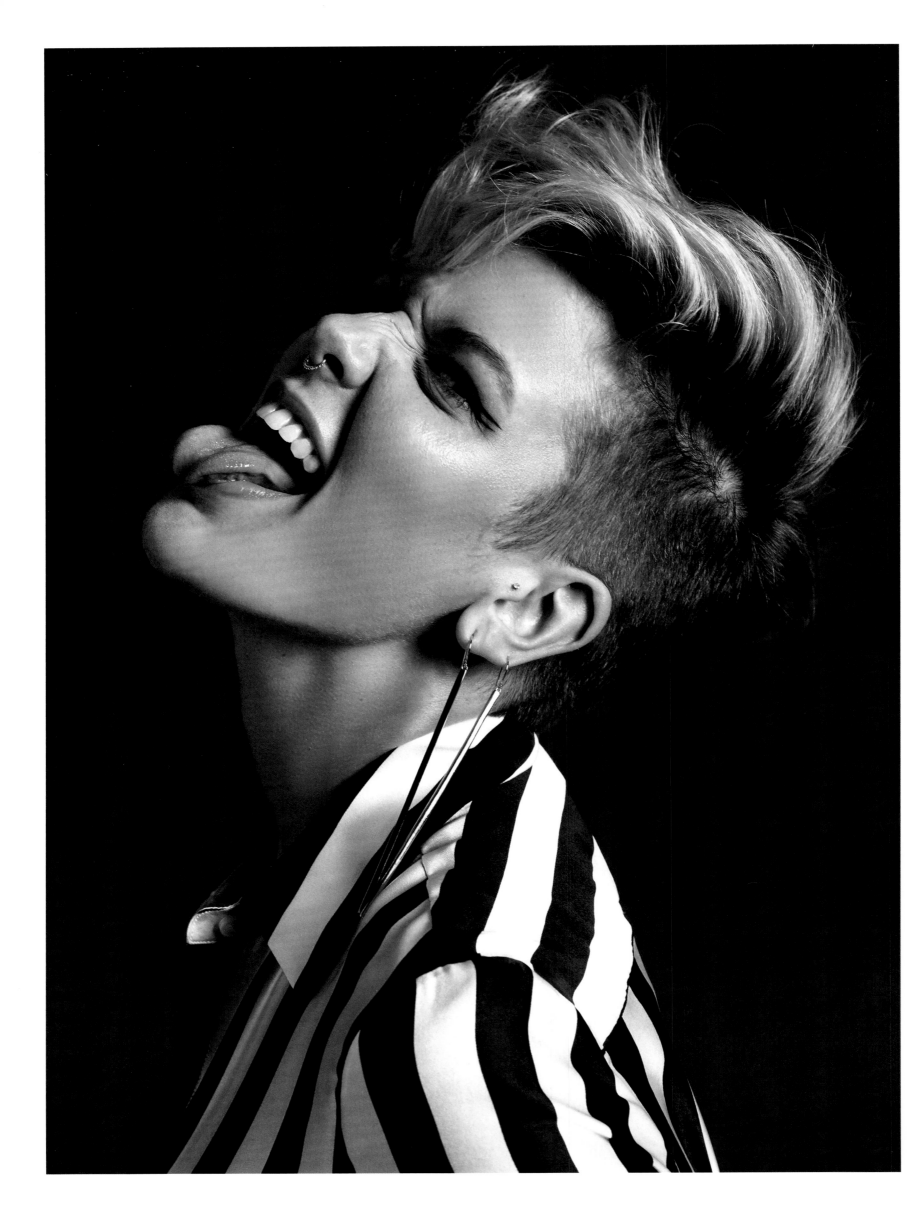

"Rebellion is the only thing that keeps you alive."

–Marianne Faithfull

All About Transformation
THE NETWORKERS

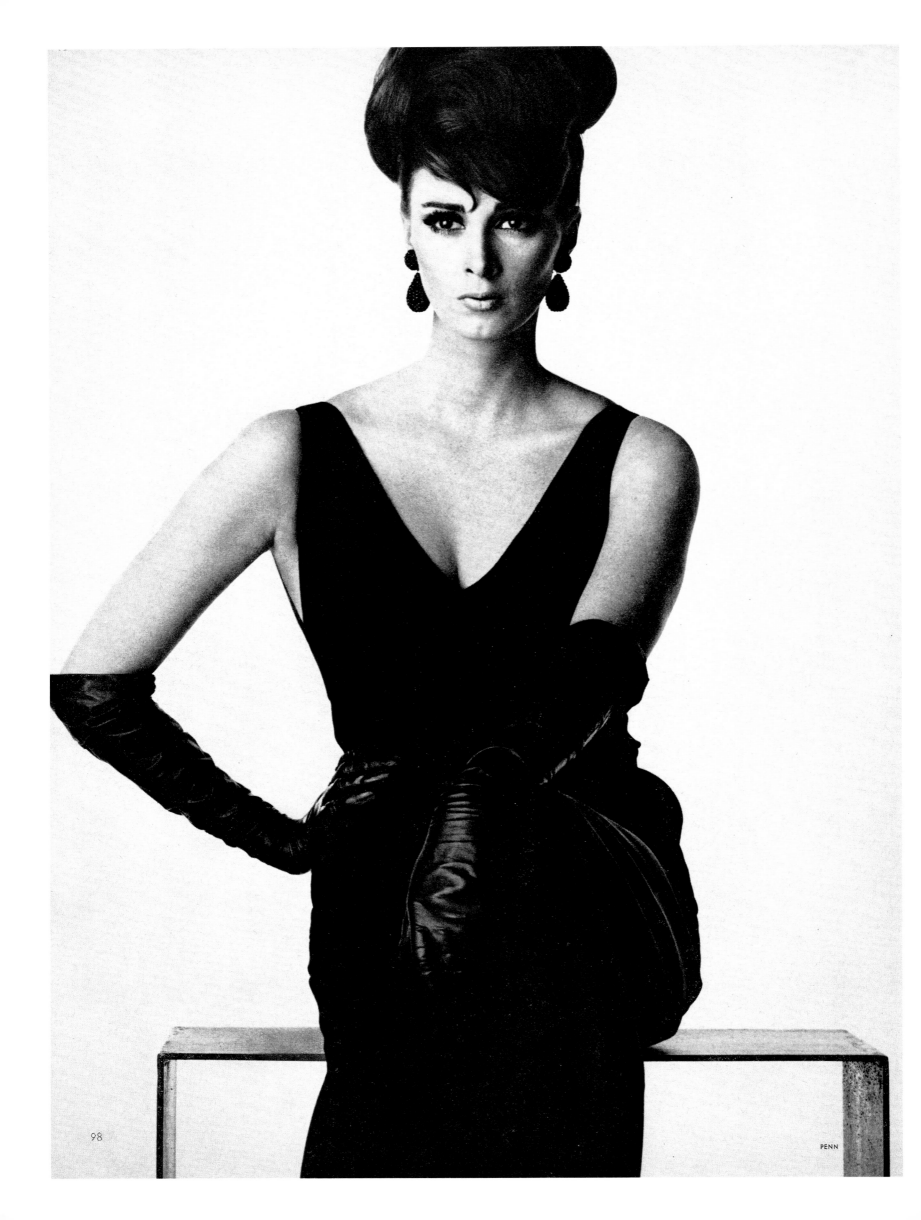

98

PENN

All About Transformation
THE NETWORKERS

"I never thought I'd be some fashion mogul!" Jessica Simpson famously declared in a *New York* magazine profile, back when sales of her fashion collection had reached an astounding $750 million a year. Flash forward only a few years, and the Jessica Simpson brand had topped the $1 billion mark, a rarity even among traditional designer megabrands.

Certain stars have the ability to transform perceptions right before our eyes, and Simpson, whose notoriety was largely fueled by televised classic dumb-blonde quips ("I know it's tuna, but it says 'Chicken by the Sea'"), has proven herself in reality to be not only a clever businesswoman, but also one of the ultimate change acts. That her fashion collection has managed to escape the sad fate of those of so many other celebrities (hot, then not) speaks to an elusive quality that is shared by potently powerful women as different as Kate Moss and Kim Kardashian. That is, by not revealing too much, Simpson retains enough of an air of mystery that allows her fans to see in her whatever it is that they most wish to see. And she was smart to create a brand with a similarly broad appeal, recognizing the desires of women beyond the fashion centers of New York and Los Angeles without resorting to clothes that are trendy.

Like mythological creatures, some of the most beautiful creatures of fashion, film, and music are shapeshifters by nature. Long before she was an Oscar-winning actress, and after growing up in Ireland with her father, the director John Huston, Anjelica Huston was for many years one of the most sought-after models in fashion, inspiring photographers from Richard Avedon to Bob Richardson. "There's room for those of us who are born with profiles and complicated faces," she said in *Allure* magazine. "I was able to take advantage of a time when unusual become something to be coveted."

You might be surprised by how many major stars began their careers in front of a fashion photographer's camera. Jessica Lange, for one, was modeling with Wilhelmina in the 1970s to make ends meet when the film producer Dino De Laurentiis contacted the agency looking for an actress to star in *King Kong*. And look back at the sparkling images of Whitney Houston, who began her modeling career when she was only sixteen years old, and you will see a million-dollar smile that would later reveal one of the most sensational voices of the twentieth century. For the record, her Wilhelmina comp card revealed Houston was 5'8" and had a 34-inch bust, a 26-inch waist, and a 34-inch hips.

OPPOSITE PAGE: ANJELICA HUSTON, 1973
FOLLOWING SPREAD: KARRUECHE TRAN, 2014
PAGES 158-159: TON HEUKELS, 2016
PAGES 160-161: LEONA LEWIS, 2015
PAGES 162-163: REBECCA ROMIJN, 2008

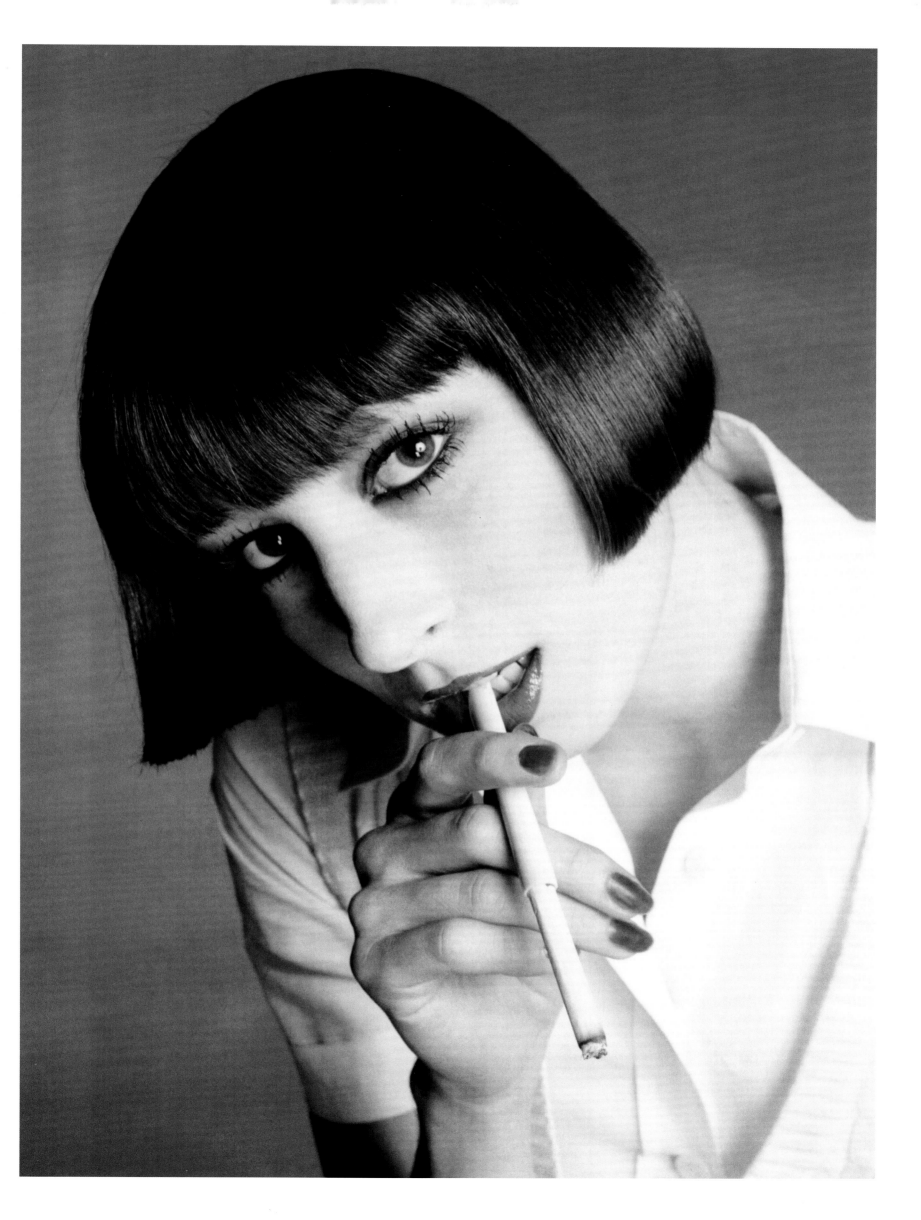

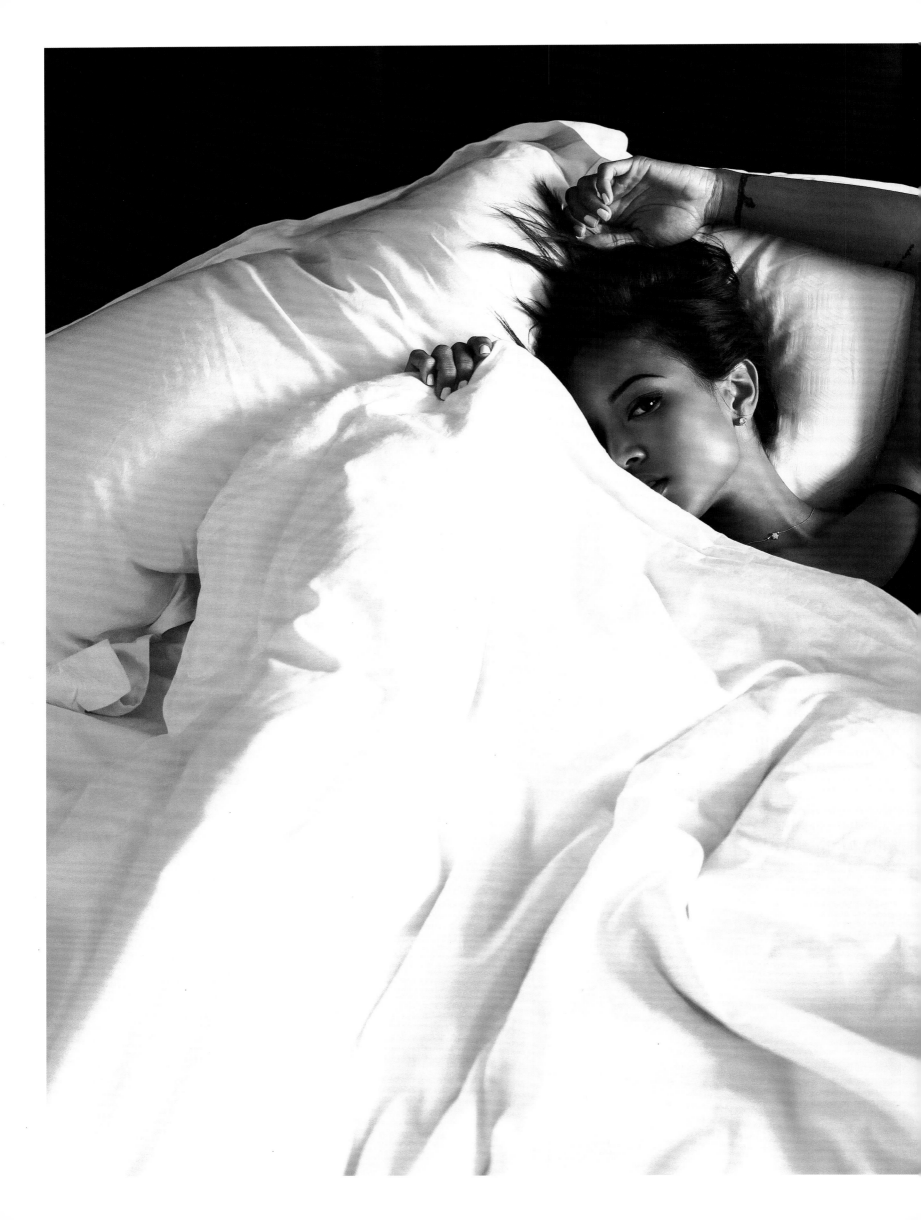

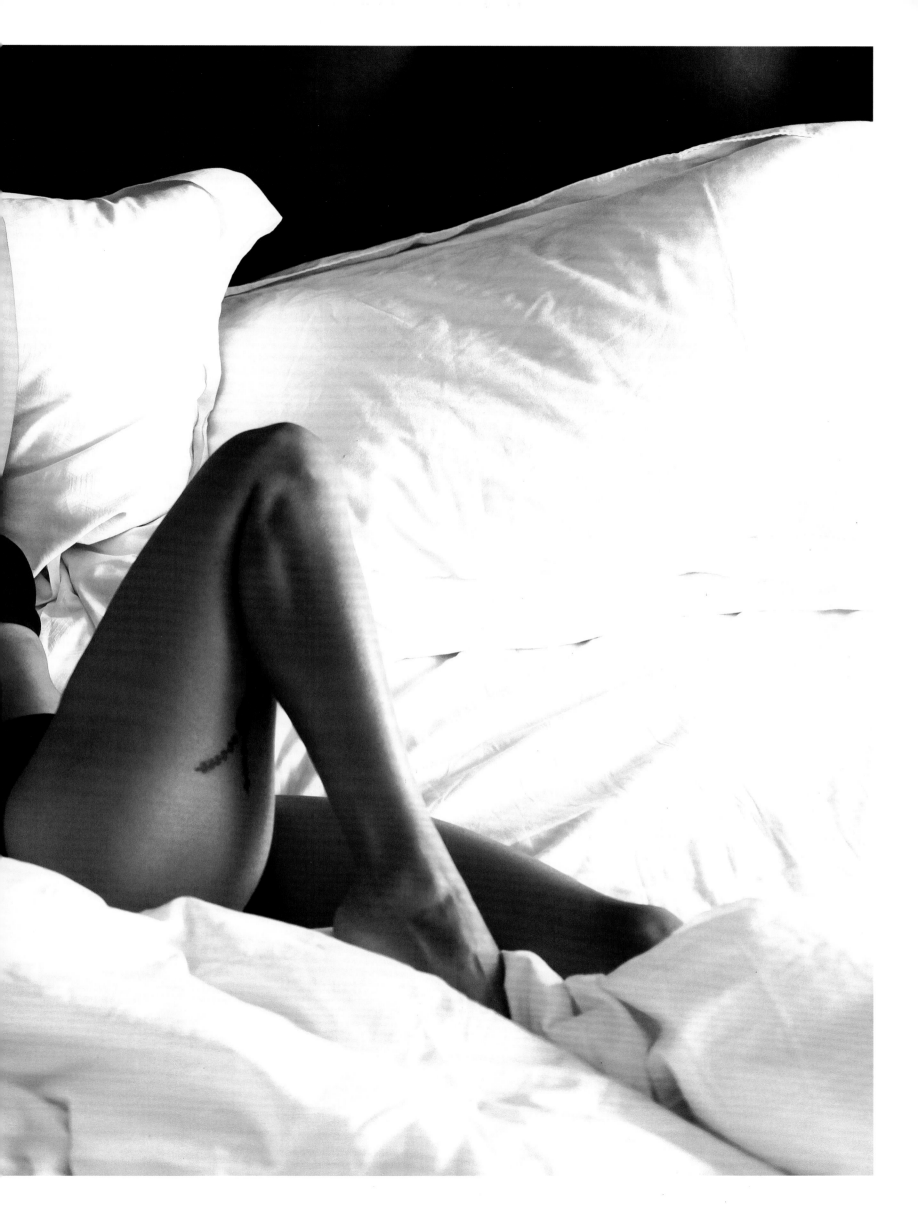

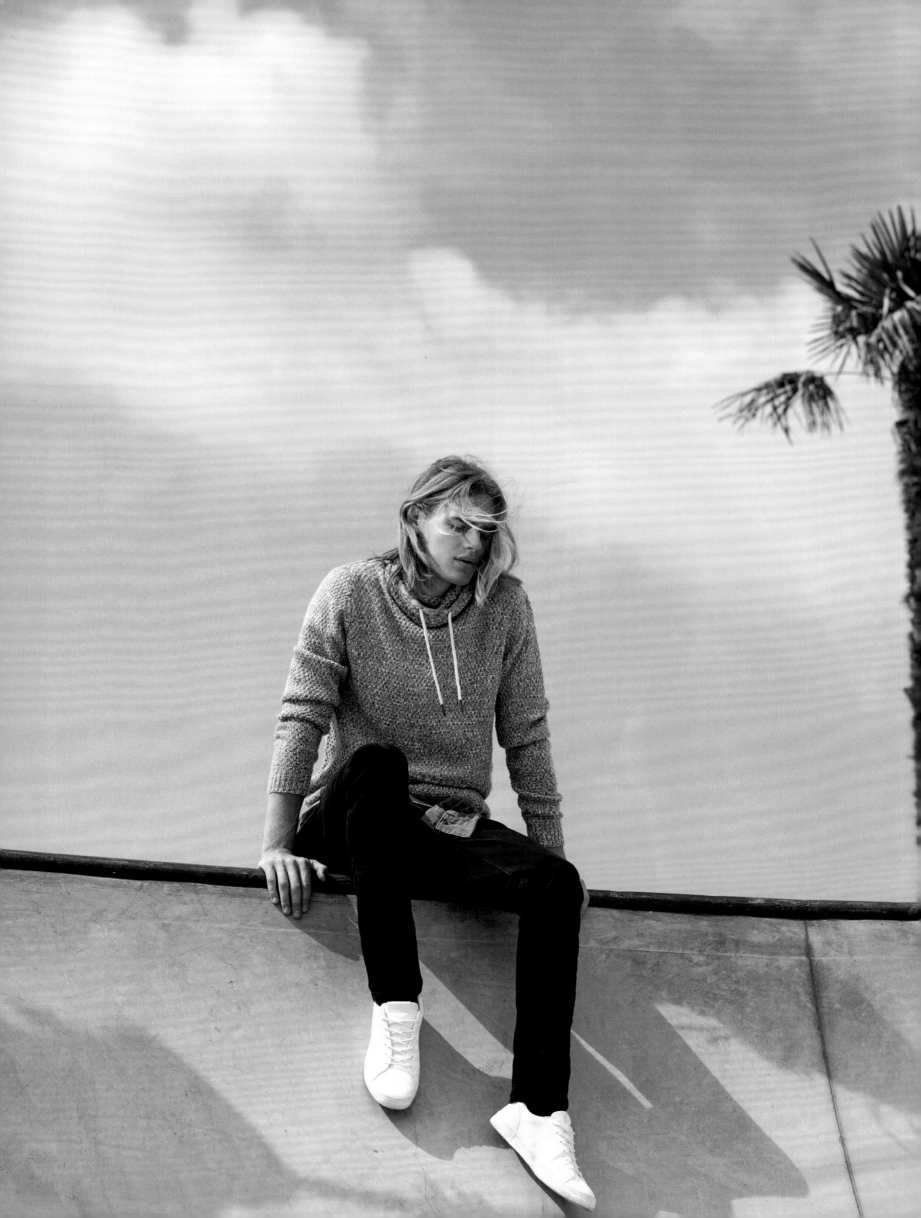

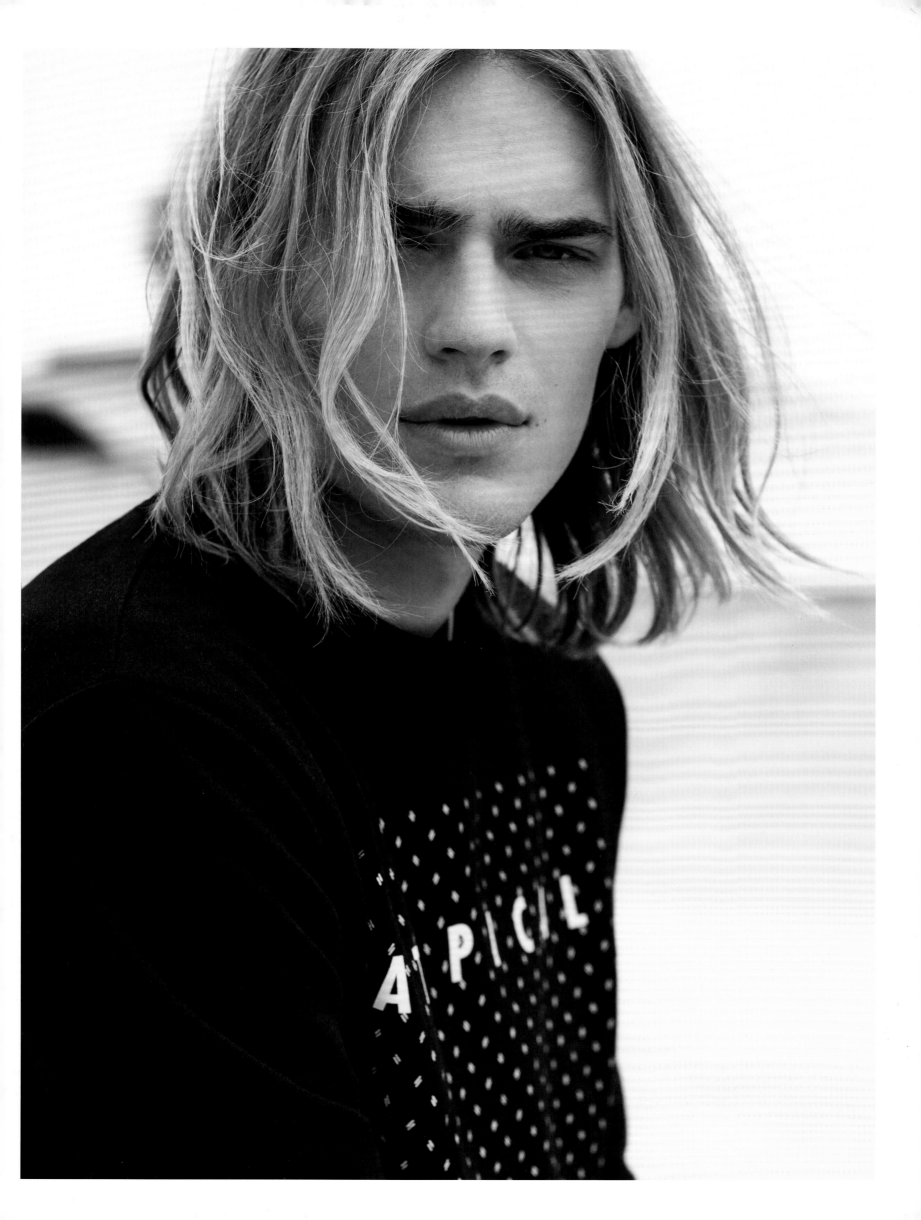

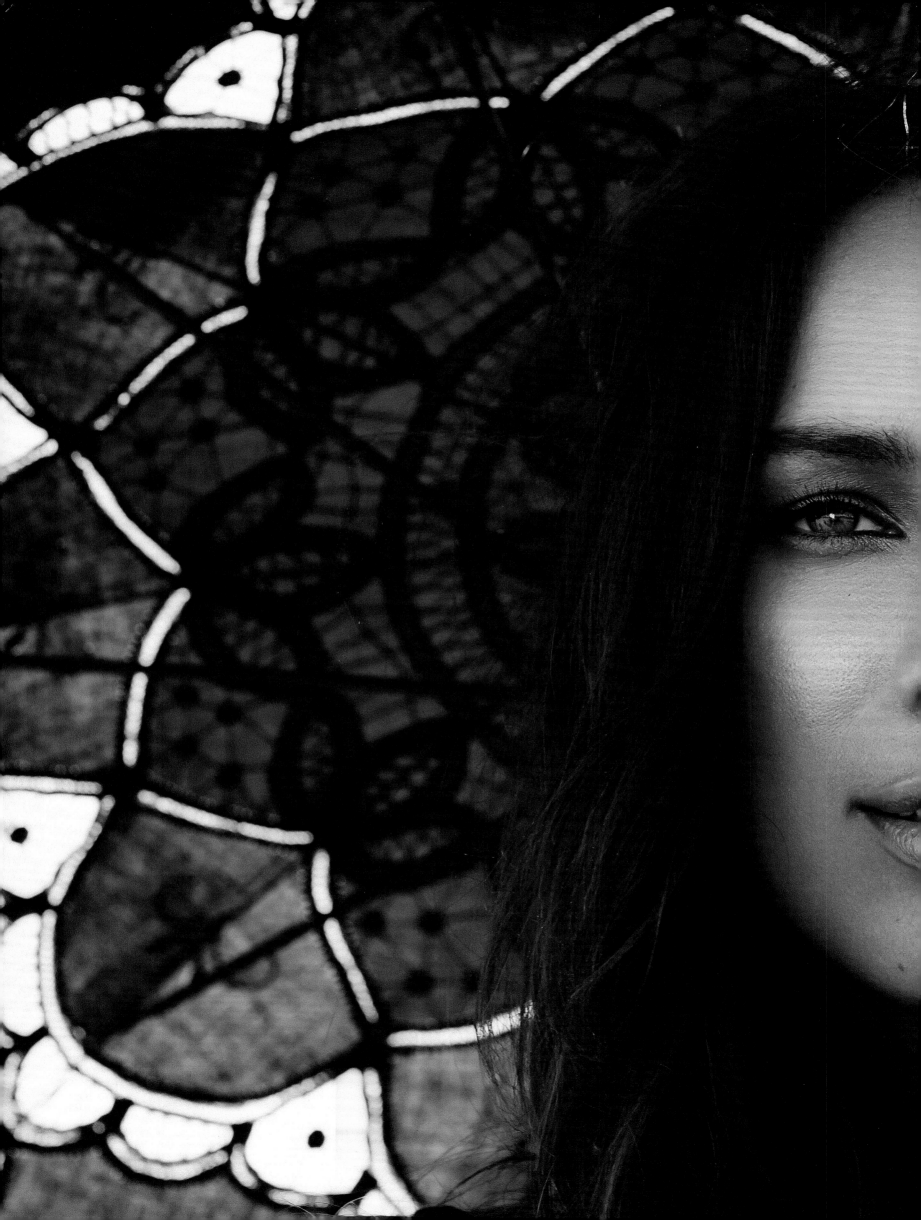

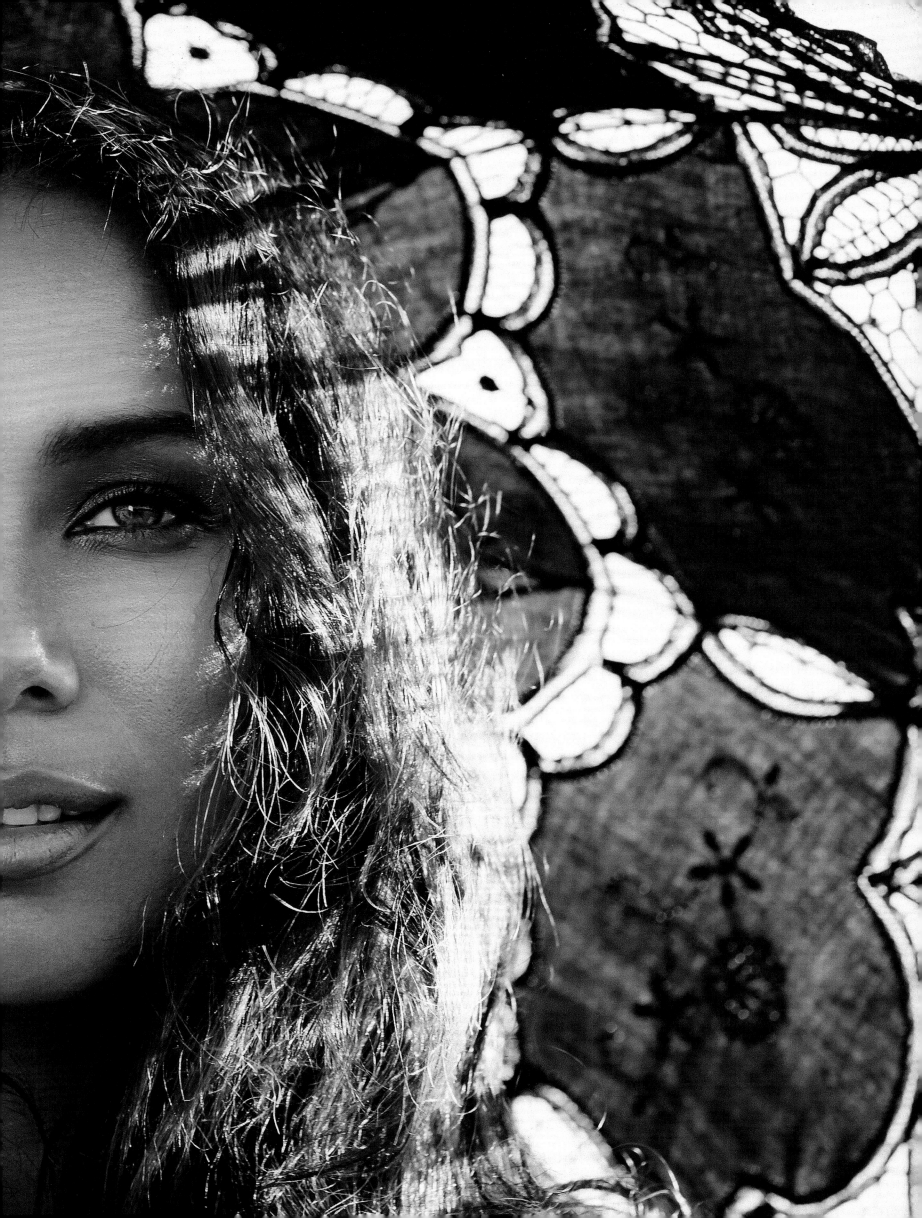

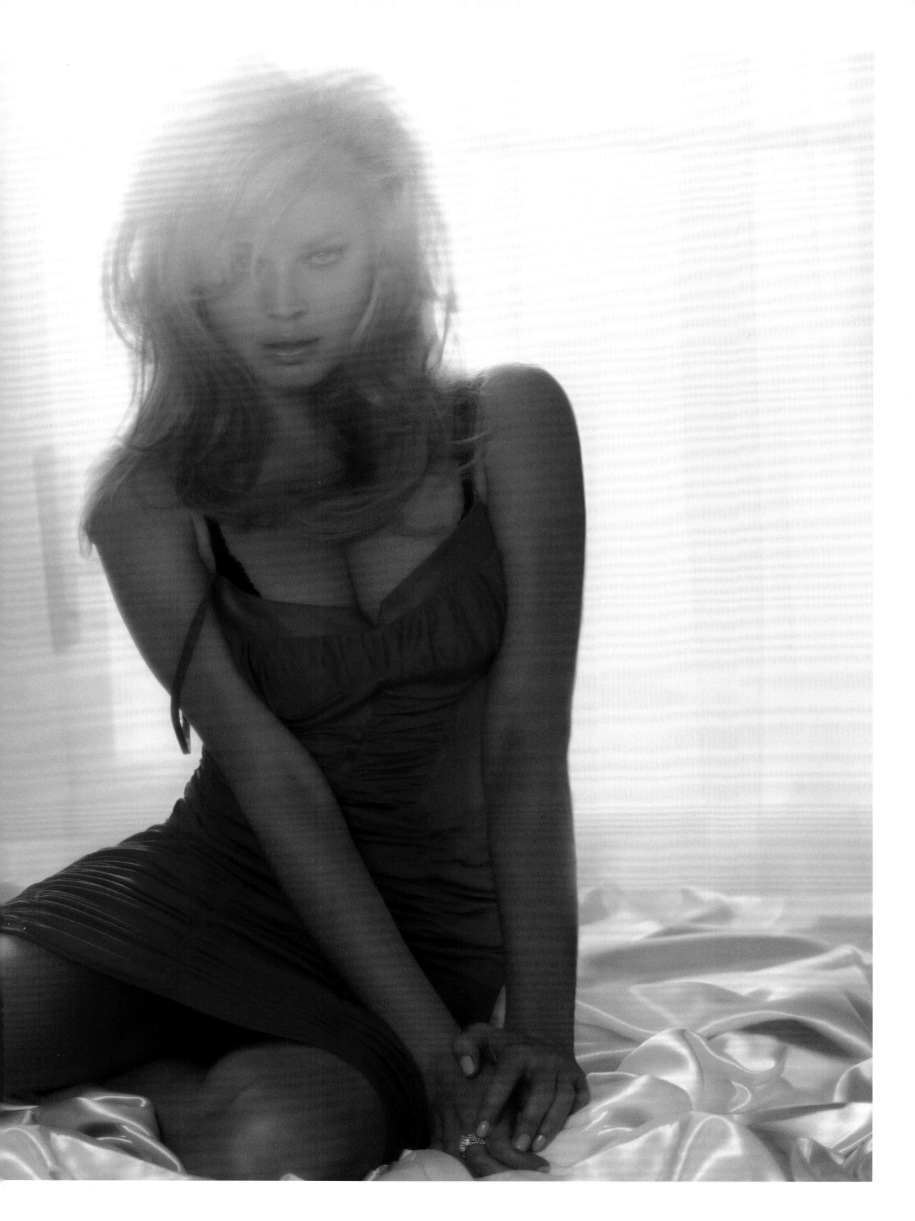

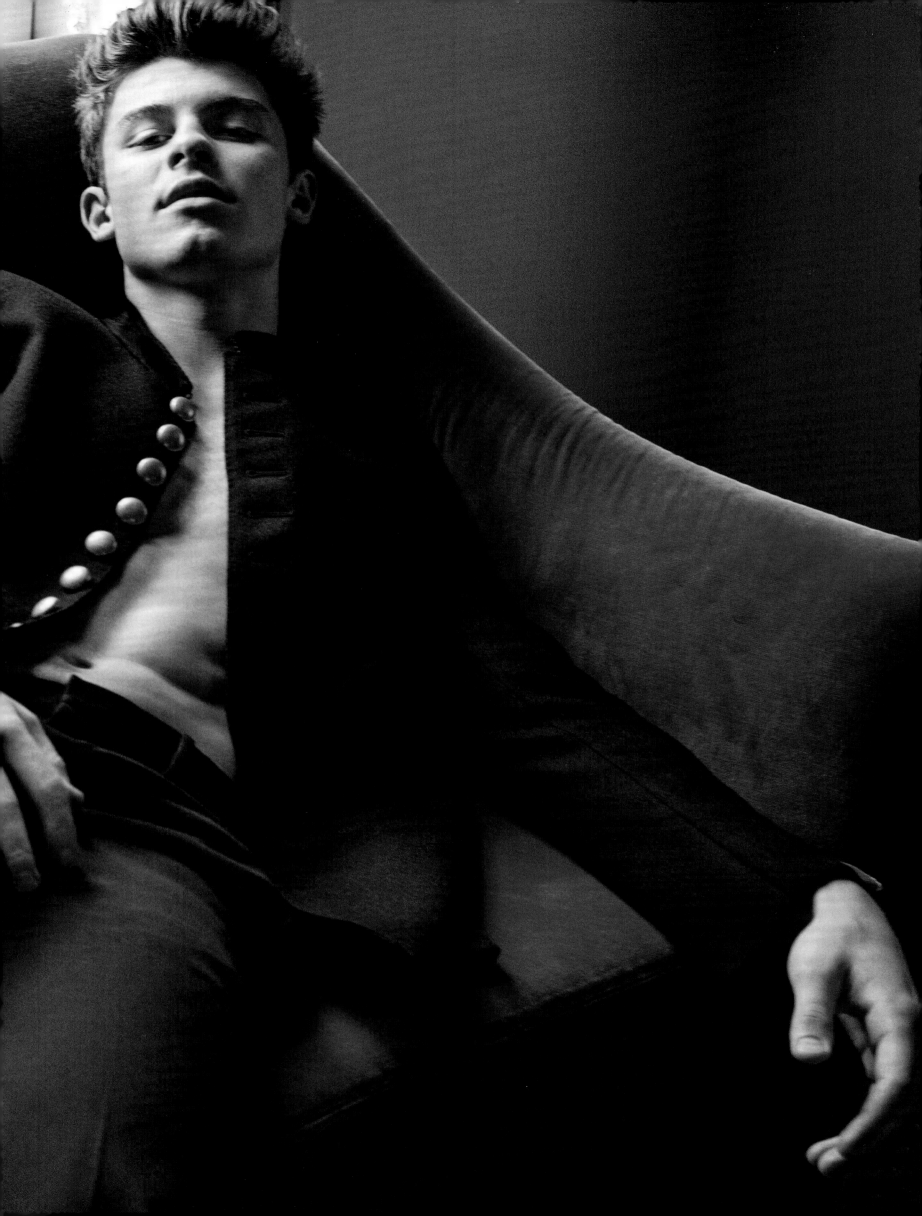

"When you grow up in the music industry, trying to be Britney Spears because that's what sells records and then realize, 'All I have to do is be myself? I should have thought of that a long time ago,' it feels good to have success come from what's actually inside of you."

–Jessica Simpson

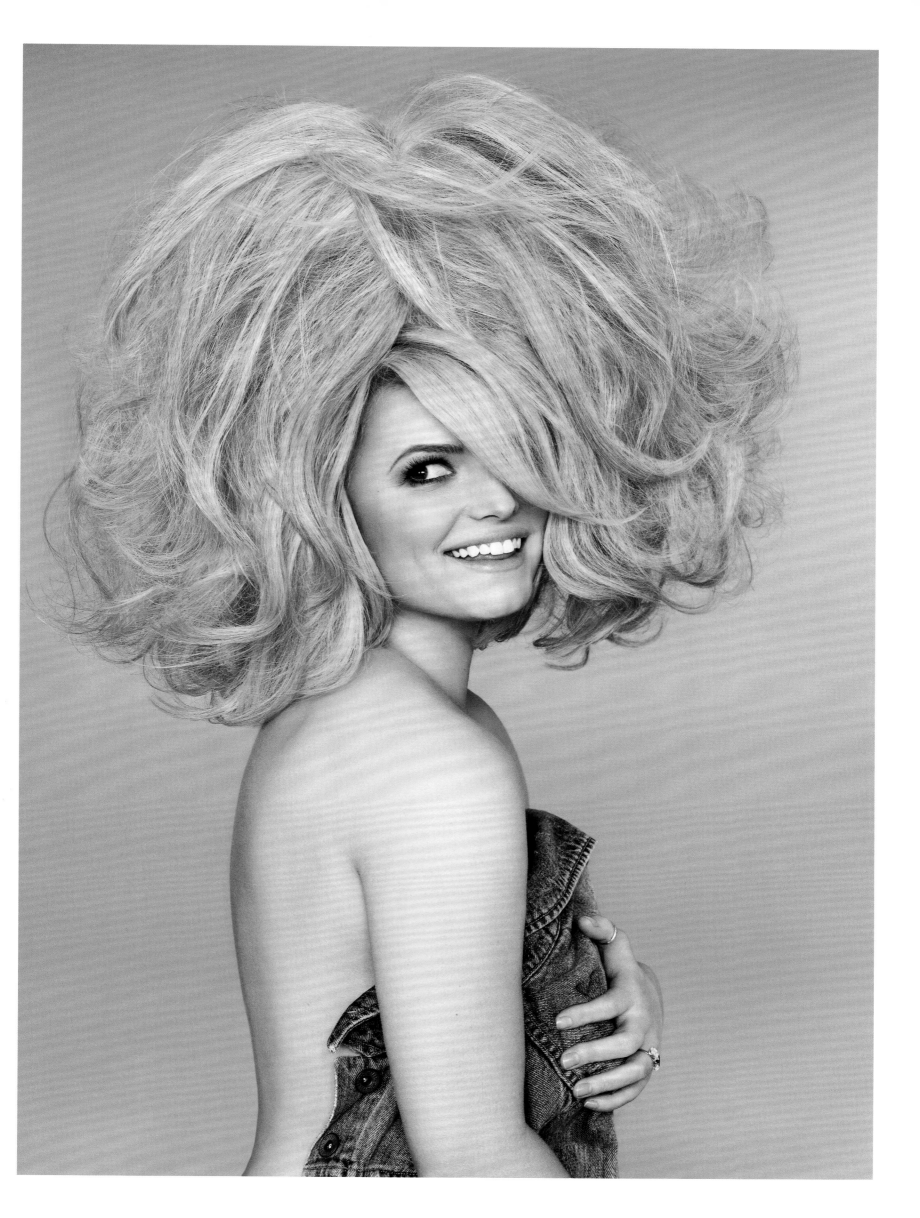

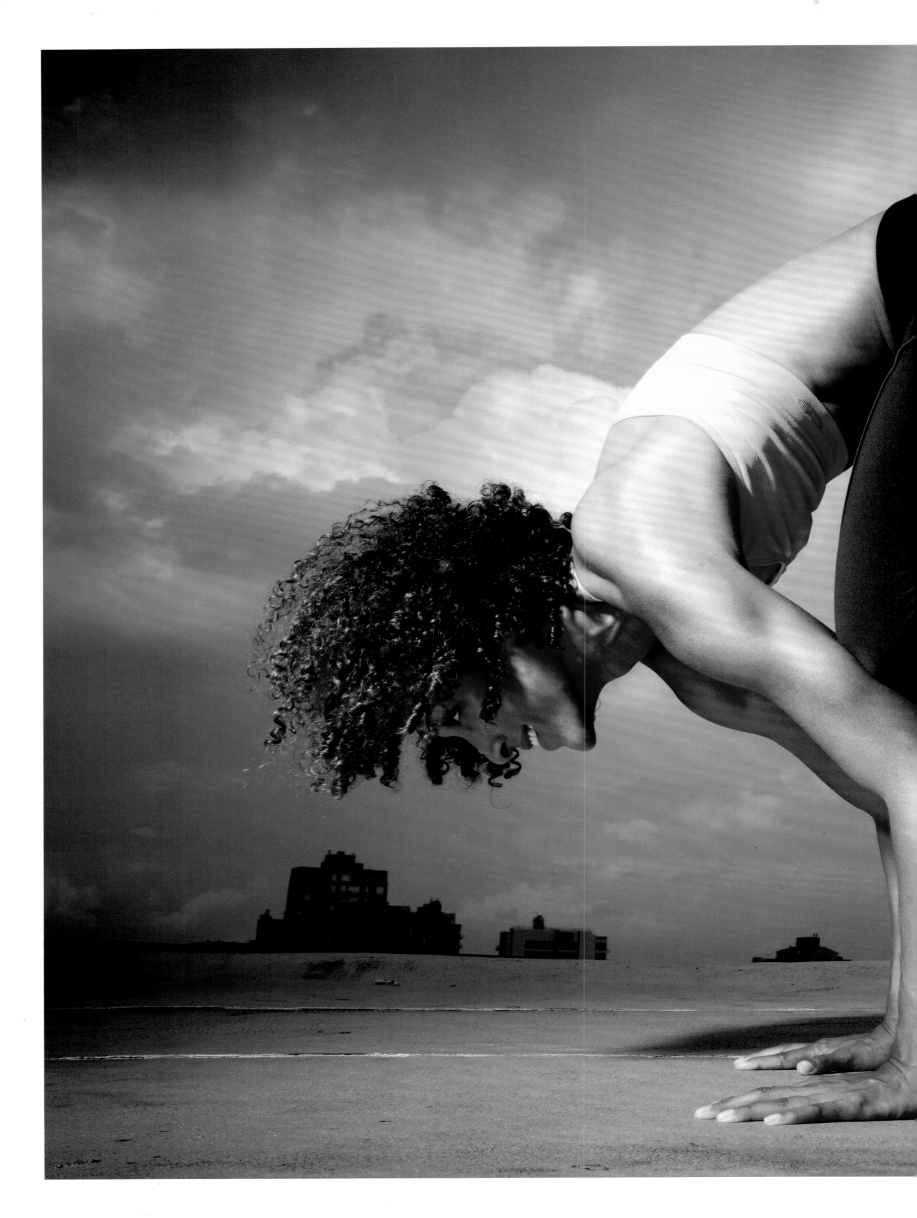

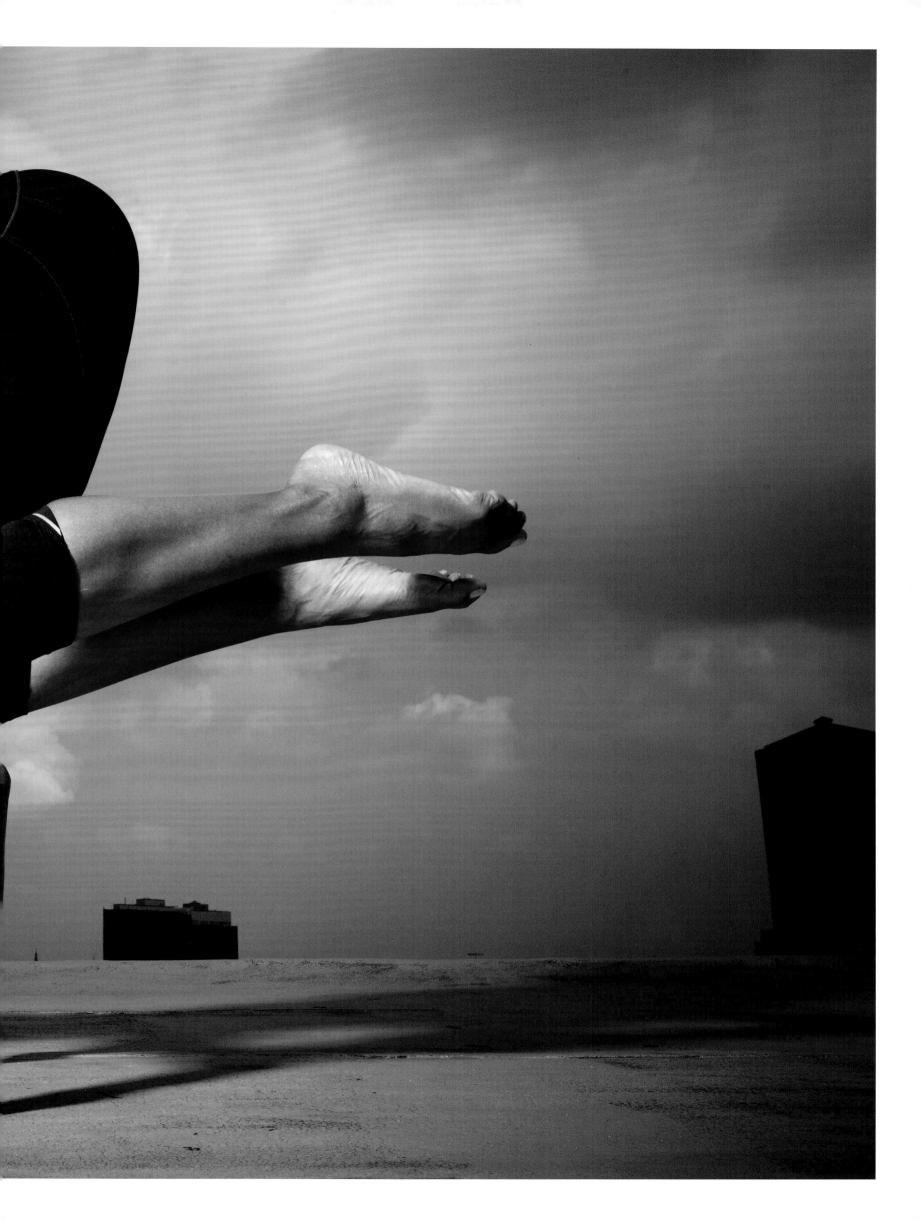

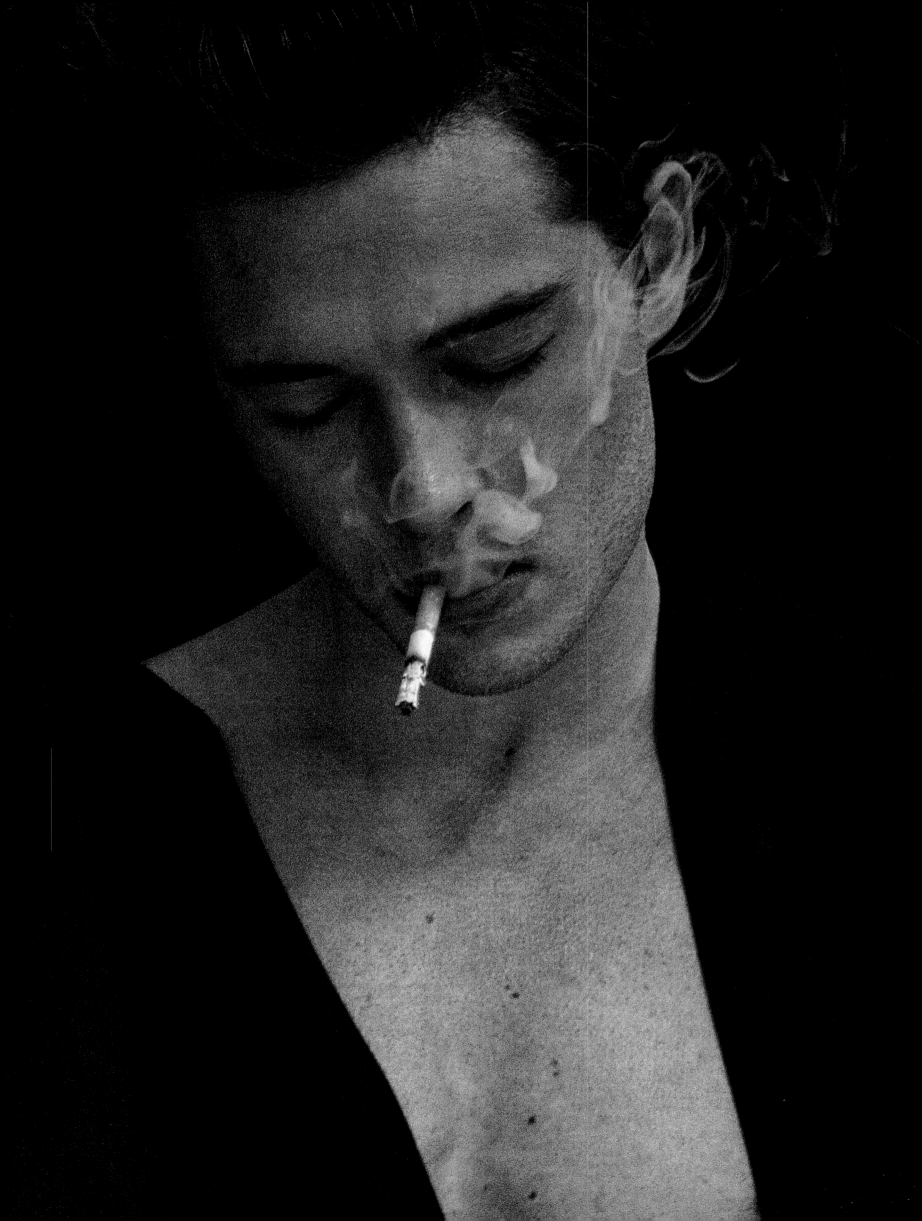

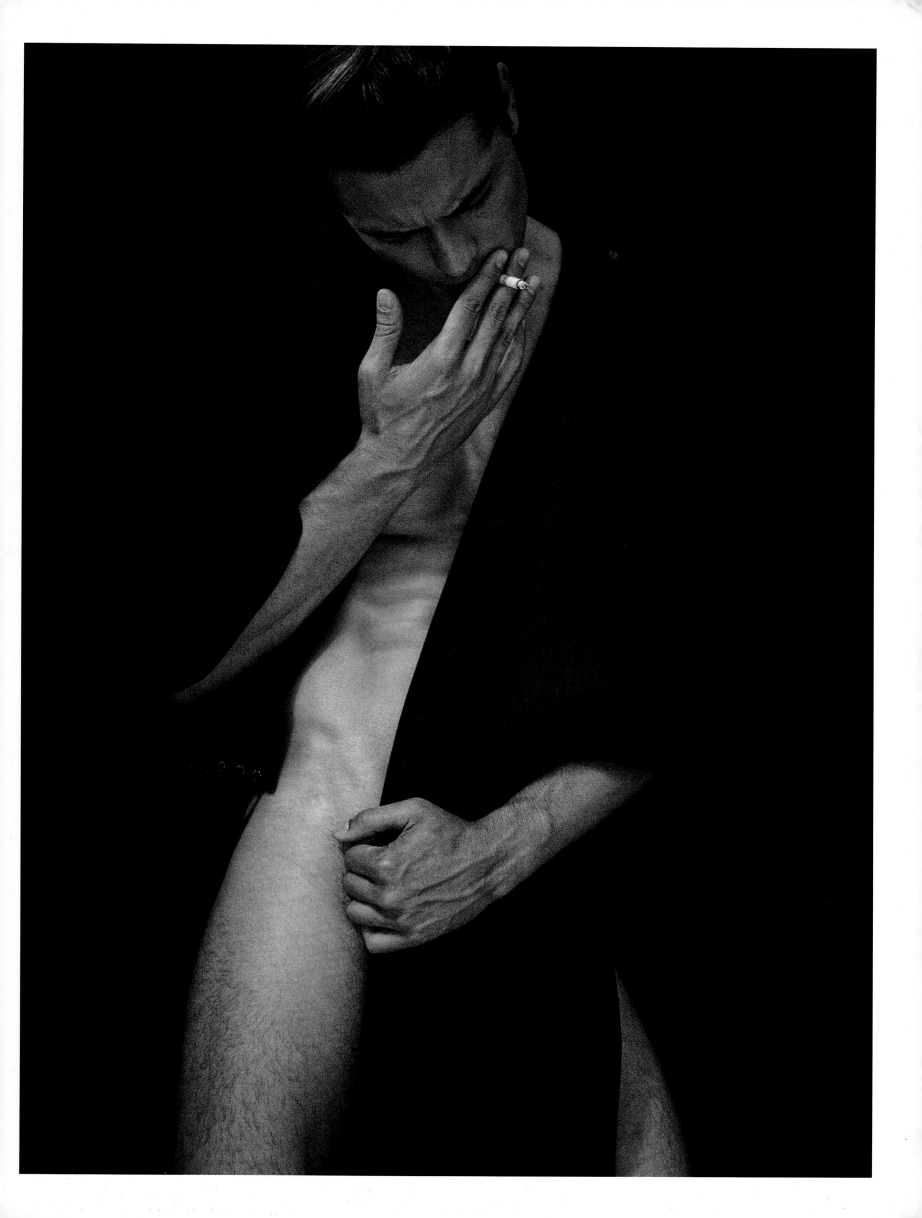

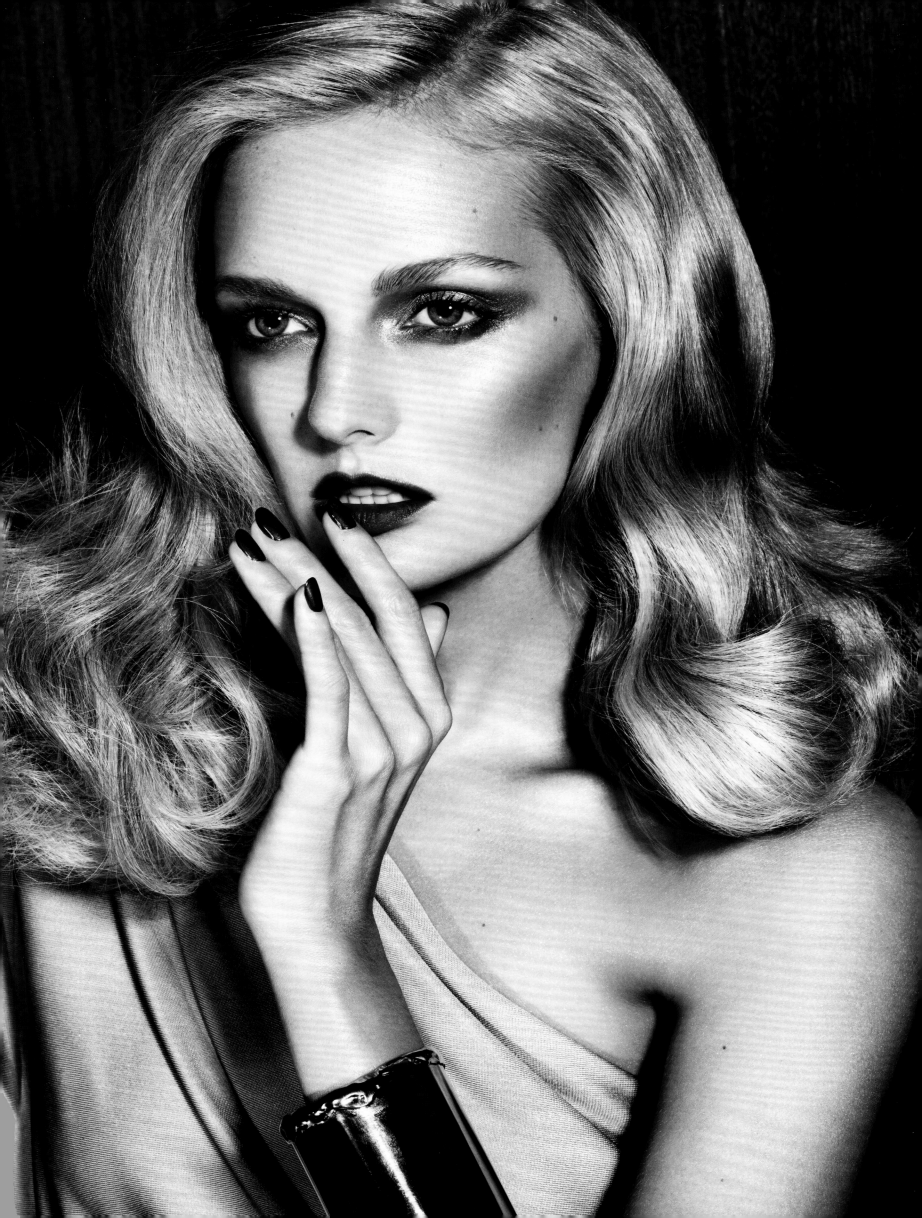

*"I hate narcissism,
but I approve of vanity."*

–Diana Vreeland

"Excess is success."

–Roberto Cavalli

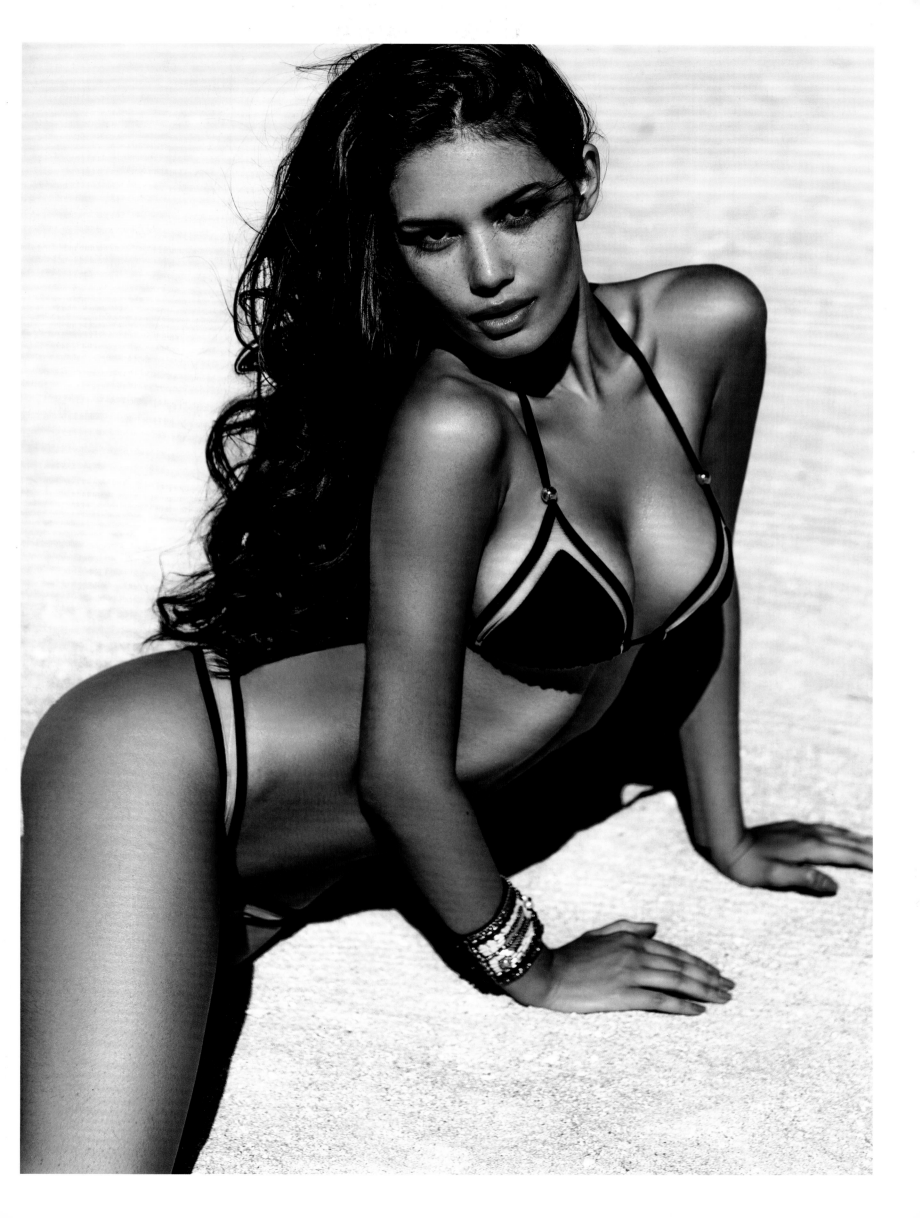

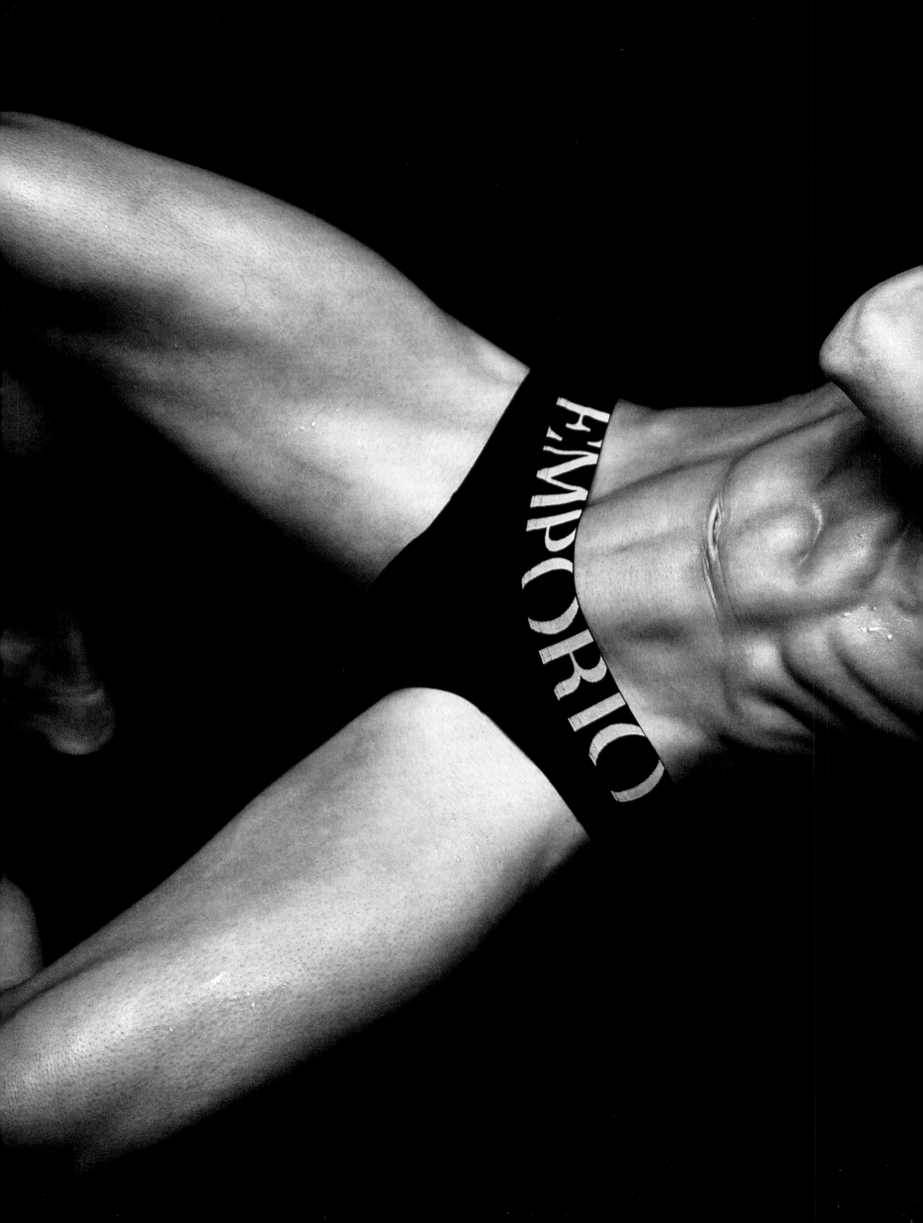

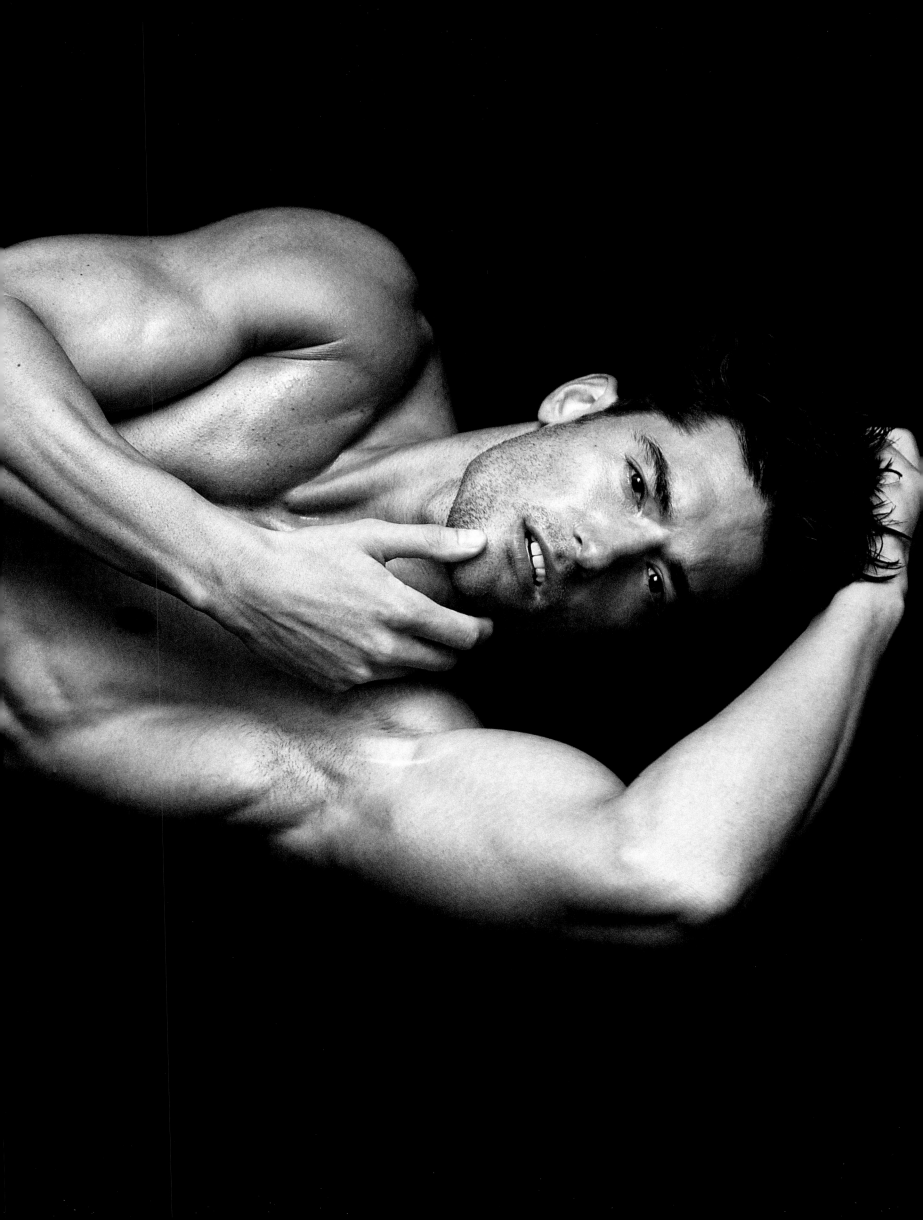

*"I like being a woman,
even in a man's world. After
all, men can't wear dresses,
but we can wear pants."*

–Whitney Houston

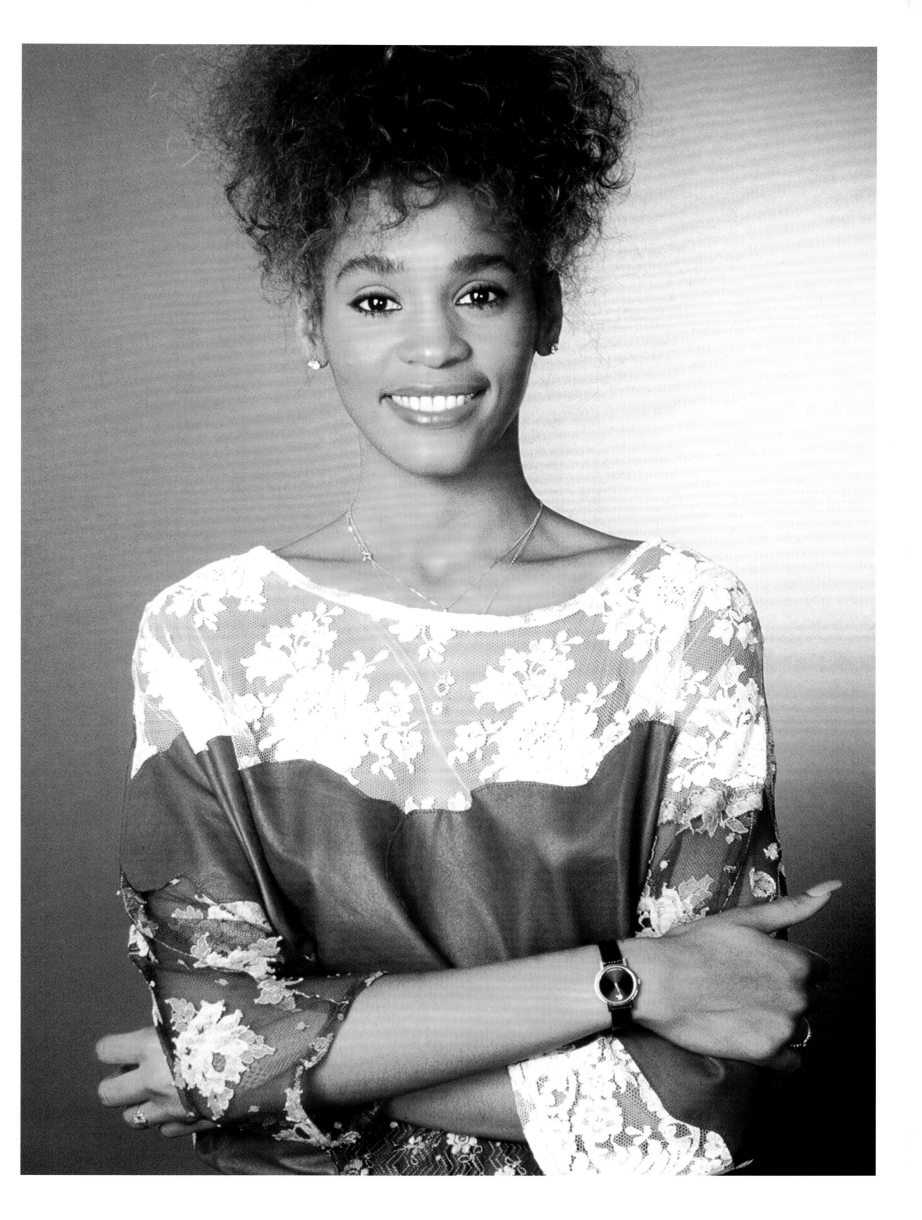

OPPOSITE PAGE: WHITNEY HOUSTON, 1984

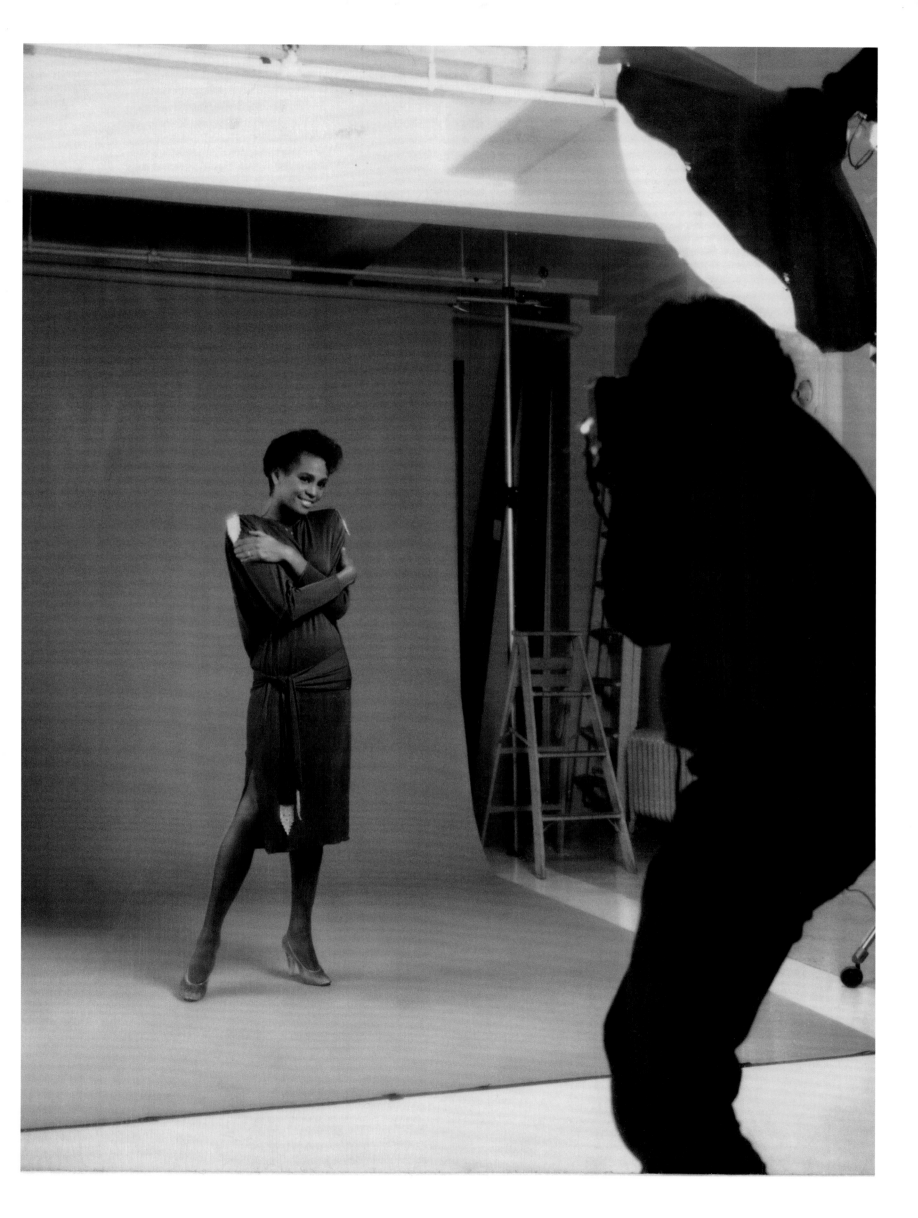

*"Over the years I have learned
that what is important in a dress is the
woman who is wearing it."*

—Yves Saint Laurent

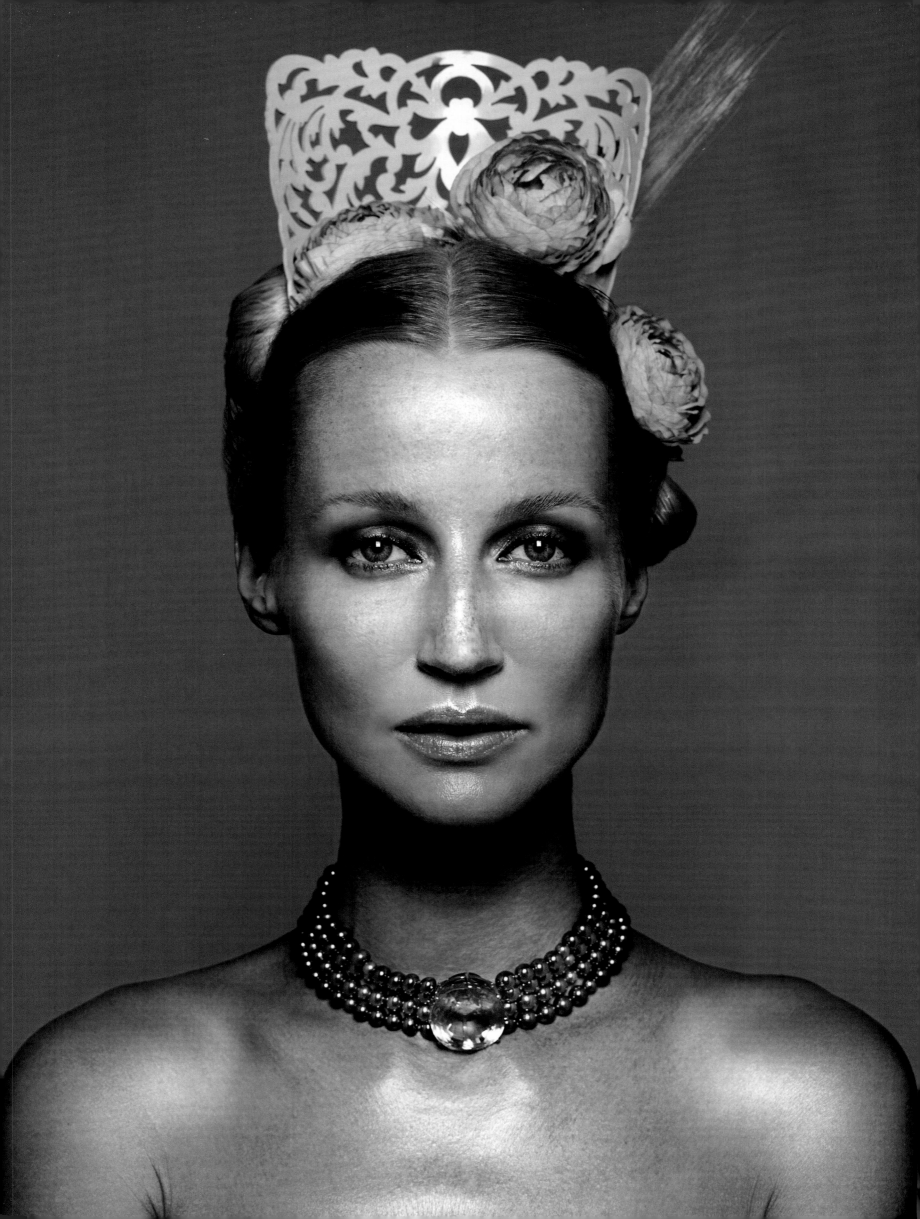

All About Reach

THE INFLUENCERS

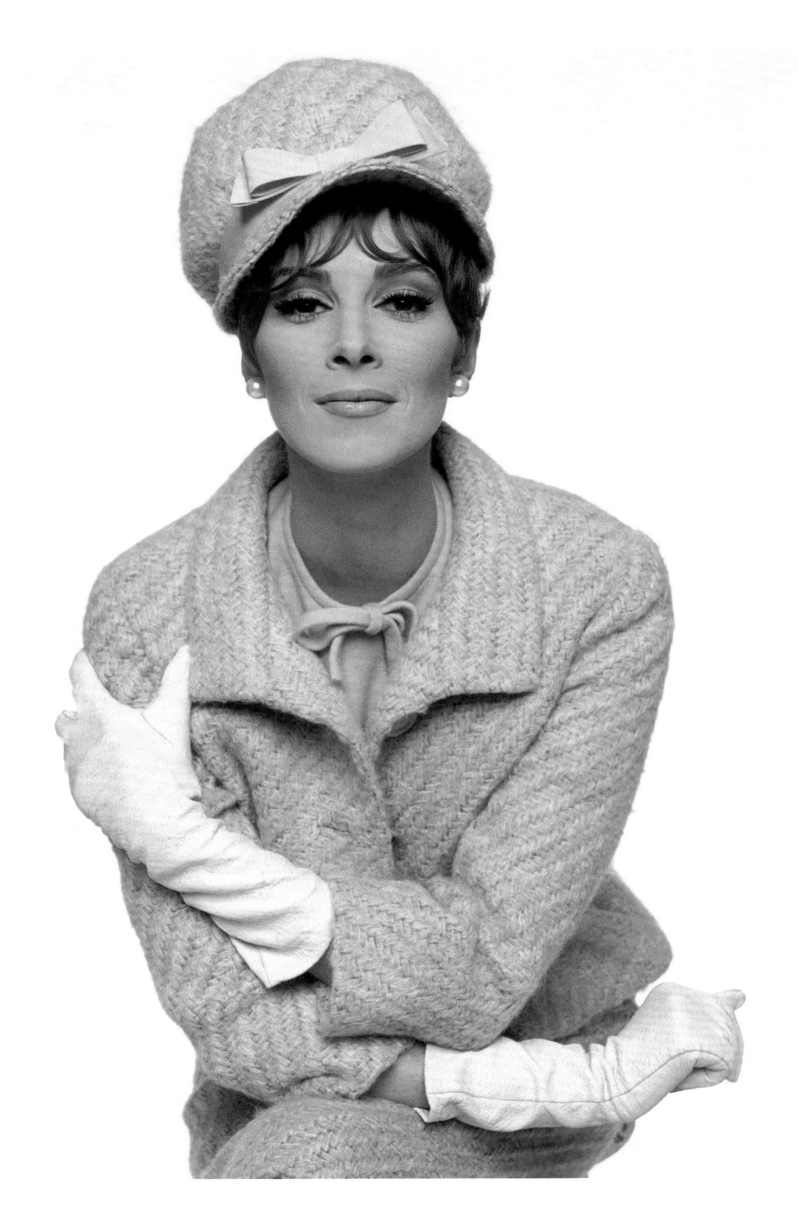

All About Reach
THE INFLUENCERS

Kylie Jenner was correct when she said that 2016 was "the year of realizing stuff," for by that time the power of so-called influencers had finally become crystal clear, even to those who once turned up their noses to the movement.

For marketers and media, measuring the impact of their messages is suddenly quantifiable in ways never before imaginable outside of a dystopian novel, especially in the once insular, now widely democratized world of fashion. As a result, it is fairly common practice today for successful models to be ranked and hired based on their measurements—not those on their comp cards, but those on their social media accounts. This is, after all, how Kylie and Kendall Jenner, each with one hundred million plus followers combined across Instagram and Twitter, went about conquering the industry.

Designers used to dismiss these modern-day luminaries in favor of bland models with no more personality or distinguishing characteristic than a coat hanger. Now, they are in high demand as ambassadors and collaborators, and Kendall Jenner has skyrocketed into the Top 50 Models ranking at Models. com, as well as being chosen by its readers as a model of the year for 2016. What's more, models of all stripes are being encouraged to show their true colors and speak up in the face of mistreatment.

While this may seem like a new phenomenon, models have, in fact, been influencers long before the term was coined. What we are really talking about here are those individuals who have the ability to drive campaigns with not only their appearances, but also by using their strong voices in support of diversity and feminism. Iggy Azalea, with her unapologetic attitude, can claim that title today, as would rising models like Barbie Ferreira, an outspoken advocate for body confidence who proudly shares images of her imperfections on Instagram.

And what model has ever wielded more influence than Iman, who built a cosmetics empire from her iconic career? She remains one of the fiercest champions of diversity, taking up the call of legendary model agent Bethann Hardison to publicly shame designers whose runway shows demonstrate a blatant disregard for models of color. In a 2013 article in the *New York Times*, Iman suggested a boycott if certain designers did not begin hiring black models. And while there is still much room for improvement, by the Fall 2017 collections, the numbers of nonwhite models had increased dramatically, when more than a quarter of the models cast were women of color, according to a survey by the FashionSpot.

Now that's influence.

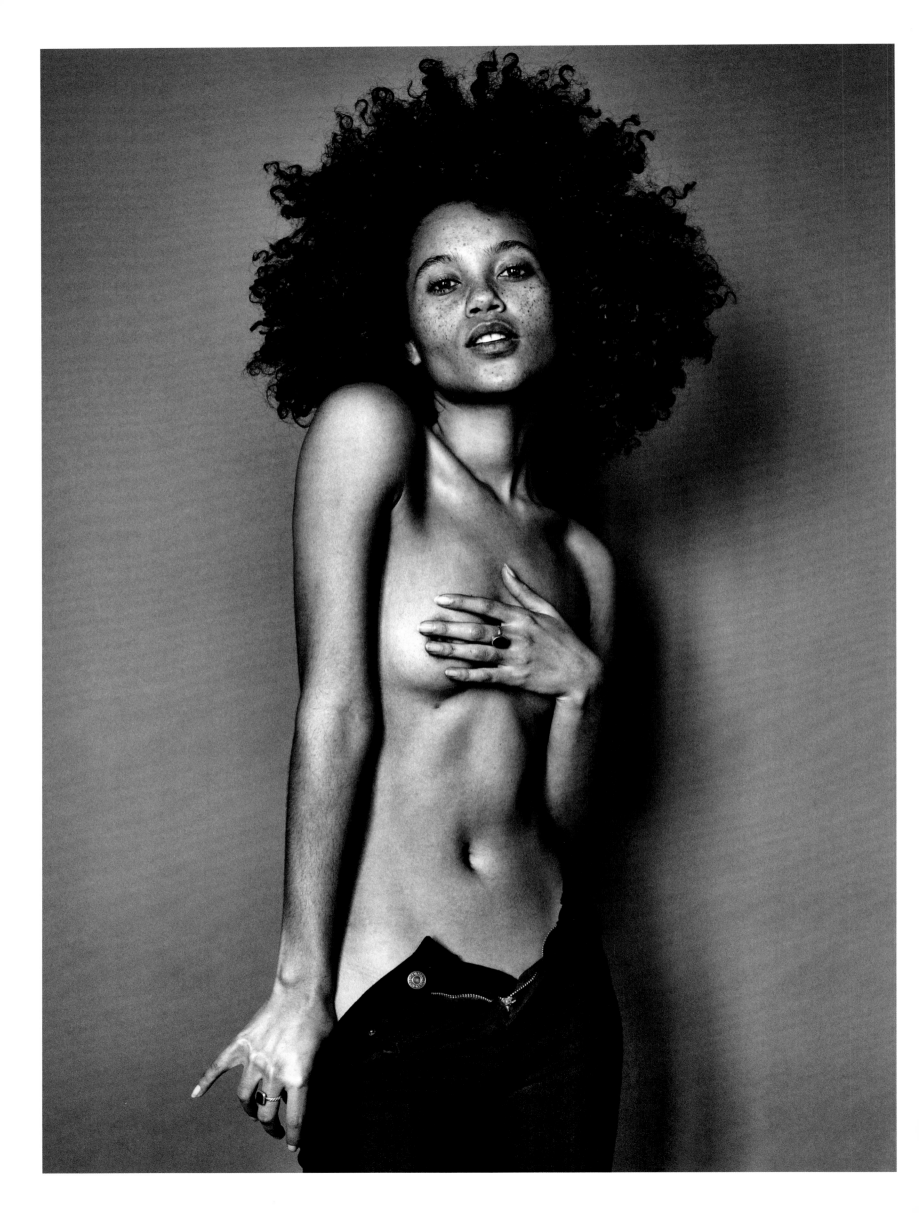

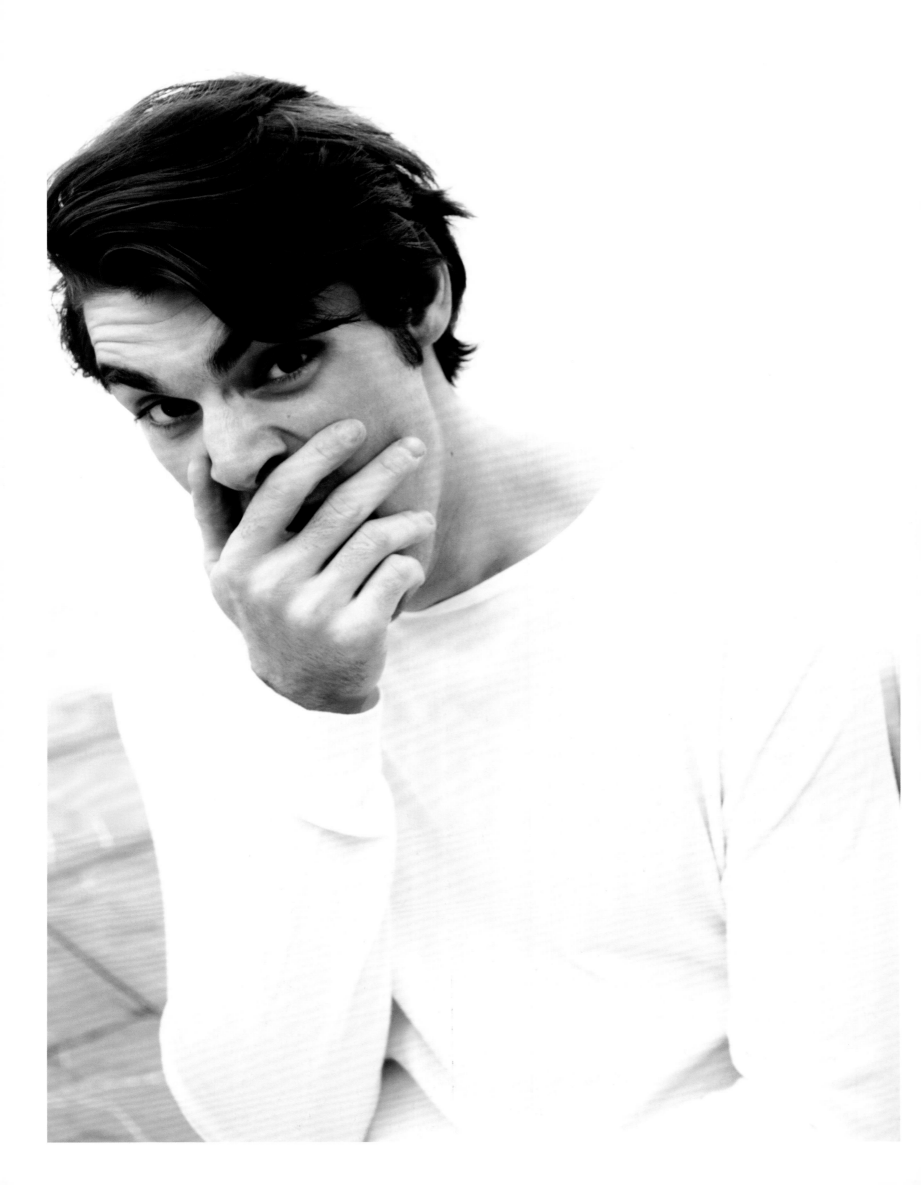

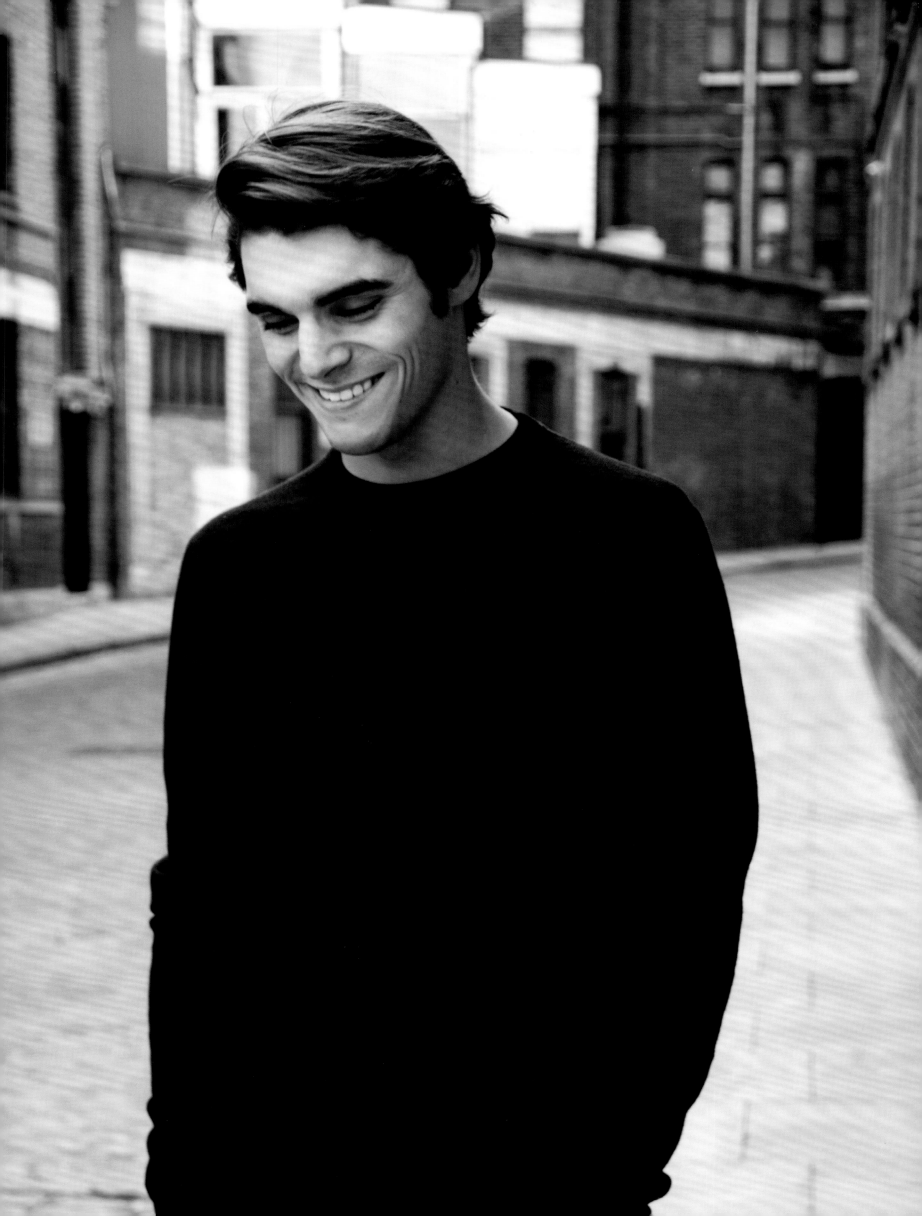

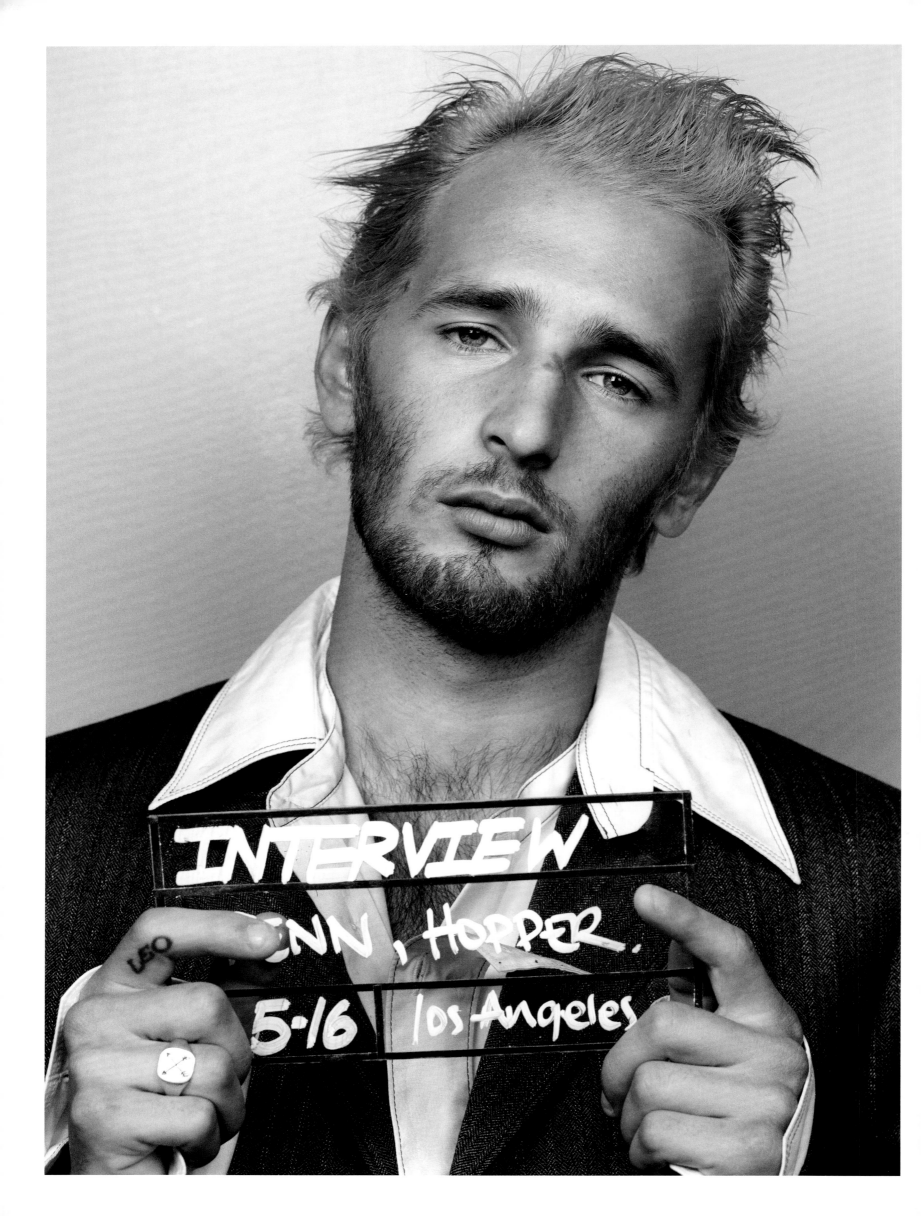

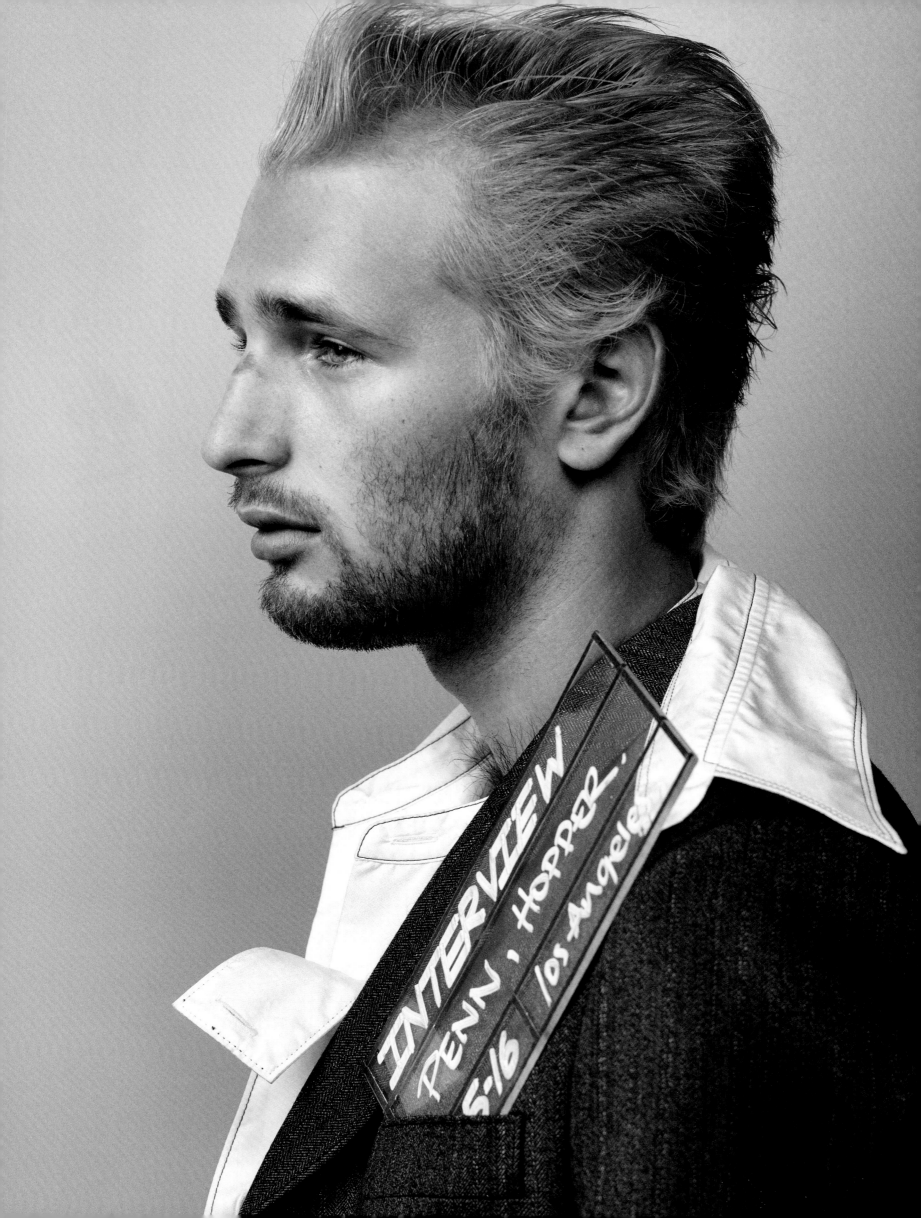

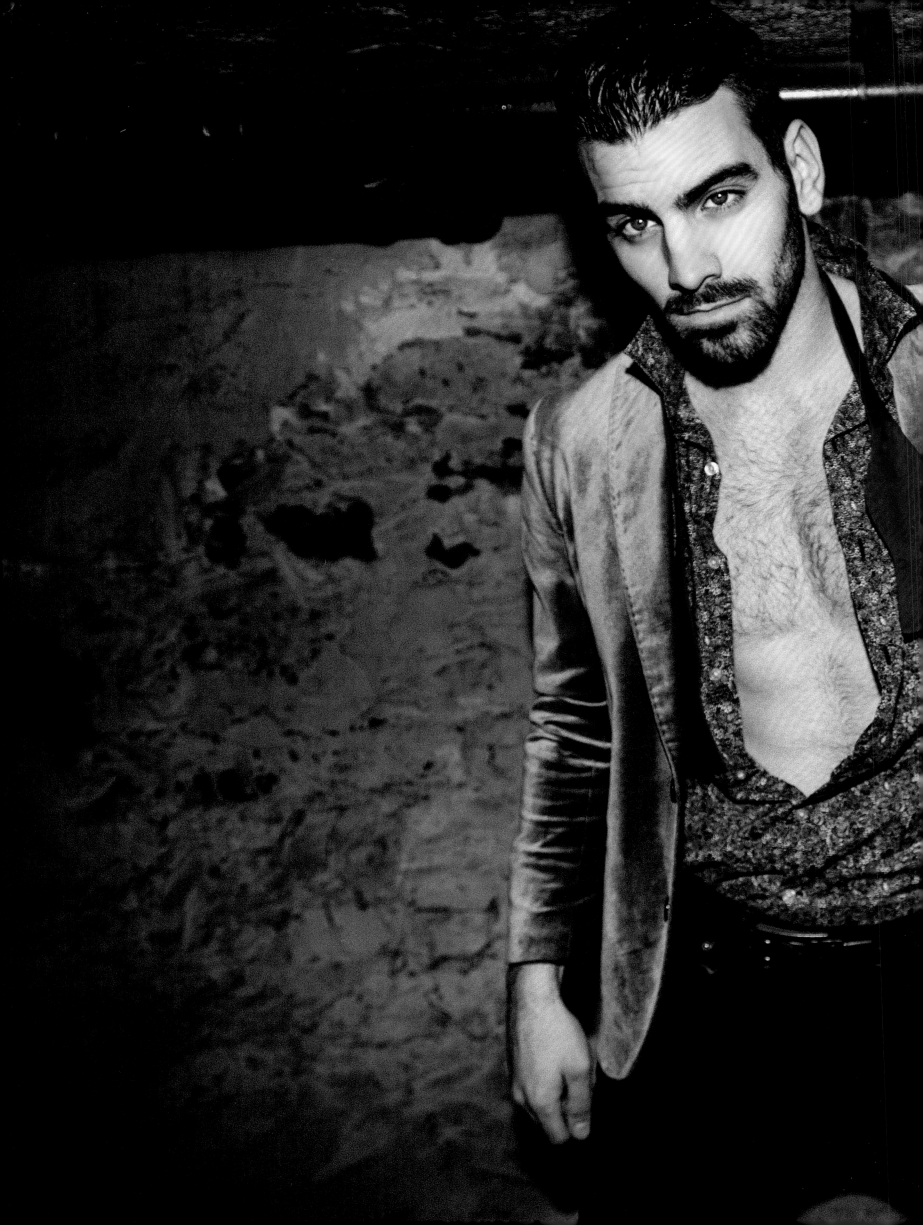

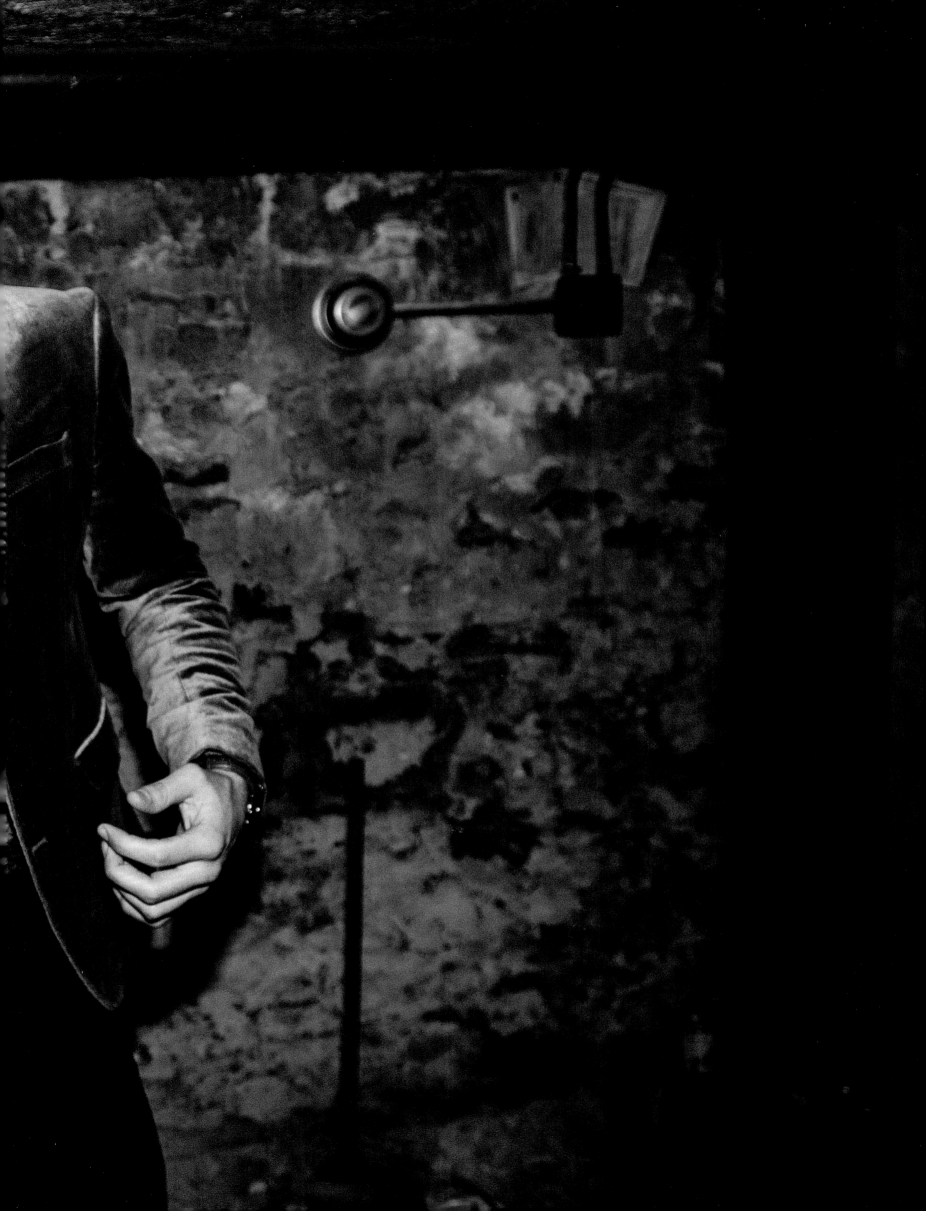

"Love of beauty is taste.
The creation of beauty is art."

–Ralph Waldo Emerson

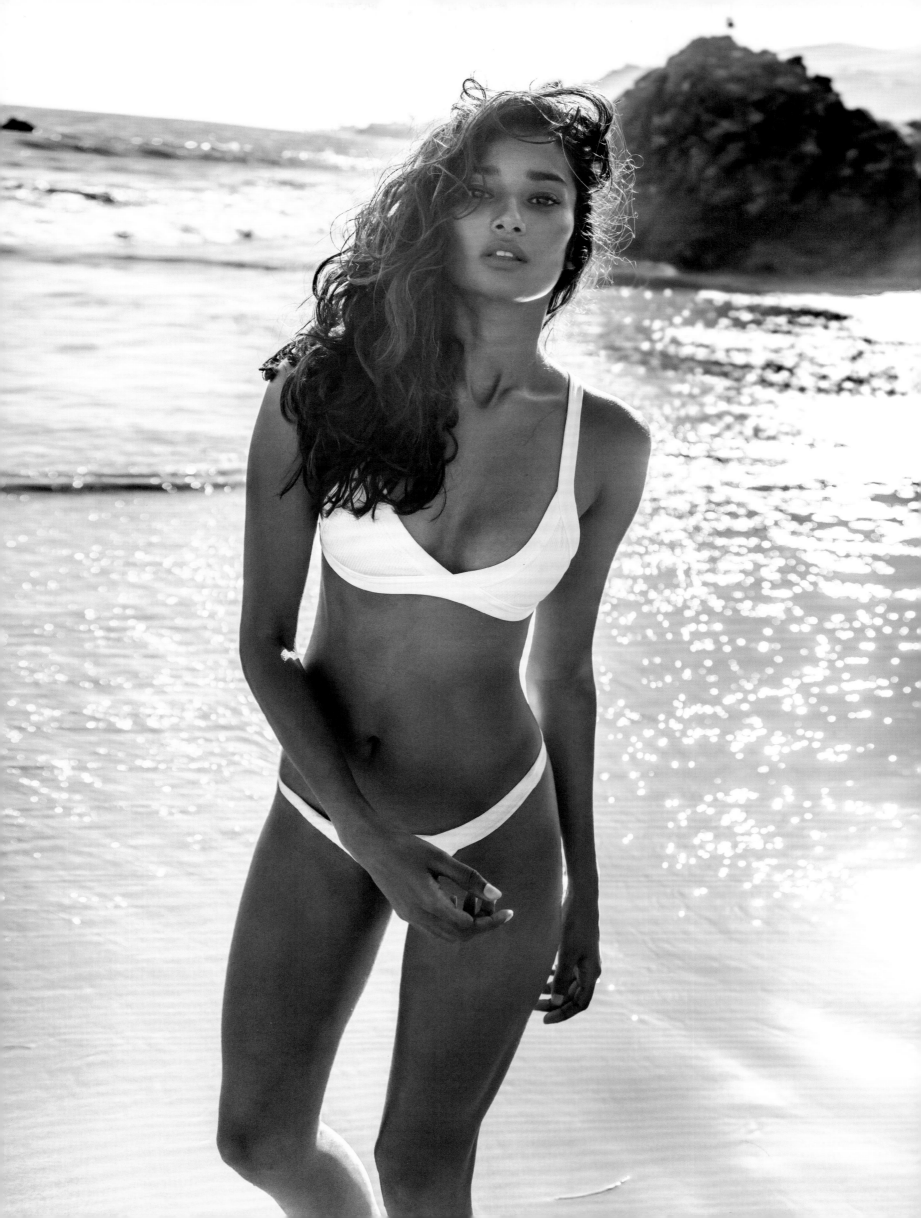

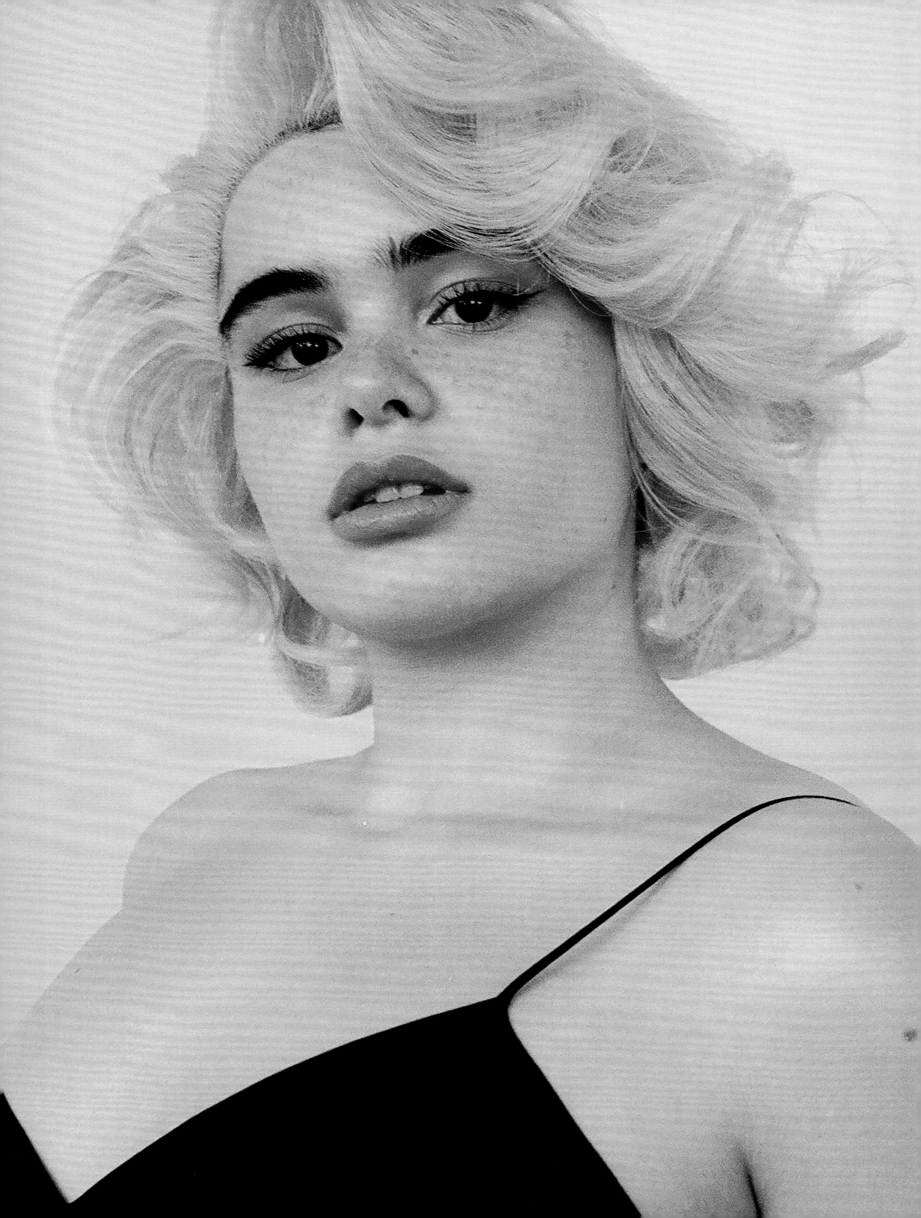

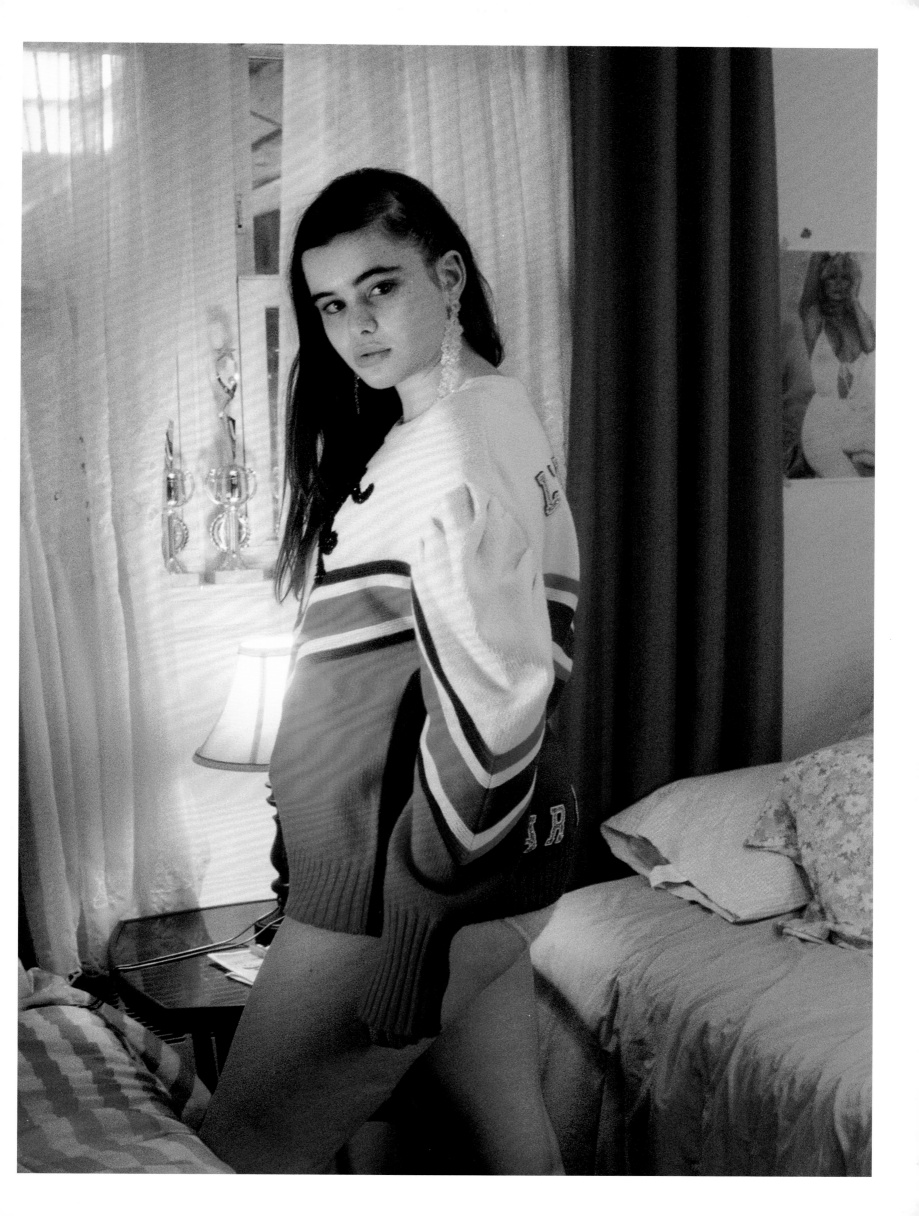

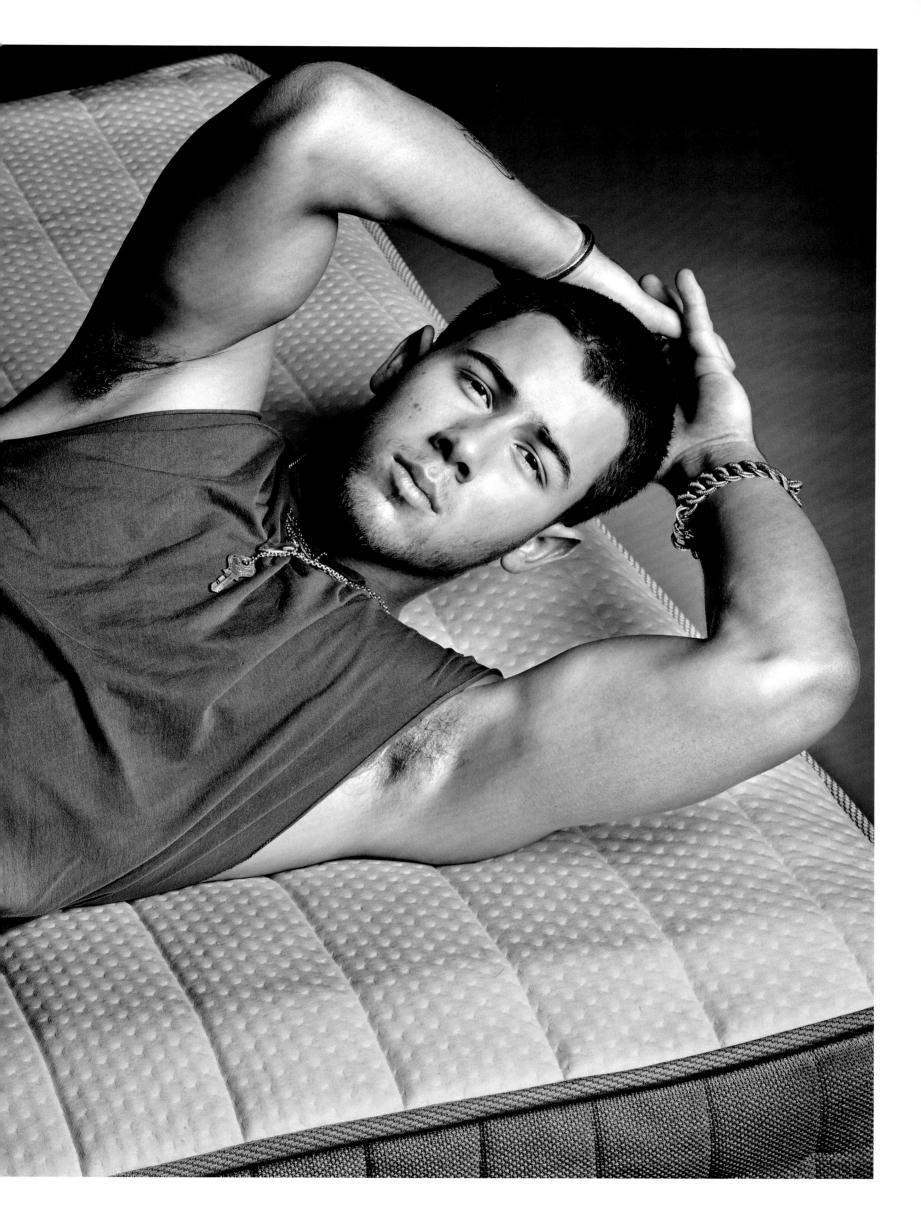

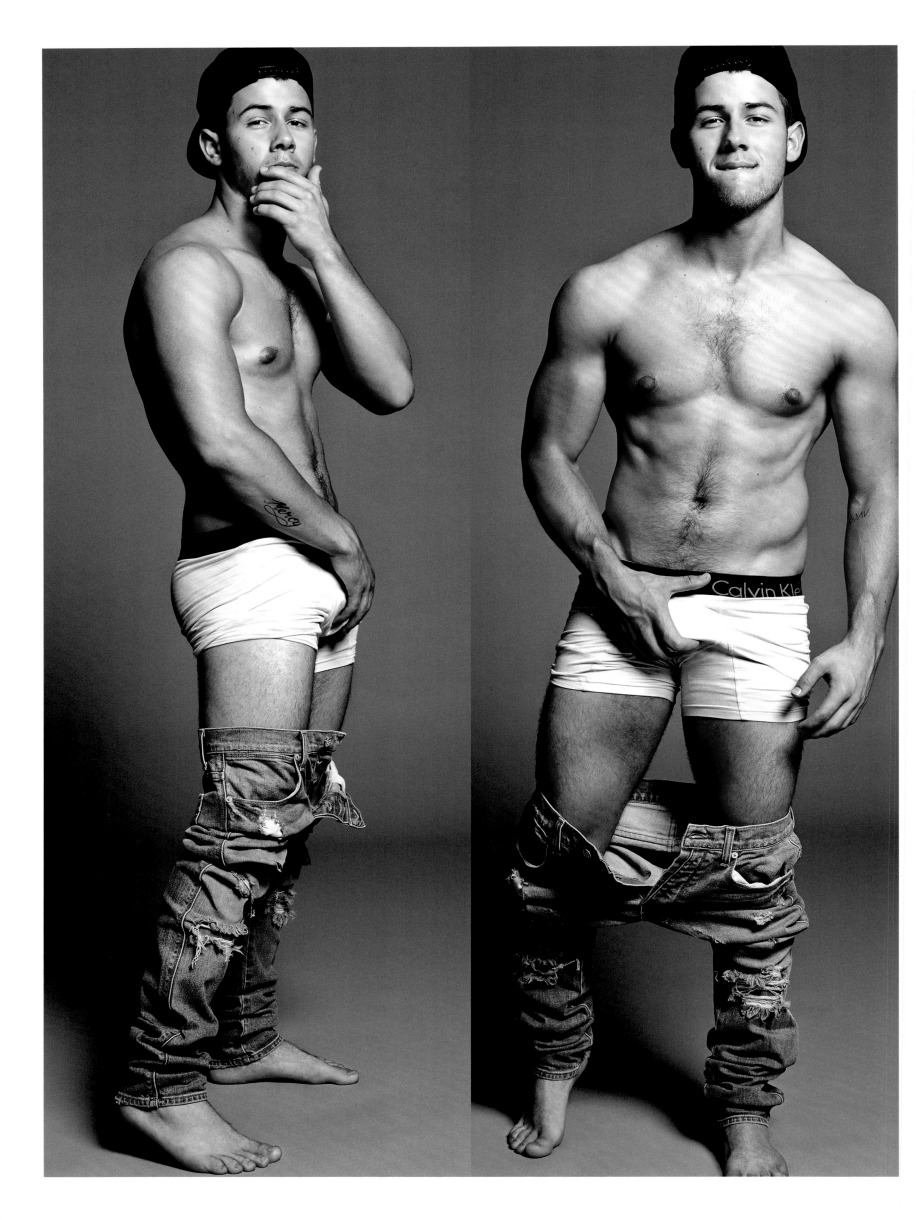

*"Fashion fosters clichés of beauty,
but I want to tear them apart."*

–Miuccia Prada

OPPOSITE PAGE: SUNG HEE, 2013

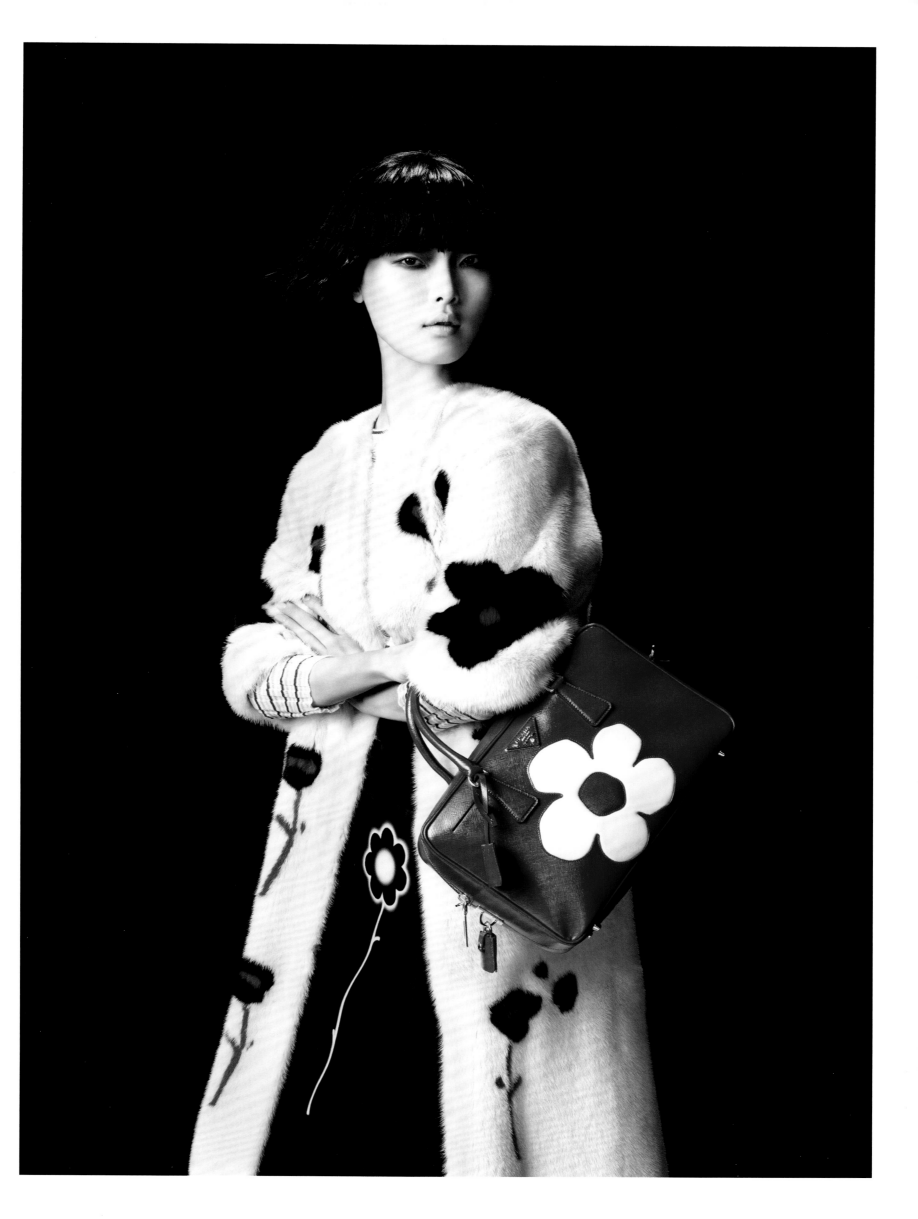

*"I naturally want to
be provocative."*

–Iggy Azalea

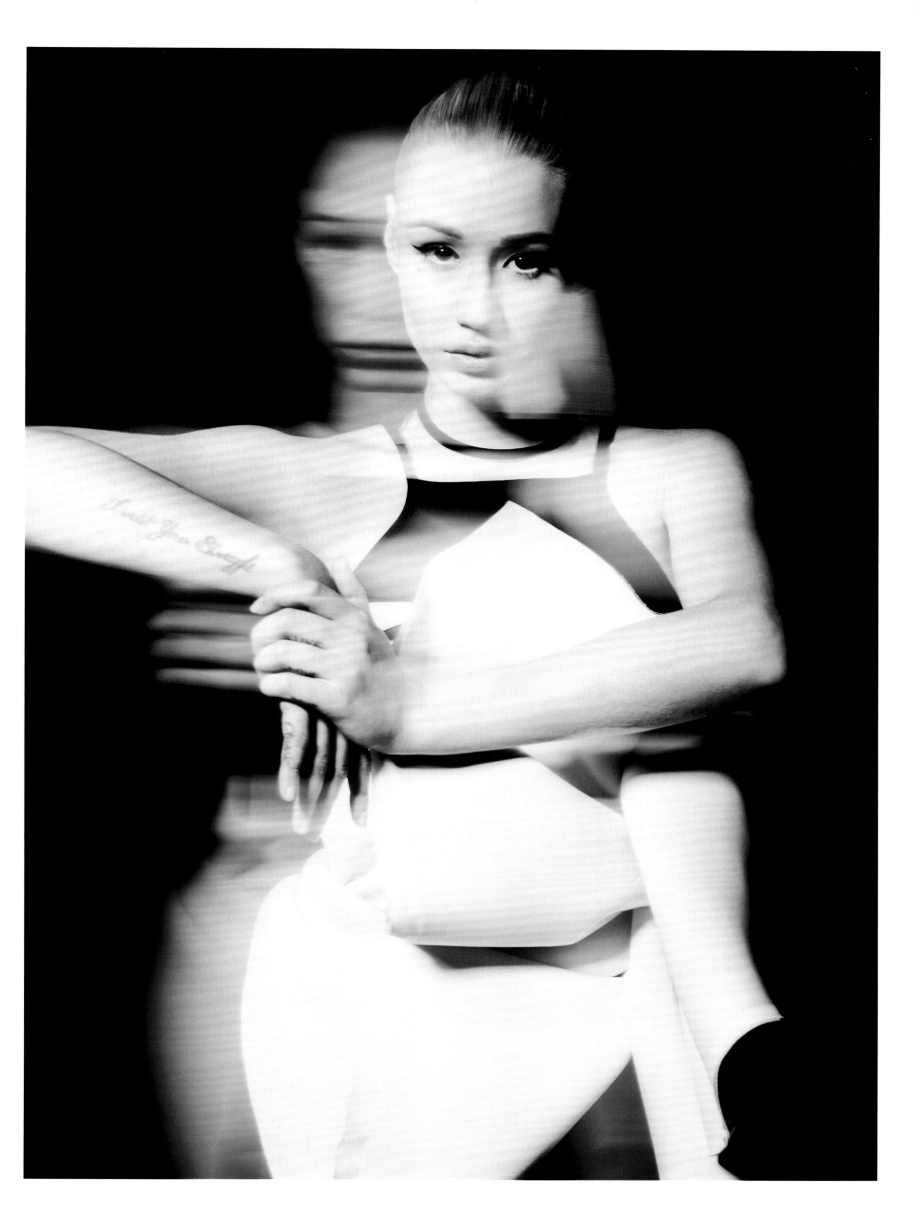

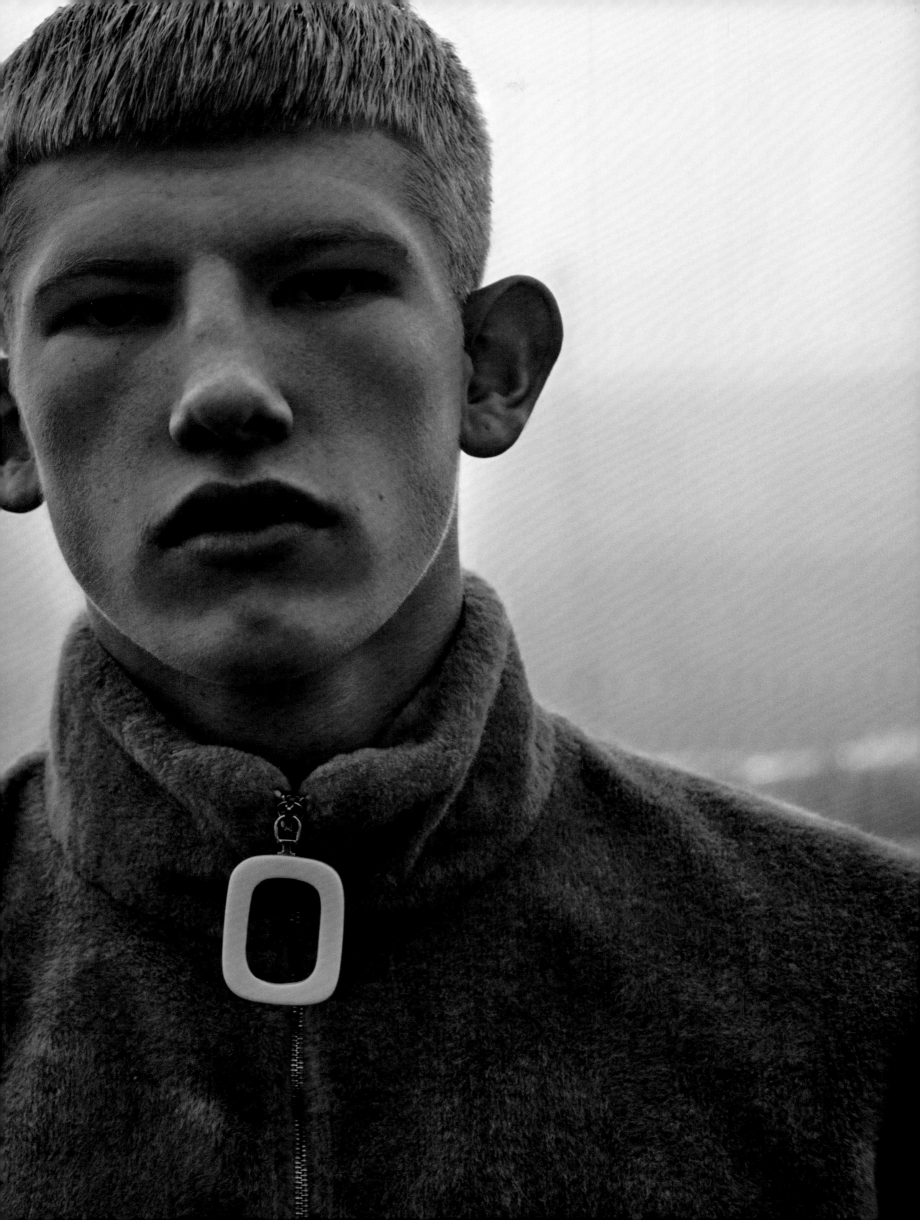

OPPOSITE PAGE: JORDYN WOODS, 2016

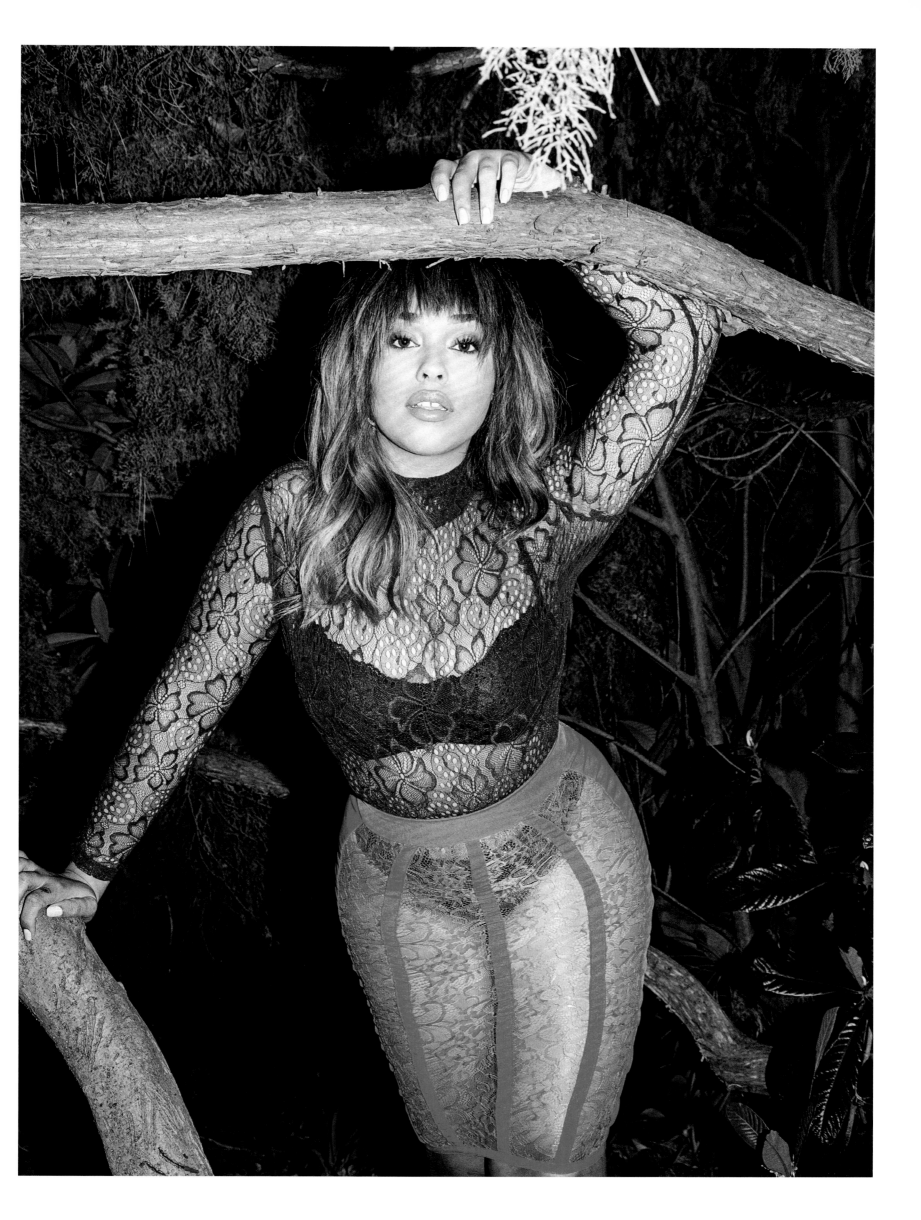

AFTERWORD
By Bill Wackermann

When Wilhelmina Cooper arrived in New York City, there was little to suggest that she would go on to become one of the most photographed models of the '60s—nor, when founding her namesake agency in 1967, that she would forge a legacy, creating a brand that is still going strong fifty years later.

While I've never had the privilege of meeting Mrs. Cooper, I do have the honor of championing her legacy every day as the current CEO of Wilhelmina. Her legacy is defined by the belief that beauty doesn't exist in a vacuum, but rather is shaped by time and culture. In fact, beauty has an obligation to change, becoming both a reflection of current circumstances and a glimpse into our collective future.

Wilhelmina: Defining Beauty celebrates only a small handful of the hundreds of beautiful and unique individuals who have played a part in Mrs. Cooper's legacy. Her spirit of change continues to fuel our growth today. From one small office in 1967 to a multinational company with offices around the world, from sixty models in 1967 to over 2,700 models, celebrities, and artists under contract today, Wilhelmina would be proud to know every three minutes a model is being booked somewhere in the world by the talented agents who work at our company—twenty-four hours a day, seven days a week.

In fact, in 2010 Wilhelmina continued to lead the market, becoming the first publicly traded modeling and talent agency on the Nasdaq stock exchange.

So, the answer is simple: beauty cannot be defined because it is ever-changing. And Wilhelmina as a company will change to reflect the needs of a new generation of models and clients. The mediums may evolve from print to digital, paper to plastic, but the message remains the same: we are dedicated to providing extraordinary talent. We are client-centered and committed to holding ourselves accountable for quality results. We are inspired to innovate and continue to evolve the definitions of beauty.

PHOTO CREDITS

ACKNOWLEDGMENTS

They say the fiftieth anniversary is traditionally gold and Wilhelmina would like to extend our warmest golden thanks to all those who made this book possible. First and foremost, we would like to thank the spirit, vision, and determination of Wilhelmina's founder, Wilhelmina Cooper, without whom there would be no Wilhelmina Models today. We would like to thank our publishing partners at Rizzoli, publisher Charles Miers, Anthony Petrillose, and Gisela Aguilar, for their exceptional work putting this book together. Thank you also to Johan Svensson for his artistic contribution and Eric Wilson for his literary expertise.

We are grateful for the continued leadership of our board of directors and our Executive Chairman, Mark Schwarz. Individual thanks and gratitude go to Wilhelmina's former owner, Dieter Esch, for his years of brilliance, and to board members Clinton Coleman, Mark Pape, Jim Roddey, Jeff Utz and Jim Dvorak.

There have been so many talented directors, agents, and team members past and present who have contributed their hearts, creativity, laughter, and magic to Wilhelmina and we thank you deeply for getting us to this place. A special thank-you to Wilhelmina's art director, Jhaim Aleman, and his team in the art department, Grace DiPaolo and Kara Biasucci, for their hard work on this project along with Daniel Omphroy in the executive office. With special appreciation to directors Jim McCarthy, Marilee Holmes, Taylor Hendrich, Jesse Blackhall, Rory Roth, Steve Miller, Nancy Ortiz, Victoria Rich, Helen Shuli, Donat Barrault, and Jay Tedder.

And finally, a huge thank-you to Patti Hansen and all the Wilhelmina talent, both represented in these pages and those not, whose words, dreams, and images make this book possible and who solidify Wilhelmina's fifty years of defining beauty!

WILHELMINA

Wilhelmina: Defining Beauty

First published in the United States of America in 2017 by
Rizzoli International Publications Inc.
300 Park Avenue South
New York, NY 10010
www.rizzoliusa.com

© 2017 Wilhelmina

Distributed in the U.S. trade by Random House, New York.

Printed in Italy.

ISBN: 978-0-8478-4860-7
Library of Congress Control Number: 2017942614

2017 2018 2019 2020 / 10 9 8 7 6 5 4 3 2 1